D0872408

ADVANCE PRAISE FOR *BLACK CULTURE, INC.*

"Essential reading for anyone curious about why major American corporations seem so intent on 'giving back' to Black cultural institutions. This significant book turns corporate sponsorships into objects of scrutiny, showing how they project an often disingenuous corporate image of caring not only about Black culture but also about Black people."

—Ellen Berrey, author of *The Enigma of Diversity*

"Patricia A. Banks makes a vital contribution to sociological theory, illuminating how Black cultural patronage is harnessed by corporations as a tool of financial and cultural power, often with pernicious implications for the same communities who are exploited for their diversity appeal. An important, penetrating analysis."

—Linsey McGoey, author of *No Such Thing as a Free Gift*

"As businesses and organizations strive to prove their commitments to equity and inclusion, *Black Culture, Inc.* provides a nuanced corrective to corporate narratives. Alongside the rich and detailed empirical analysis, the conceptualization of 'diversity capital' is a crucial intervention with relevance across the social sciences."

—Dave O'Brien, author of *Culture is Bad For You*

"*Black Culture, Inc.* is an important book. In connecting corporate sponsorship of Black cultural institutions with urgent issues of racial justice, Banks demonstrates the wide, and often disturbing, ramifications of corporate efforts to increase their 'diversity capital.' Packed with scholarly insights, relevant case studies, and vivid anecdotes, this engaging book should be read by scholars, practitioners, students, and anyone interested in Black cultural institutions and how American corporations use cultural philanthropy."

—Victoria D. Alexander, author of *Sociology of the Arts*

BLACK CULTURE, INC.

BLACK CULTURE, INC.

How Ethnic Community Support Pays
for Corporate America

PATRICIA A. BANKS

STANFORD UNIVERSITY PRESS
Stanford, California

STANFORD UNIVERSITY PRESS
Stanford, California

©2022 by the Board of Trustees of the Leland Stanford Junior University. All rights reserved.

Printed in the United States of America on acid-free, archival-quality paper

Library of Congress Cataloging-in-Publication Data
Names: Banks, Patricia A., author.
Title: Black Culture, Inc. : how ethnic community support pays for corporate America / Patricia A. Banks.
Other titles: Culture and economic life.
Description: Stanford, California : Stanford University Press, 2022. |
 Series: Culture and economic life | Includes bibliographical references and index. |
Identifiers: LCCN 2021034836 (print) | LCCN 2021034837 (ebook) |
 ISBN 9781503606777 (cloth) | ISBN 9781503631250 (ebook)
Subjects: LCSH: Art patronage—United States. | African American arts—Finance. |
 Ethnic arts—United States—Finance. | Corporate sponsorship—United States. |
 Corporations—Public relations—United States. | Social responsibility of business—
 United States.
Classification: LCC NX711.U5 B36 2022 (print) | LCC NX711.U5 (ebook) | DDC
 700.89/96073—dc23
LC record available at https://lccn.loc.gov/2021034836
LC ebook record available at https://lccn.loc.gov/2021034837

Cover design: Amanda Weiss

Cover imagery: Building, Adobe Stock; billboard, shutterstock

Typeset by Kevin Barrett Kane in 11/14 Minion Pro

To Cherry A. McGee Banks and James A. Banks

Table of Contents

Figures

Acknowledgments

I had the good fortune to work on this book during a residential Andrew W. Mellon Foundation Fellowship at the Center for Advanced Study in the Behavioral Sciences (CASBS) at Stanford University. During that sabbatical year, Mount Holyoke College also provided funding to support research and writing. I am grateful for assistance from archivists and other staff at the Library of Congress, Smithsonian Institution Archives, the Schomburg Center for Research in Black Culture, and the Northeastern University Archives and Special Collections. It has been such a pleasure working with Frederick F. Wherry, Jennifer C. Lena, and Marcela Maxfield on this project. As co-editors of the Culture and Economic Life Series, Fred and Jenn have been a constant fountain of encouragement and inspiration. Marcela, senior editor at Stanford University Press (SUP), provided invaluable guidance in shaping the book project through each stage. Comments from anonymous reviewers at SUP were particularly constructive for revising the manuscript.

It was incredibly enriching to spend a year learning from and with my colleagues at CASBS in 2018–2019. I especially enjoyed talking about art and culture with Margaret Levi and inequality and organizations with Elizabeth A. Armstrong. Discussion during and after my CASBS talk (2019) with Jerry A. Jacobs, Maya Tudor, Sherman James, Kim M. Williams, Ying-Yi Hong, Bart Bonikowski, Jennifer J. Freyd, Miriam Golden, Linda Woodhead, Kirsten Wysen, and others helped to shape the direction of the project at a pivotal time. Sally Schroeder, Mike Gaetani, and all of the CASBS staff helped to make the year a rich and fulfilling experience.

When I presented at the Sociology Department at Stanford University (2019), it was a lovely surprise to have Tomás R. Jiménez, my former officemate from graduate school at Harvard, give such a warm and thoughtful

introduction for the talk. Discussing my work on race and philanthropy at the University of Pennsylvania with Annette Lareau, Karyn Lacy, Sam Friedman, Brooke Harrington, Shamus Khan, Rachel Sherman, Cristobal Young, Daniel Laurison, and Elliot B. Weininger sharpened my insights about culture and inequality. It was especially meaningful to present at the Culture, Organizations, and Identities Panel at the Southern Sociological Society Annual Meeting in Atlanta, GA (2019). It was a full circle moment as Timothy J. Dowd, a co-organizer of the panel, was my faculty liaison at Emory University when I was collecting data for my dissertation on art collecting in Atlanta, and a couple of years later I started working with Vaughn Schmutz, the other co-organizer of the panel, as co-editor-in-chief at *Poetics*.

Participating in the Race in the Marketplace (RIM) Research Network and attending the first 2017 Race in the Marketplace Forum at the Kogod School of Business at American University has been foundational in my continuing to pursue a research agenda addressing how race and markets influence one another. At the conference I connected and reconnected with scholars, such as Frederick F. Wherry, David K. Crockett, Cassi Pittman Claytor, Corey D. Fields, Sonya Grier, and Anthony Kwame Harrison, whose research shapes my thinking about race, culture, and identity. Conversations with Arlene Dávila over the past few years have also informed my understanding of the intersections between race, culture, and markets. I especially appreciate the insightful feedback about the project from its inception from my colleagues at Mount Holyoke College—Eleanor R. Townsley, Kenneth H. Tucker, Ayca Zayim, and others. Thanks also to Sedem Akposoe for research assistance. Being in conversation with Kimberly Juanita Brown, Aneeka Ayanna Henderson, and other members of The Dark Room: Race and Visual Culture Faculty Seminar has given me the opportunity to consider African American culture and identity from a range of disciplinary perspectives.

Comments and questions at the following talks and panels were especially generative: the Sociology Department at the University of California, Berkeley (2019); the Sociology Department at Stanford University (2019); the Center for Advanced Study in the Behavioral Sciences at Stanford University (2019); the ASA Consumers and Consumption Mini-Conference at Rutgers University, Camden (2018); the Elites session at the Eastern Sociological Society Annual Meeting (2020); the Culture, Organizations, and Identities Panel at the Southern Sociological Society Annual Meeting (2019); the Center for Visual Culture at Bryn Mawr College (2021); the Willson Center for Humanities and Art and

the Institute for African American Studies at the University of Georgia (2021); and the Department of Sociology and Anthropology at Mount Holyoke College (2019).

This book is particularly significant to me because it grows out of research that I first began as a graduate student at Harvard when I was studying art collecting and racial identity. It was there that I became interested in race and cultural capital. The core concept in this book, *diversity capital*, builds on Prudence L. Carter's concept of "Black cultural capital." Insights that I learned from her when she served on my oral examination committee examining race, class, and cultural consumption continue to shape my approach to culture and inequality. As in all of my work, I am influenced by the scholarship of my dissertation committee members: Lawrence D. Bobo, William Julius Wilson, and Michèle Lamont. The vibrant intellectual communities at Spelman College and the UNCF/Mellon program—Cynthia Spence, Walter R. Allen, and Sarah Willie-LeBreton—always motivate my research.

I am most grateful for the enduring support of Cherry A. McGee Banks, James A. Banks, and Angela M. Banks, who serve as an ongoing intellectual foundation for my scholarship.

BLACK CULTURE, INC.

1

Diversity Capital

"LADIES AND GENTLEMEN, please welcome president of the General Motors Foundation, Vivian Pickard." As the audience at the 2014 Washington Auto Show applauds, Pickard, who is African American and wearing a stylish black-and-white pinstriped pantsuit, walks to the podium of a large stage that showcases General Motors' newest vehicles. "Good afternoon everyone," she says smiling. "It is my pleasure to welcome you to the Chevrolet exhibit at the Washington DC Auto Show." As is routine at auto shows, Pickard reports that two GM cars were just given national vehicle awards. But soon her presentation takes a surprising turn. Pickard announces that the GM Foundation is giving a million dollars to the Smithsonian to help build its newest museum, the National Museum of African American History and Culture (NMAAHC).

Like GM, corporations across the United States engage in philanthropy and sponsorships in the Black cultural sector. Open a brochure for an African American performing arts organization, such as the Alvin Ailey American Dance Theater, and you'll see logos for corporations like American Express and American Airlines. Or visit the website for a Black cultural center like the Apollo Theater, and you'll notice acknowledgments to corporations like Coca-Cola and Citigroup. Some Black cultural initiatives, such as the Martin Luther King, Jr. Memorial and NMAAHC, owe their very existence to big corporate gifts. GM and the fashion brand Tommy Hilfiger were the two largest private donors to the MLK Memorial, giving $10 million and $6 million, respectively.

Similarly, dozens of million-dollar grants from businesses like Microsoft and Wells Fargo were founding donations for NMAAHC. Corporate sponsors like McDonald's and AT&T also underwrite the Essence Festival, which is the largest Black music festival in the United States. Some businesses, like Ford Motor Company, support Black cultural initiatives across various local communities. In 2019, the automaker gave or made commitments to support Black cultural nonprofits such as The Charles H. Wright Museum of African American History in Detroit ($120,000), the National Civil Rights Museum in Memphis ($255,000), and the National Underground Railroad Freedom Center in Cincinnati ($170,000). Smaller donations and sponsorships from corporations are important sources of supplemental support for many other Black cultural institutions as well as Black initiatives at majority institutions. For instance, a $5,000 corporate grant can be used to help produce an exhibition catalogue at a Black museum, or a Black dance company can use a $2,500 corporate gift to help support an after-school program for children.

On its face, Black cultural patronage by corporations is a selfless act. Companies give generously to preserve the nation's cultural heritage and to contribute to the public good in other ways. However, from my research drawing on an extensive array of data (such as public relations and advertising texts on corporate cultural patronage and observations at sponsored cultural events), I show how Black cultural patronage is not just altruistic: It pays for business too. In the pages that follow I describe how Black cultural patronage by corporations is a form of what I term *diversity capital*. Black cultural patronage allows businesses to solve problems and leverage opportunities related to race and ethnicity and other social differences. Examining Black cultural patronage sheds light on how ethnic community support (i.e., philanthropy and sponsorships related to racial and ethnic minorities) is an important cultural resource for corporations; this ethnic community support allows corporations to project an image of being inclusive and equitable while strengthening their corporate interests. By engaging in Black cultural patronage, companies such as GM not only cultivate a broadly inclusive corporate image but also the perception that they specifically value African Americans.

These insights not only deepen our understanding of corporate philanthropy and sponsorships, but they advance theory on race and cultural capital. Although there is growing research on Black cultural capital as a practice that signals Black identity,[1] this scholarship focuses on individuals. By developing the concept of diversity capital, *Black Culture, Inc.* shows how cultural practices

related to African Americans and other racial and ethnic minorities are a resource for establishing and maintaining racial images at the organizational level.

Along with advancing the literature on race and cultural capital, *Black Culture, Inc.* also contributes to the scholarship on corporate diversity. There is increasing attention to the racial images of companies, however this scholarship centers on employment.[2] For example, studies examine how workforce diversity programs, such as affirmative action and mentoring programs, signal that firms are equitable. Other research calls attention to the ways that a diverse workforce itself projects an image that companies are "diverse, modern, and open to all."[3] But by examining ethnic community support, this book provides a more comprehensive theoretical view of how companies convey to stakeholders that they are racially inclusive.[4] Moreover, by focusing on specifically Black community support, this book provides important insight on the Black side of diversity branding. While Arlene Dávila's classic text *Latinos, Inc.* outlines the tactics that companies use to appeal to Latinx consumers,[5] with some exceptions,[6] there has been little systematic analysis of African American marketing in the social sciences.[7]

Finally, *Black Culture, Inc.* also illuminates practical concerns around race-related philanthropy and sponsorships.[8] Uprisings over the deaths of George Floyd and other African Americans in the summer of 2020 set off an outpouring of corporate giving to racial justice causes.[9] For example, retail giant Walmart, which made a $5 million donation to NMAAHC in January 2020, pledged to give away $100 million to racial equity causes after the nationwide protests. Similarly, multinational investment bank Goldman Sachs and Altria (the parent company of cigarette manufacturer Philip Morris), which were both founding donors of NMAAHC in 2016, dedicated $10 million and $5 million, respectively, to support racial justice causes in the aftermath of the uprisings.

Although these donations deliver social benefits, the analysis in *Black Culture, Inc.* suggests that race-related corporate giving may also come at a cost. Ethnic community support conveys an image that companies are inclusive and equitable, but in reality some of these businesses have poor track records around diversity.[10] Indeed, in some cases ethnic community support is strategically deployed to manage the images of companies accused of racial harm. For example, in the aftermath of racial image crises, businesses like Papa John's, Gucci, and Denny's announced donations to support African American initiatives.[11] The history of corporate community support places all these dynamics in perspective.

Giving to Communities

Just as community support is a meaningful part of the culture of social groups, like the upper class, it is also an important aspect of the culture of corporations. In fact, the histories of corporate and elite philanthropy are intertwined. When large cultural institutions were formed in the 19th century in the United States, the main patrons were wealthy individuals who earned their money through capitalist enterprises.[12] These wealthy industrialists took profits from business and invested them in the cultural life of the cities where they lived and worked.[13] For example, heirs of automobile magnate Henry Ford were early supporters of the Detroit Institute of Arts in Michigan, and department store scion Marshall Field was a founding patron of the Art Institute of Chicago and the Field Museum.[14]

In the 1960s and 1970s, patronage in the business community shifted. Whereas before it was mainly wealthy owners and managers who gave individually, by the 1960s and 1970s more and more gifts were coming from businesses themselves.[15] During that era of growing social protest, businesses were accused of undermining the public good. For example, companies were accused of engaging in practices that harmed the environment and violated the rights of workers. Anti-corporate activism was also race related as companies were charged with propping up the apartheid regime in South Africa and enacting discriminatory hiring practices in the United States.[16] As public scrutiny of the ethical practices of businesses intensified, corporations started to embrace a doctrine of corporate social responsibility. This ethos dictates that companies have an obligation to improve society and the communities where they do business.[17] One way that corporations deliver social good is through philanthropy and sponsorships.[18] Together these activities, referred to in this book as community support, are among the main vehicles through which companies "give back" to society.[19]

Just as the 1960s and 1970s were important for corporate community support as a whole, they were also notable for specifically Black community support. This was an era of Black cultural flowering as cultural institutions such as the Studio Museum in Harlem and the Dance Theatre of Harlem were established. Though these organizations were mainly grassroots affairs, they received corporate support even then. For example, in the 1970s an oil company contributed $45,000 to the DuSable Museum of African American History in Chicago, and in the 1970s companies like Aetna and New England Life gave

four-figure grants to support the National Center of Afro-American Artists, a Black arts organization in Boston. Corporations have also been long-time supporters of Black initiatives related to civil rights and education. For instance, in the wake of the urban uprisings in the 1960s, large companies made donations to nonprofits such as the National Association for the Advancement of Colored People, the United Negro College Fund, and the National Urban League.[20]

While it is clear that corporations are an important source of support for Black-focused initiatives, cultural and otherwise, it is not so apparent how companies benefit from their support. Sociological scholarship on corporate images, culture, and race offers some clues about the racial benefits of ethnic community support.

Enhancing Corporate Images

Corporate community support is motivated by enlightened self-interest.[21] On one hand philanthropy and sponsorships provide social value. For example, gifts to museums and theaters are beneficial for society since they help to make the arts accessible to local communities. At the same time, corporations receive dividends for these good works. Or, they benefit materially and symbolically.[22] With respect to symbolic benefits, community support bolsters the public image of companies. Community support in the cultural sector is specifically considered a "highbrow form of advertising."[23] Through engaging in activities such as sponsoring museum exhibitions and donating to capital campaigns for arts centers, corporations convey a positive image to the public.[24] For example, in keeping with her assertion that "corporations generally fund art as a public relations gambit,"[25] Victoria D. Alexander finds that in comparison to other types of museum patrons, corporations are more likely to fund exhibitions with wide appeal to the public.[26] While sociological scholarship accounts for how community support is a cultural practice through which corporations manage their image, there is little investigation of how community support directed at racial and ethnic minority initiatives may be used in a very specific fashion—to symbolically craft their racial image.

Race and Cultural Capital

To gain insight on how ethnic community support functions as a distinct form of corporate image management, we can turn to the sociological scholarship

on cultural capital. Cultural capital is a concept that was developed by French sociologist Pierre Bourdieu and his colleagues to explain class inequality.[27] Bourdieu concluded that culture, or more specifically what he termed "cultural capital," was at the root of class reproduction. As Bourdieu conceptualized it, cultural capital consisted of forms of middle- and upper-class culture—such as a taste for and understanding of "high culture"—that provided a class return. Through gaining an appreciation for high culture via family and educational socialization, the middle and upper class reproduced their class status.

While incredibly influential, cultural capital theory as conceptualized by Bourdieu has been critiqued.[28] In Bourdieu's elaboration of the concept, it is the culture of dominant groups, such as the middle and upper class, that functions as a resource. Moreover, cultural capital is defined in reference to class, rather than other types of categories, such as race and ethnicity. Other scholars have further elaborated cultural capital to account for how the culture of non-dominant groups and racial groups can function as resources.[29] For example, Prudence L. Carter uses a modified theory of cultural capital to explain the educational experiences of Black urban youth.[30] On one hand, she finds that having lower stocks of dominant cultural capital, or cultural capital as traditionally defined, explains their lower educational outcomes. However, Carter also shows that having high stocks of nondominant cultural capital, or cultural capital associated with a marginalized group, is important at school. Specifically, Black cultural capital—or a taste for and understanding of Black culture—plays an important role in the social life of Black youth. Engagement with Black urban culture—such as listening to hip hop—determines who is considered authentically Black among peers.[31] Carter theorizes that Black cultural capital is class-specific so that other forms of Black culture are important for racial membership among the Black middle and upper class. A growing body of research shows how practices such as collecting African American art and patronage at African American museums are forms of Black cultural capital that the Black upper-middle and upper class use to convey their racial identity.[32]

Black cultural capital is not the only innovation to cultural capital theory that relates to ethnoracial boundaries. There is also the argument that elites reproduce and maintain their status through possessing multicultural capital. This view asserts that in contemporary life, elites distinguish themselves not by having exclusive cultural tastes but rather through embracing culture from across social lines.[33] As "omnivores," elites signal that they are at ease with and open to all groups; with their eclectic tastes, they enjoy everything from

classical music to rhythm and blues and appreciate foods from foie gras to black-eyed peas and cornbread.[34]

Although the scholarship on Black cultural capital helps us to understand how Black culture provides a very specific return—projecting a Black identity—it focuses on individuals. Similarly, research asserting that consuming diverse culture signals openness also focuses on individuals. We still know very little about how cultural practices linked to racial and ethnic minorities offer benefits to organizations, such as enhancing an organization's racial image.

The Racial Images of Organizations

Although race has traditionally been understood as a characteristic of individuals, it is increasingly viewed as an attribute of organizations.[35] To that end, one facet of an organization's overall image is its racial image.[36] If we consider an organization's image as stakeholders' perceptions of an organization,[37] then we can think about an organization's racial image as the specifically racial aspects of that impression, such as whether or not an organization is perceived as connected to a particular racial group or whether or not it is viewed as discriminatory. For example, a corporation may be seen by consumers and other stakeholders as treating Latinx employees and buyers equitably or as treating them unfairly. In a similar vein, a corporation may be viewed as creating products that are used by and/or intended for use by African Americans or as producing products not consumed by and/or not appropriate for them to consume.[38] Likewise, a corporation may be perceived as being deeply involved in the Asian American community or having little to do with it.

Having a diverse and inclusive image can have positive consequences for companies.[39] First, it is useful for appealing to ethnoracial minority consumers who want to see themselves reflected in brands.[40] For example, over one-third of respondents to a survey on diversity in advertising noted that they had stopped supporting a brand because it did not represent their identity.[41] Given changing demographics in the United States where there is more buying power among minorities—both because of growing numbers and increasing class mobility—appealing to ethnoracial minority consumers is critical for many companies' long-term survival.[42]

Having a brand associated with inclusivity and minorities is also important for appealing to the "general market" or white consumers. Over the course of the 20th century and into the 21st, white racial attitudes and beliefs about

principles of equality have generally improved.[43] There has also been a shift in white attitudes along some measures of social distance. For example, although 65 percent of white people opposed marriage between African Americans and white Americans in 1990, by 2008 the proportion of white people who opposed such a union had dropped to around 25 percent.[44] Not only are white Americans more racially tolerant along some measures, but racism has shifted from Jim Crow to color-blind.[45] While the former was based on explicit beliefs about Black inherent inferiority, the latter rests on the assertion that everyone is equal. These changes in white racial attitudes and beliefs suggest that companies that project an inclusive image will appeal to many white consumers too.

It is also the case that an association with African Americans can help companies appeal to consumers across racial lines because Blackness is linked to edginess and being on trend.[46] For example, athletic shoe companies like Nike rely on Black athletes as spokespeople to lend their brands a veneer of cool and appeal to a global consumer base. Similarly, soft drink companies like Sprite have used African American rap stars as representatives to increase the cool quotient of their brands.[47]

Along with appealing to consumers, a diverse image may provide businesses with other advantages. For instance, businesses seek to gain legitimacy among peers.[48] Given that today most large firms have diversity programs,[49] an image recognized as valuing diversity puts companies in step with their peers. A racist image is also likely a deterrent for attracting racial and ethnic minority employees who presumably avoid firms with a reputation for excluding non-white people. Finally, given that since the 1960s discrimination against customers and workers has been illegal, an image as nondiscriminatory appears to provide a degree of legal protection for companies. Simply having a program that promises workforce equality, or what legal scholar and sociologist Lauren B. Edelman terms "cosmetic compliance," is sufficient to legally protect organizations if a discrimination suit is brought against them.[50]

Diversity Capital and Racial Image Management

Being perceived by stakeholders as diverse and inclusive is often beneficial for companies, and they use ethnic community support as a cultural resource to project this image. In this way, ethnic community support is a form of diversity capital. Like ethnic community support more broadly, Black cultural patronage is a cultural practice that allows businesses to solve problems and

leverage opportunities related to race and ethnicity and other social differ-ences.[51] Companies mobilize Black cultural patronage to project a racial image that is generally diverse and inclusive and that is specifically connected to Af-rican Americans.[52] As theorists of organizational image management assert, "organizations must create, maintain, and in many cases regain a legitimate image of themselves in the eyes of their stakeholders."[53] Given that in the post–civil rights era it is often advantageous for corporations to be viewed as diverse and inclusive, they engage in various strategies to promote this image.[54] Ethnic community support is one of the cultural practices that companies draw on to project the image that they include, and treat with respect, racial and ethnic minorities.

The racial image management that companies engage in may be directed at a specific racial and ethnic group, such as African Americans, or it may be aimed at a wider racial audience, such as ethnoracial minorities or people across all racial and ethnic groups.[55] Along with varying by audience, racial image man-agement may also differ with respect to the dimension of racial image that is being projected and the time horizon during which it takes place. With respect to dimension, companies may aim to project racial authenticity (caring about and having a genuine connection to a particular ethnoracial group), openness (including and valuing people of all ethnoracial groups), and/or equity (treat-ing people from all ethnoracial groups fairly, justly, and impartially).[56] With re-spect to time horizon, in some cases companies are engaging in reactive racial image management where they are responding to a racial image crisis. In other cases, racial image management is proactive and potentially helps to protect a firm in the event that a racial image crisis occurs later.[57]

Racial image enhancement via ethnic community support takes place through various processes. One mechanism through which it occurs is that supporting ethnic causes is a signifying act that communicates that companies not only care about the specific cause they are supporting, but also the ethnora-cial group associated with the cause. In this way, ethnic community support functions as a diversity sign. By simply giving to an ethnic cause, companies project an image of caring about inclusion and equity.[58] However, often com-panies don't simply support an ethnic cause: They also publicize their support of that cause.

To promote their support of an ethnic cause, companies typically discuss it in social media, such as Twitter and Facebook, and owned media, such as press releases and blogs. They also pay for advertisements, such as in magazines. In

addition, companies seek out journalists to report on their support in earned media, such as newspaper articles. Recipients of company support often publicize it in media channels that they control as well. Diversity framing in these various media channels is also a mechanism through which ethnic community support can project an image of companies as diverse and inclusive:[59] Frames are the "angle[s], schema[s], or narrative arc[s] that . . . highlight one or more aspects of an event, issue, or actor."[60] I define *diversity framing* as the use of words, phrases, images, and sounds to communicate that ethnic community support is a manifestation of a company's valuing of diversity.[61] For example, if a company sponsors a gospel concert, diversity framing might involve producing a press release that explicitly includes the phrase, "This gift reflects our commitment to the African American community." Or the press statement may include a comment from a diversity manager, or include statistics about the percentage of workers at the firm who are African American. Diversity framing might also occur in the production of a promotional video about a gift, narrated by a person who "sounds" Black or includes testimonials about the company's diversity by Black workers. Diversity framing goes beyond the basic act of publicizing gifting to further the symbolic association of companies with diversity.

When companies engage in ethnic community support, there is also often a place-based aspect of that support. For instance, a company may give money to a capital campaign for a building, or it may contribute to an event that will occur in a particular venue. Various dynamics at these support-related sites can project an image that a company cares about diversity. At events that include presenters, such as emcees, diversity framing in their discourse can project an image that a company is committed to inclusion and equity. For example, a presenter may tell audience members that a company is sponsoring a gospel concert to "give back to the Black community." Other messaging also conveys an image of companies as valuing diversity, such as free giveaways at venues like tote bags and t-shirts printed with ethnic marketing taglines.

In a related vein, the capacity for ethnic community support to brand companies as diverse is tied to corporate signage. Support-related sites typically include signage with the company name and/or logo. Some signs show the company name and/or logo along with text or images that associate a company with including and valuing ethnoracial minorities. For example, as will be discussed in more depth in Chapters 5 and 6, at Black events sponsored by McDonald's, the company's African American marketing slogan "Black & Positively Golden" is displayed alongside the Golden Arches logo on banners

throughout event venues. It is also the case that with company names displayed within and outside of venues, the venues themselves, along with what takes place in and around them, become linked to the company.[62] This includes "ethnic" elements and happenings, such as ethnic rituals and ethnic-related emotional displays in and around the venue. For example, when Black eventgoers engage in rituals such as African American sorority and fraternity "strolls" to songs at corporate-sponsored concerts, the ethnic embeddedness of the event increases, thereby deepening the association of the company with Blackness.[63]

Studying Black Cultural Patronage by Corporations

To study Black cultural patronage by corporations, I draw on a wide corpus of data including a database of public relations and advertising texts on corporate cultural patronage. The corporate cultural patronage database includes several hundred PR and advertising documents produced and co-produced by corporations concerning their philanthropy and sponsorship in the arts. These documents were gathered from sources such as news databases (like Factiva) as well as the online press release archives for corporations and cultural organizations. I sampled cases of Black cultural patronage by corporations and, for comparison, cases of "mainstream," Latinx, Asian, and Native American patronage. This database also includes a collection of documents produced by corporations such as diversity reports and diversity timelines. I also draw on in-depth interviews with corporate executives. These interviews offer perspective on the motivations underlying corporate support of Black culture.[64]

In addition, my analysis relies on firsthand observations from Black cultural events supported by companies, such as fundraising events at Black cultural institutions, as well as observations from panels and conferences on philanthropy, ethnic marketing, and corporate diversity. For example, I attended the ANA (Association of National Advertisers) Multicultural Marketing and Diversity Conference in Miami, as well as sessions on corporate philanthropy at the AFP (Association of Fundraising Professionals) Fundraising Day in New York conference. I also attended Black cultural events sponsored by corporations such as the opening weekend of NMAAHC, the Essence Festival in New Orleans, the McDonald's Inspiration Celebration Gospel Tour in the DC metro area and in Tallahassee, and Afropunk in Brooklyn.

Archival data also inform the analysis. I traveled to the physical archives for various arts organizations to collect documents related to corporate support.

This includes sites such as the Library of Congress for data on the Alvin Ailey American Dance Theater, the Smithsonian Institution Archives for documents on NMAAHC and other museums, and the Northeastern University Archives and Special Collections for information about the Elma Lewis School of Fine Arts and the National Center of Afro-American Artists. To understand corporate support of Black culture by tobacco companies like Brown & Williamson, I analyzed documents from the Truth Tobacco Industry Documents database. The 990-PF filings of corporate foundations provide additional insight on business support of Black culture. While all these data aren't specifically touched on in the chapters, they broadly inform my understanding of how Black cultural patronage conveys an image that businesses value diversity.[65]

Outline of the Book

Case studies focusing on the Smithsonian's National Museum of African American History and Culture, the National Civil Rights Museum, the Kool Jazz Festival, the Essence Festival, the Inspiration Celebration Gospel Tour, and Afropunk highlight the mechanisms through which support of Black culture conveys an image that companies value diversity and inclusion. In Chapter 2, I investigate corporate philanthropy and sponsorships at the Smithsonian. Located in Washington, DC, the Smithsonian is one of the largest cultural complexes in the world. While the federal government provides substantial support for Smithsonian museums, they also rely on private support. The model for funding is what is called a public-private partnership. Smithsonian museums require support from private patrons, including corporations, for their livelihood. Private support for the Smithsonian is an important part of the institution's legacy as it was a wealthy patron, James Smithson, who provided the initial funds to establish the institution. But, like other major cultural institutions in the United States, the funding mix at the Smithsonian has shifted over time to include more corporate patrons. This chapter uses NMAAHC as a lens to understand corporate funding at the Smithsonian.

Analyzing major gifts and sponsorships at NMAAHC, I show how corporate patrons such as AT&T and Bank of America use diversity framing in owned and paid media around their support to make the case that they value inclusion and are connected and committed to African Americans. Corporations also use support of the National Museum of the American Indian (NMAI) to make diversity claims. However, in contrast to NMAAHC where

corporations draw on support to make claims of valuing diversity and African Americans, support at NMAI is used to signal valuing inclusion and Native Americans. In a sharp departure from ethnic Smithsonian museums, gifts to majority museums at the complex, such as the National Museum of American History and the National Air and Space Museum, are less often used to make claims about corporate diversity.

Conceptually, this chapter extends theory on Black cultural capital from individuals to organizations. Practically, it offers important insight on the Smithsonian and identity. The Smithsonian is well recognized for shaping the national identity of the United States. However, this chapter shows how it is also an important institution for shaping corporate images. In exchange for providing money to support national patrimony, corporations receive the benefit of improving their image, including their racial image.

Chapter 3 puts a spotlight on the commodification of symbols linked to Black freedom movements by examining Denny's support of the National Civil Rights Museum (NCRM). Through the lens of this partnership that took place in 2002 but is still promoted by the company today, this chapter examines how Black community support is used by businesses to clean up their images when they are soiled by accusations of racism. When corporations experience an image crisis, one response is to use impression management strategies to rehabilitate their image among customers and other stakeholders.[66] This chapter describes how ethnic community support is a strategy to deal with image crises that are racial in nature, or what I term *racial image crises*. The soiled racial image of Denny's dates to the early 1990s when the company was accused of discriminating against Black customers, including a group of Black Secret Service agents. Major lawsuits were filed against Denny's and eventually settled. Years later in 2002, Denny's was still addressing the aftermath of the discrimination claims. In an attempt to prove that they were committed to diversity and inclusion, Denny's donated $1 million to NCRM. PR and advertising around the donation, such as a television commercial and ads placed in Black media like *Ebony* magazine, were used to construct an image of the company as a champion of diversity. While anti-discrimination laws and shifts in social norms advocating diversity mean that it is in the interests of all corporations to project a diverse image, it is of the utmost importance for companies like Denny's that have undergone a racial image crisis.

Chapter 4 turns attention to Big Tobacco. Today, close to 85 percent of Black smokers use menthol cigarettes as opposed to less than one-third of white

smokers.[67] The higher rate of menthol cigarette use among Black smokers is partly attributable to targeted advertising in the Black media.[68] However, the role of the Black media in promoting menthol cigarettes in editorial pages has been largely overlooked. Examining the case of the Kool Jazz Festival, a music concert sponsored by the tobacco company Brown & Williamson (B&W) in the 1970s and 1980s, this chapter outlines how advertisements, along with editorial content in Black newspapers, promoted menthol cigarettes to African Americans. Drawing on content analysis of ads and articles about the Kool Jazz Festival in Black newspapers, along with documents from the Truth Tobacco Industry Documents archives, this chapter provides an overview of how the Black press reinforced B&W messaging about the festival and the company. In many instances, articles in Black newspapers included verbatim and paraphrased quotes from B&W public relations texts. By using such messaging, media were actively involved in projecting an image of the company as being a good corporate citizen and caring about the African American community.

Chapter 5 goes inside the Essence Festival in New Orleans. Dubbed the "Party of the Year," the Essence Festival is an annual music event featuring R&B and other historically Black genres of music. While it is well recognized that the event draws major corporate sponsors like Coca-Cola, McDonald's, and AT&T because of the opportunity to market to Black consumers, less is known about the specific processes through which businesses engage eventgoers at the festival. Drawing on observations at the Essence Festival, along with various texts related to the event, this chapter outlines the mechanisms through which Black consumers become engaged with brands at the festival. Building on research about the ways that music influences action, consciousness, and emotion,[69] the chapter describes how popular R&B, hip hop, and gospel music playing in the New Orleans Convention Center draws festivalgoers to corporate booths where they are exposed to corporate branding. Once in the booths, the mainly Black attendees sing along to the familiar tunes and do the dances often performed to the songs. The emotions and behavior of the festivalgoers (which are influenced by the music played in the booths) create an atmosphere of fun and bonding. So, the music facilitates marketing to Black eventgoers because it attracts them to corporate booths where they are inundated with corporate messaging; at the same time, Black eventgoers' emotions and behavior in the booths help brands to project an image of Black pride, joy, and togetherness.

The theme of companies using Black cultural patronage to signal racial authenticity to Black consumers continues in Chapter 6, which looks at the fast

food industry. Despite growing warnings that fast food is harmful to health, it remains popular among diners in the United States, especially African Americans.[70] While public health officials and scholars argue that targeted marketing, such as a higher saturation of fast food commercials airing during African American television shows and on Black television networks, is partly responsible,[71] little attention has been paid to cultural sponsorships. To cast light on the role of cultural sponsorships in marketing fast food to Black diners, this chapter goes inside the Inspiration Celebration Gospel Tour. This annual gospel concert, which is sponsored by fast food giant McDonald's, travels to different cities across the United States such as the Washington, DC, metro area (DMV, including DC, Maryland, and Virginia), Atlanta, Chicago, and Tallahassee. Drawing on participant observation at the Inspiration Celebration Gospel Tour, along with PR texts (such as press releases and online postings), this chapter outlines how this gospel music sponsorship conveys an image of McDonald's as African American and sacred to Black consumers. Diversity framing and gospel framing in promotional texts about the event reinforce the McDonald's image as being tied to the African American and Christian communities. At the concert venues, rituals and statements by presenters also project an image of McDonald's as African American and sacred. Concertgoers are active participants in this process. For example, they enthusiastically repeat McDonald's Black marketing tagline, "Black & Positively Golden," at the urging of the event hosts. Attendees also participate in Christian rituals, such as prayers led by event presenters, thereby increasing the association of the McDonald's image with the sacred.

Chapter 7 explores how consumers co-create the racial images of companies that sponsor Black cultural events by examining corporate portraiture. Using the case of Afropunk, a music festival featuring Black punk musicians, this chapter outlines how festivalgoers create social media posts that lend corporate sponsors like AT&T a Black and edgy image. At Afropunk and other Black music festivals, corporate sponsors host photo booths where concertgoers can memorialize their time at the event. The booths are typically highly designed and feature branding such as company logos. Concertgoers are encouraged to post the photos to their social media accounts using special corporate hashtags. In playing this role, festivalgoers are engaging in a process of *prosumption promotion,* whereby as "prosumers"—or those who both produce and consume goods and services like social media—they are creating content that generates awareness and enhances the images of businesses. Given that in the instance

of Afropunk many of the social media posts feature Black attendees donned in an avant-garde style, the posts convey an image of the companies as not only African American, but also cool.

The conclusion brings together the book's main arguments and highlights contributions to the scholarship on cultural capital and the literature on corporate philanthropy and sponsorships. In particular, I highlight how shifting the unit of analysis of theory on race and cultural capital from individuals to organizations, and developing the concept of diversity capital, gives us a richer understanding of the racial image management of businesses. The conclusion also outlines directions for future research on ethnic community support and sketches how the concept of diversity capital offers insight for understanding corporate support of Native American, Asian, and Latinx culture.

The next chapter places ethnic community support within the broader context of community support by examining corporate patronage at Smithsonian museums. We will see how gifts to ethnic and non-ethnic museums provide distinct image benefits.

2

The Racial Return

1984. 1968. 1954. 1948. 1865. 1863. 1808. 1776. 1565. 1400. As our glass elevator at the National Museum of African American History and Culture (NMAAHC) descends deeper into the ground, each time period that we pass is marked in white letters on a black concrete wall. "Welcome to the 1400s," the tour guide remarks, as the elevator comes to a halt on the ground floor. With that, we enter the dark hall of an exhibition on the trans-Atlantic slave trade. In the slavery and freedom galleries, we encounter artifacts and artworks such as relics recovered from a Portuguese slave shipwreck and a life-size statue of Thomas Jefferson. The Jefferson sculpture is surrounded by a stack of bricks carved with the names of people he enslaved. As we make our way up each floor of the museum, we travel forward in time—encountering the Jim Crow era, the 1960s and 1970s freedom movements, and beyond. On the top floor, where daylight is filtered through bronze filigree encasing the windows, there is a more celebratory mood. There, Chuck Berry's candy-apple red Cadillac Eldorado meets us as we walk into the musical crossroads galleries.

These and the other 36,000 artifacts and artworks collected by NMAAHC project a new national identity for the United States.[1] Through the lens of the museum, the United States is still defined by an enduring quest for democracy and freedom, but it is a more complicated past marked by triumph, incomprehensible inhumanity, and paradox. Although critics have lauded NMAAHC for projecting a new, more complex racial identity for the nation, what has been less obvious is the museum's role in defining the racial images of corporations.

17

NMAAHC owes its existence in part to corporate America. Dozens of million-dollar donations from companies like Aetna and American Express funded the institution and the racial reckoning that it birthed. However, we can't acknowledge these corporations for their role in funding the crafting of a new national racial identity without also recognizing how their patronage enabled the construction of their own racial images. In this way, patronage at NMAAHC functions as a form of diversity capital for corporations: It is a cultural practice that provides corporations with a racial return. In this case, that racial return is a positive racial image. More specifically, corporate funders of the museum leveraged their patronage as a vehicle to project an image that they value inclusion and are connected and committed to African Americans. These benefits are produced via the promotion of NMAAHC patronage in PR and advertising texts.

At the most obvious level, PR and advertising texts that announce corporate gifts to NMAAHC imbue corporations with a halo of Blackness because NMAAHC itself is a signifier of Blackness. A gift to the museum conveys that businesses not only care about the museum itself but also the people whose culture is displayed there. Just as sociologist Prudence L. Carter describes how consuming Black culture, such as hip hop, is a vehicle through which Black urban youth construct their racial identity, PR and advertising texts announcing gifts to NMAAHC are a tool used by companies to project their racial image.[2] The Black meaning of NMAAHC is transferred to companies simply by the names, and often logos, of the two organizations appearing together in PR and advertising texts. At the same time, PR and advertising texts about patronage to NMAAHC establish an African American and diverse image of corporations by the specific discourse that is included in the texts, and for online versions, the links that are provided in the texts. By using diversity framing (e.g., words, phrases, images, and sounds that emphasize diversity) in PR and advertising texts about gifts to NMAAHC, companies bolster their image as committed to equity. For example, the inclusion of specific statements in a press release about a gift (such as "This gift reflects our longstanding involvement in diverse initiatives") or statistics demonstrating a company's equitable hiring practices in a press release about a donation paint a portrait of corporations as valuing diversity. Similarly, in online texts about gifts, such as blog posts, diversity framing tactics—like tagging posts with "diversity" and including links to corporate diversity reports—reinforce corporate images as inclusive.

Patronage at NMAAHC is not unique for its role in enhancing the images
of corporations. Despite criticism that the Smithsonian sells "its name, prestige
and integrity" by relying on corporate donations, the practice has gone on for
decades.[3] As we will see, corporations regularly use PR related to gifts to Smith-
sonian museums to cultivate images linked to their core missions. For instance,
gifts to the National Air and Space Museum (NASM) and the National Museum
of Natural History (NMNH) are used to craft images such as a commitment to
aviation and a dedication to wildlife conservation, respectively. What is unique
about giving to NMAAHC is that it is a tool for crafting corporate racial images
linked to inclusion and African Americans. Patronage at the National Museum
of the American Indian (NMAI) offers a similar benefit, but gifts there are used
to project a corporate image of inclusion linked to First Nations people.

To place the image-enhancing value of NMAAHC corporate patronage in
a broader context, it is important to understand the history of the Smithson-
ian and its founding. This history covers corporate patronage at non-ethnic
Smithsonian museums and patronage at NMAI. Taken together they represent
the pattern of supporting NMAAHC as a practice of racial image cultivation.

Founding Years

In 1765, James Smithson was born in Paris, France, to Elizabeth Keate Hunger-
ford, a descendant of European royalty, and Hugh Smithson, the future Duke
of Northumberland. His death over 60 years later would change the cultural
history of the United States. Smithson was an Oxford-educated scientist with
a passion for geology. He was also a member of scientific organizations such
as the Royal Society of London. Over his lifetime he published over two dozen
scholarly papers. When Smithson passed away in Genoa, Italy, in 1829, the main
heir was his nephew Henry James Hungerford.[4] But, after the nephew passed
away just six years later, Smithson's fortune was left to the United States for
the founding of the Smithsonian Institution. Smithson's will dictated that if his
nephew passed away with no heirs, his estate would go toward the formation
of an institution in the new country dedicated to "the increase and diffusion
of knowledge."[5] The release of Smithson's $508,318 bequest was not straight-
forward. Various stakeholders, such as federalists and nationalists, questioned
whether the fledging nation should accept the funds. Lawyer and diplomat
Richard Rush led the charge for acquiring the bequest, even going to court and
posting a half-million-dollar bond to insure Smithson's properties. On August

10, 1846, federal legislation officially established the Smithsonian Institution, the United States' first national cultural and scientific institution.[6]

Corporate Giving to the Smithsonian

While initial funding for the Smithsonian was provided by Smithson's bequest, by the turn of the next century corporate funders had a growing presence. With increasing concern that federal appropriations were not keeping up with needs, Smithsonian leadership aggressively pursued corporate money. In 1991, a policy prohibiting the display of corporate logos in Smithsonian museums was dropped. By 1992, various museums had signed deals with companies like Lego, Paramount, and Orkin Pest Control.[7] For the Smithsonian's 125th anniversary in 1995, I. Michael Heyman, then-secretary of the Smithsonian, targeted corporations with the hope that they would chip in $100 million to mark this momentous year.[8]

While corporate funding was increasingly sought after by the Smithsonian leadership in the 1990s and into the 2000s, there was also recognition that corporations wanted a greater return for their largesse. "Corporate funding has been an important source of additional revenues for our educational efforts in research, exhibitions and national outreach," Heyman remarked in 1998.

> Unlike in the past, however, corporations now ask more from us than simple acknowledgment of support. For instance, in return for a sponsor's giving to the Smithsonian a percentage of its product sales, or funding an activity or exhibition, the sponsor may ask to use the Institution logo in corporate advertising, identifying the company as "a proud supporter of the Smithsonian."[9]

In this new era of corporate funding, sponsors very actively used PR and advertising around their patronage to construct specific images for their brands and products. In 1992, Orkin Pest Control began funding the National Museum of Natural History's Insect Zoo. After the initial $500,000 sponsorship, the special area of the museum featuring live insects was renamed the "O. Orkin Insect Zoo." The Orkin sponsorship was criticized by various stakeholders. "It certainly will give Orkin a corporate advantage to have the prestige of the Smithsonian rub off on their bug-killing service," the leader of one public-interest group remarked.[10] Despite the critique, Orkin continues to promote the partnership, emphasizing how, as a company, they are educating the public about insects. In 2021, a special page dedicated to the sponsorship noted that "Over a

million visitors each year visit the O. Orkin Insect Zoo and are discovering the global ecological importance of insects and the interdependent relationships between insects and people."[11]

In the late 1990s, the Star-Spangled Banner, a 30- by 34-foot flag that inspired Francis Scott Key to write the national anthem of the United States was in need of an overhaul. The Ralph Lauren Corporation chipped in $10 million to the effort spearheaded by the National Museum of American History (NMAH). Today the company uses the gift to reinforce its brand of classic American style. "The Iconic Flag Sweater" offered on its online shopping website features an American flag with 13 stars. As expected, details about the sweater, such as its "25¼" sleeve length" and "rib-knit hem" are listed. Less expected, the description section also reinforces the association of the sweater with the Star-Spangled Banner by mentioning the company's 1998 donation to help restore it. It notes that, "The sweater's 13 stars and stripes recall early American flags, including the one that flew over Fort McHenry during the War of 1812, which inspired Francis Scott Key to write 'The Star-Spangled Banner,' and the restoration of which Ralph Lauren generously helped underwrite in 1998."[12]

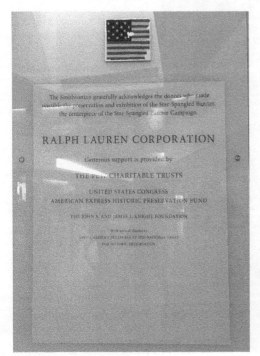

Figure 2.1 Sign acknowledging Ralph Lauren contribution to the "Star-Spangled Banner" campaign, National Museum of American History, Washington, DC.

In 2001, the National Museum of American History was fundraising for its new permanent exhibition "America on the Move." The $20-million exhibition tells the story of how transportation over the course of the late 19th century to the late 20th century shaped national identity and transformed the economy. ExxonMobil contributed $2 million toward the effort, and its PR around the gift positions the company as providing the essential fuel that enabled the revolution in transportation. A press release for the donation notes that "ExxonMobil and its heritage companies have played a leadership role in developing high quality products over these many years to fuel this transportation evolution," including "fuels and lubricants used in the Wright brothers' first airplane flight" and "lubricants used in the International Space Station."[13]

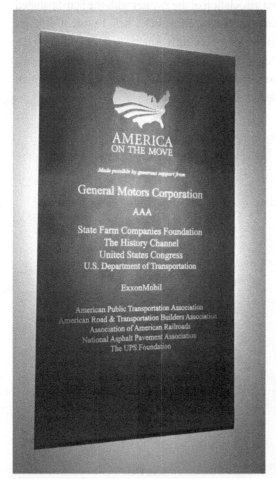

Figure 2.2 Sign acknowledging ExxonMobil and other support for the "America on the Move" exhibition, National Museum of American History, Washington, DC.

Companies use various Smithsonian museums to reinforce other aspects of their image. For example, Target—which casts itself as a company that provides affordable, well-designed products—uses its sponsorship of Cooper Hewitt, the Smithsonian Design Museum, to reinforce this image. Target is a sponsor of the museum's annual National High School Design competition where students are presented with a design problem to solve. Target promotes the competition on its website to bolster its image as a design-focused company. An online feature for the 2017 competition was titled "Nurturing the Next Generation of Design: Target's Helping Budding Designers Think Big." The post noted that since the company believes that "great design—and super-talented young people—can help solve real problems," they have sponsored the competition "to encourage budding designers to think big."[14]

Aerospace companies contributing to the National Air and Space Museum's $250 million campaign to renovate the museum are using PR around their gifts to reinforce their images as central players in the industry. For example, a 2014 press release announcing Boeing's $30 million gift toward the effort notes that, "Boeing and the aerospace industry are at the forefront of innovation, with ideas that have changed the world in ways that could never have [been] imagined 100 years ago."[15] In honor of the gift, a major exhibition space in the museum was renamed the "Boeing Milestones of Flight Hall." Similarly, in 2012, a $10 million gift from Lockheed Martin—the aerospace and defense company—resulted in a "named" IMAX theater at the museum.[16]

While corporations use gifts to non-ethnic Smithsonian museums to bolster various non-ethnoracial aspects of their images, their gifts to ethnic

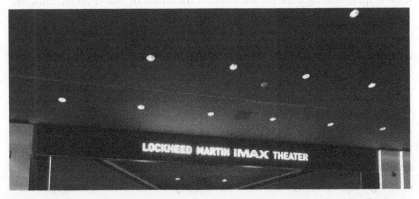

Figure 2.3 IMAX theater named for aerospace and defense company Lockheed Martin, National Air and Space Museum, Washington, DC.

museums are often used to cultivate a pro-diversity image. This can be seen in PR related to patronage at NMAI and NMAAHC.

The National Museum of the American Indian

The National Museum of the American Indian (NMAI) opened in 2004. However, the roots of its collection go back to the 19th century. In 1916, George Gustav Heye, a private collector of Native American artifacts, opened the Museum of the American Indian (MAI) in New York City. As NMAI was being established in 1989, the MAI collection was transferred to the Smithsonian. Corporate support would be an important part of the NMAI fundraising plan in the coming years. Donations from corporations were also sought out by MAI in the years prior to the collection transfer.

In 1985, the MAI staff devised a plan for recruiting corporate donors. The plan was described in a section of a fundraising proposal titled "The Significance of Corporate Support."[17] The plan, as well as an accompanying fundraising brochure, noted that a gift to the museum would signal that a corporation cared about Native Americans. The red-and-white fundraising brochure invited corporations to become part of an exclusive corporate friends group: the Calumet Circle. For a donation between $1,000 and $5,000, corporations would enjoy benefits such as free admission to the museum and a 15 percent discount on museum purchases. The brochure also reminded corporate prospects of the signaling benefits of membership. At the end of the description of the program, it is noted that "By becoming Circle members corporations can demonstrate their respect and concern for the cultural traditions of Native Americans, the most disadvantaged ethnic enclave in America."[18]

Fundraisers for NMAI also sought out corporate support with the hope that a desire to signal a connection to Native Americans would appeal to prospects. NMAI was envisioned as the United States' leading museum focused on First Nations people. One iteration of the fundraising plan sought $9 million from the business sector including $3 million from "Corporations (philanthropic)" and $6 million from "Corporations (cause marketing)."[19] Fundraisers reasoned that a gift to NMAI would be the perfect occasion for companies to nurture a reputation as linked to Native Americans. One document created for the fundraising team in the 1990s was a list of "Corporations with Indian Names."[20] The document was accompanied by a description noting that it "was created for cause-related marketing purposes, with the hope that some of the firms

will see value in association with the NMAI."[21] In 1990, producers of the Native American–focused film *Dances With Wolves* used support of the museum to bolster the authenticity of their production.

Starring and directed by Hollywood star Kevin Costner, *Dances With Wolves* follows the story of a Civil War soldier who forms ties with the Lakota people. Cultural authenticity was a concern for Michael Blake, the writer of the screenplay, as well as the production team. A note in Blake's screenplay for the film indicates in all capitals: "*ALL INDIAN DIALOGUE WILL BE IN NA-TIVE DIALECT AS INDICATED BY TRIBE. SUBTITLES WILL BE USED.*"[22] Similarly, Cathy Smith, an expert in restoring Native American artifacts, was hired to monitor the historical accuracy of the Native American costumes in the movie.[23] When the film debuted, there was a Smithsonian screening organized as a fundraiser for the not-yet-open NMAI. Costner arrived at the benefit in Native American dress. By sponsoring this fundraiser and hosting the opening at the Smithsonian, the Native American authenticity of the film was reinforced. It was further bolstered by comments made by the film's PR team and the director of NMAI in the media.

At the opening, Christine LaMonte, an Orion Pictures publicity and promotion executive, described the NMAI fundraising project as symbolic of Native American traditions of giving. "The whole thing grew out of the giveback that Indians do," she reflected:

> When someone gives you a gift, you give it back to them. Kevin felt the Lakotas gave him their cooperation and trust. . . . [W]e knew that there was a new American Indian museum and thought how wonderful to be able to give them something more by giving them the film to raise money for the museum. So we approached the Smithsonian to ask them if they wanted to use the film as a benefit.[24]

Comments by W. Richard West, Jr.—then director of NMAI—further reinforced the film's authentic links to Native American culture. "I think the real significance of this event is that the picture—by the way it deals with Indian culture—has many parallels with what we need to do at the National Museum of the American Indian," he said. "This movie speaks quite literally through the Indian tongue . . . and that is a powerful metaphor for what the Indian museum has to be. It has to be seen through Indian eyes and articulate its interpretation with Indian voices."[25]

As the museum fundraised into the next decade, companies continued to use PR about their gifts to project an image of being committed to Native

Americans. Commenting on why Goldman Sachs became one of the first companies to join the NMAI Corporate Membership Program, a Goldman Sachs executive remarked in the NMAI newsletter, "The NMAI helps people understand and appreciate the diversity of different Native American cultures. This respect for people reinforces our firm's policies of valuing our people and the diversity of their origins. This is what makes our nation so unique, and contributes to the strength of our business."[26]

In 2004, Accenture, a management consulting firm, made a contribution to NMAI. In a press release about the gift, Kedrick Adkins the company's global chief diversity officer and US managing director, commented that "The museum fills an important void in our history and as a company committed to diversity we're proud to be associated with such a strong symbol of U.S. history and contemporary society." The release also outlined the company's new scholarship programs for Native American students. Through an Accenture Scholars program, $20,000 scholarships would be given to Native American students, and through Accenture Fellows and Finalist Scholarships programs, grants of $10,000 and $2,000 would be given to support Native American education.[27]

More recently, Bank of America and Ralph Lauren drew on their NMAI patronage to signal their commitment to Native Americans. Bank of America highlighted its sponsorship of the NMAI exhibition "Nation to Nation: Treaties Between the United States and American Indian Nations" (which ran through January 2018) in a special section of its website devoted to its Native American Professionals Network (NAPN). Promoting its sponsorship as an example of the NAPN's "community involvement," the discussion of the sponsorship includes a statement from Jeff Carey, "a cofounder of the Native American Professional Network." Carey notes, "Continuing our bank's long tradition of supporting NMAI, we are very proud to cosponsor this milestone exhibition which tells the history and legacy of U.S.-American Indian diplomacy in our nation's history."[28] And Ralph Lauren's 2017 social responsibility report discusses its multi-year pledge to NMAI as an expression of the company's "longstanding history of celebrating the rich history, importance, and beauty of our country's Native American heritage."[29]

As the Smithsonian was wrapping up the NMAI campaign in 2004, fundraising for NMAAHC was just starting. As in the past, corporations were solicited to donate, and they used their giving to shape their public image. Like NMAI, NMAAHC was specifically used by corporations in their diversity image work.

The National Museum of African American History and Culture

Although NMAAHC did not open until 2016, the seeds for its development were planted a century before. In 1915, a Black veterans group established a fund to create a memorial honoring Black service in the military.[30] By 1929 their efforts had expanded to establish a national African American museum and President Calvin Coolidge signed a law authorizing its construction. But, with the stock market crash a few months later and no firm federal support in hand, this iteration of a national African American museum ultimately failed.[31] In the 1980s and 1990s there were other pushes to found such a museum, but these efforts were unsuccessful too.[32]

Finally, in 2001, President George W. Bush signed the National Museum of African American History and Culture Plan for Action Presidential Commission Act of 2001. This bill set in motion the establishment of NMAAHC. Fundraising consultants J. Richard Taft and Alice Green Burnette were hired to conduct a study with prospective donors to get a sense of their interest in supporting a national African American museum. After reaching out to major corporations, the consultants determined that corporate interest in such a museum would be high. "Corporations display considerable interest in supporting the NMAAHC through sponsorships/marketing projects that can tie their products to the Museum and to the African American community" the consultants wrote in a report to Congress.[33] In their view, the symbolic association of the museum with African Americans would prove especially appealing to businesses:

> We are able to envision dozens of marketing and sponsorship relationships that would enable corporations to serve their societal commitments, as well as to benefit from building brand identity—through the NMAAHC—with the African American community. We have concluded that it would significantly benefit the NMAAHC if it developed an integrated marketing program that would provide naming and other recognition vehicles. These would be very attractive to business, particularly to those large consumer product companies that promote extensively to African Americans.[34]

The proposed fundraising plan for NMAAHC relied on corporate support. After individuals who would be pursued to give a total of $75 million to build the museum, the next largest group of sought-after donors were corporations. Corporations (including support through sponsorships/marketing and gifts) would be pursued to contribute $23 million or around 18 percent of the

hoped for $125 million from the private sector.[35] The proposed staffing budgets also reveal the importance of corporate prospects to the fundraising plan. The budgets for years two and three include a salary for a dedicated "corporate sponsorships/marketing" staffer and a "foundations/corporations fundraiser," respectively.[36]

When NMAAHC opened in 2016, corporate support was robust. Of the more than $400 million in private-sector funding for the museum, over $100 million was provided by corporations that gave seven-figure donations. Like NMAI, corporations used PR around gifts to NMAAHC to make a statement about their commitment to diversity. But in this case, they specifically crafted an image of being committed to and caring about African Americans.

AT&T was among the dozens of supporters designated as "founding donors" of NMAAHC. A gift of $1 million granted the company this special patron status. The company's name is listed with other major supporters on the museum's donor wall. With this public listing, AT&T is symbolically linked to the United States' central repository for African American art and artifacts. But, public communication about AT&T's NMAAHC patronage did not end there. The company released a series of public relations texts that reinforced its image as a firm committed to diversity. An older mode of PR—the classic press release—was used toward this end along with newer modes of PR such as blog posts and diversity reports. These texts not only communicate the basic fact of AT&T's $1 million gift to NMAAHC, but they also reinforce the meaning that the gift reflects the company's commitment to diversity.

One press release titled "AT&T Contributes $1 Million to the National Museum for African American History and Culture in Washington, D.C." recalls AT&T's history with African Americans. The press release begins, "AT&T is giving $1 million to the National Museum for African American History and Culture in Washington, D.C. The contribution qualifies AT&T as a Founding Donor." Later, the press release describes AT&T's past ties with African Americans, declaring that "AT&T history is also African American history. Alexander Graham Bell hired African American inventor Lewis Latimer in the 1800s. He developed the drawings necessary for the first telephone's patent."[37] This press release points out other diverse aspects of the company in a series of bullet points. The last two points on the list include "AT&T spends billions with African American suppliers and ranked No. 1 in DiversityInc's 2015 'Top Companies for Supplier Diversity,'" and "African Americans make up nearly 20% of the AT&T workforce, 13% of management and 15% of the board of directors."[38]

Two African American workers at AT&T posted about the gift on the company's "Your Inside Connections" blog. In a post titled "A 'Baby Bell-Head' Reflects on the AT&T Contribution to the National Museum for African American History and Culture," Gerald King, a senior client services project manager, wrote, "I'm grateful to AT&T for being a company that actively supports diversity and inclusion. It's a great comfort to know that I've invested my career in a company that invests in my community."[39] At the end of King's blog post there is a link to the diversity section of the AT&T website, "Diversity, Equity & Inclusion," and a link to download a copy of the company's "Diversity & Inclusion" report.[40]

Exelon, an energy company, was also a founding donor at NMAAHC. Like other large businesses, Exelon produces diversity reports that outline inclusivity initiatives. The 2016 diversity report begins with a statement from Christopher M. Crane, Exelon's president and CEO. In it he emphasizes that "diverse perspectives" are "fundamental to our business and our core values." Exelon's $1 million gift to NMAAHC is featured in the report as exemplary of the company's commitment to community organizations and diversity. The summary of the gift in the report is titled "Exelon Foundation Donates $1 Million to Smithsonian's National Museum of African American History and Culture," and the statement asserts that the "Donation advances the Foundation's commitment to promote diverse perspectives and support institutions making a difference in its communities."[41]

Exelon created a promotional video about the NMAAHC gift that features several Black employees testifying to the company's diversity. The description accompanying the video highlights inclusivity as well: "EAARA members Royce Strahan, Carla Dennis and Sandor Williams discuss the Exelon Foundation's $1-MIL donation to the Smithsonian National Museum of African American History & Culture, along with D&I [Diversity & Inclusion] as a core value of Exelon."[42] The video is tagged "DIVERSITY," and by clicking the tag you are taken to the company's other online videos with a diversity theme.

Exelon's NMAAHC gift is also featured in a newsletter for Pepco, a company owned by the corporation. Here Crane describes the donation as an expression of the company's commitment to diversity, noting "Diverse perspectives and backgrounds are fundamental to understanding and celebrating who we are as a nation . . . [and] . . . fundamental to our business and our core values."[43] This statement by Crane is repeated in a press release about the gift to NMAAHC. The press release includes a comment from Lonnie G. Bunch

III, then the director of NMAAHC, praising the company: "With Exelon as a member of the museum family, we are strengthened in our resolve to examine a people's journey and a nation's story."[44]

Another press release about the Exelon NMAAHC gift titled "Part of Our Fabric: Exelon's Philanthropy, Workplace Programs Reflect Dedication to Inclusion" highlights the company's internal diversity efforts. The press release features three color photographs of NMAAHC's façade. It begins, "We believe in the value of diverse perspectives. It's one of the reasons the Exelon Foundation has donated $1 million to the National Museum of African American History and Culture (NMAAHC)." The press release includes a comment from Janese Murray, the vice president of diversity and inclusion. Murray notes that diversity and inclusion is "integrated into everything we do, including our performance metrics." The release continues to describe in more detail the company's diversity practices noting, "Each senior leader at Exelon creates a diversity and inclusion plan and measures progress" and that in 2015 the company "spent $1.4 billion with women- and minority-owned suppliers." This NMAAHC press release also notes that Exelon has 36 employee resource groups such as "the Exelon African American Resource Alliance and Exelon PRIDE."[45]

Like Exelon, Bank of America was a seven-figure donor to NMAAHC. A press release for Bank of America's NMAAHC gift describes it "as a demonstration of our commitment to diversity and inclusion."[46] Bank of America drew on its relationship with NMAAHC in PR related to the celebration of Black History Month in February 2019. That month the company released a special video about NMAAHC featuring Bunch. The spot titled "The Power to March Forward" opens with Bunch saying, "History isn't reserved for black-and-white photos covered in dust. We have the power to make history. With every song recorded, every hashtag created, with every barrier broken, history is alive, and we make it every day." As Bunch talks, images of figures such as Frederick Douglass, Harriet Tubman, Stacey Abrams, and Billie Holiday flash behind him. At the end of the video, the logos of Bank of America and NMAAHC appear on screen side by side.[47] PR around Bank of America's association with NMAAHC to celebrate Black History Month continued on Twitter. On February 1, 2019, the bank tweeted "We're proud to support our partners at the National Museum of African American History and Culture, @NMAAHC, who have the #PowerTo inspire the next generation of history makers during #BlackHistoryMonth."[48]

African American history was also at the heart of PR produced by 21st Century Fox for their donation to NMAAHC. As NMAAHC was being built, the

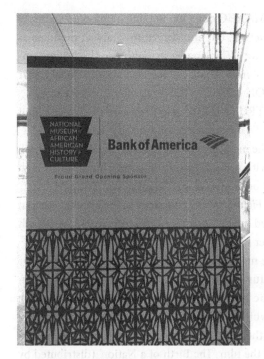

Figure 2.4 Bank of America's "Proud Grand Opening Sponsor" sign at NMAAHC opening weekend, Washington, DC.

company was involved in two major films starring African Americans. One film, *Hidden Figures,* is a biographical drama about Katherine Johnson and other African American women mathematicians who worked at NASA during the international space race. The other film is *Birth of a Nation,* which is a fictionalized drama about Nat Turner, an enslaved man who led a rebellion in 1800. Just as Orion Pictures used NMAI to promote *Dances With Wolves,* a film focused on Native Americans, 21st Century Fox used their donation to NMAAHC to promote *Hidden Figures* and *Birth of a Nation,* films focused on African Americans.

In September 2016, the media company posted on their blog with the title: "21st Century Fox supports the Smithsonian National Museum of African American History & Culture." The post begins by noting that the company is a Keystone donor ($2 million and above) to the museum. The post includes links to the promotional sites for *Hidden Figures* and *Birth of a Nation,* as well as a statement from an executive that the gift to the museum "underscores 21CF's commitment to bringing diverse voices and perspectives to our audiences."[49]

The blog post about the NMAAHC donation not only reinforced an image of the company as valuing diversity, but also helped to establish the films as authentic products of Black history. The broader marketing for both films emphasized that they were "true" stories. About 23 seconds into the official trailer for *Birth of a Nation*, "BASED ON A TRUE STORY" flashes across the screen.[50] "BASED ON THE UNTOLD TRUE STORY" also flashes on the screen about midway through the *Hidden Figures* trailer.[51] 21st Century Fox's NMAAHC blog post not only reinforces the messaging of the films as true stories of Black history by associating them with a Black history museum, but also through text repeating the refrain that both movies are "true stories." The NMAAHC blog post summarizes *Hidden Figures* as "the true story of the brilliant African American women who crossed gender and race lines to help NASA launch astronaut John Glenn into outer space."

With *Birth of a Nation*, the marketing of the film as a "true" Black historical narrative was taken even further; the NMAAHC blog post not only describes the film as an authentic retelling of the past, but also includes a link to Nat Turner's actual Bible, which is housed at NMAAHC.[52] The post notes: "One of the objects housed in the NMAAHC is the Bible that belonged to Nat Turner, the main character of the film 'The Birth of a Nation' (distributed by Fox Searchlight Pictures), which is based on a true story." Clicking the link in the blog post takes readers to the NMAAHC web page for the Bible, where it is labeled "Bible belonging to Nat Turner," and there are several high-resolution images of the artifact.[53]

In October 2016, a month after NMAAHC opened, Nate Parker, who stars as Turner in the film, posted on his Facebook page about the Bible. The post includes photographs of Parker examining the Bible in a dimly lit room at the Smithsonian: "With #NatTurner Bible @nmaahc @smithsonian. #LegacyMoments for our children and our children's children. #ReclaimHistory #NatTurnerLives."[54]

While 21st Century Fox gave a NMAAHC donation in the Keystone category, Target, a major retail corporation, gave at the Cornerstone level ($5 million and above). Target was also among five "grand opening" sponsors. Target's iconic logo, a red-and-white bull's-eye, was featured on a sign on the museum's ground floor during the opening weekend. The sign, decorated on the bottom with NMAAHC's signature lattice shell exterior, featured the logo of NMAAHC on the left—a purple and white depiction of the museum's corona structure—and the Target bull's-eye logo on the right. The placement of the

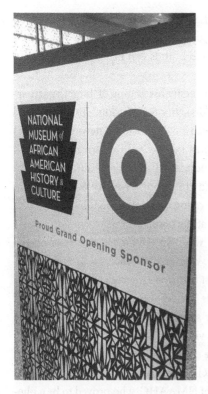

Figure 2.5 Target's "Proud Grand Opening Sponsor" sign at NMAAHC opening weekend, Washington, DC.

Target logo on a sign inside the museum and in PR and advertising texts about the opening helped to reinforce an image of the company as valuing diversity and African Americans. The use of diversity framing in Target's promotional materials about their support further nurtured this image.

In 2016, just before the museum opened, Target sponsored a special airing of *CBS This Morning* that was filmed at the museum. During the show, Laysha Ward, Target's chief corporate social responsibility officer, was featured in a promotional segment about the company's sponsorship. In the segment Ward noted, "Inclusivity is one of Target's core beliefs, and we're really committed to creating a diverse and inclusive environment for our guests, for our team members, and the communities."[55]

Messaging about the NMAAHC sponsorship as an articulation of the company's diversity was also present in a special post on Target's *A Bullseye View* blog. The post, hosted on the company's corporate site, features a conversation between Target CEO Brian Cornell, who was then a board member at

NMAAHC, and Bunch. When asked what he was most proud of about "the journey to bring this museum to life," Cornell replied that it was "the power that individuals, organizations, and trusted brands can bring to the quest for greater opportunity and equality."[56]

The blog post further reinforced the diversity messaging of Target's partnership with NMAAHC by one of its tags, "diversity & inclusion." This tag linked to another page on the Target corporate website that includes news and features on diversity.[57] The last statement in the post is, "Excited to learn more? Check out the National Museum of African American History and Culture's website for more information and resources, and check out Diversity & Inclusion at Target to see more of what our teams are doing." This statement includes a link to a web page on diversity and inclusion at the company.[58]

Target's association with NMAAHC was also referenced in a post on the company's "Pulse" blog in February 2016. Written by Monee, an African American promotions leader at Target, the post features Target's celebration of Black History Month. "Our theme this year is 'Celebrating a Century of African-American Art & Culture' where we have sought to recognize the accomplishments of African-Americans by way of visual arts, performing arts, fashion, music and education," Monee wrote. She continued to describe how the company had hosted a special event "unchARTed" that included Bunch: "We heard from Lonnie Bunch, Founding Director of NMAAHC, who proved to be a phenomenal storyteller and gave us a peek into what it's been like to create the next landmark on the National Mall."[59]

Monee's post included a link to purchase products from Target's "Black History Month assortment." In 2019, the still-active link led to a special shopping page titled "Celebrate Black History Month." There, online shoppers could purchase Black-focused books like Vashti Harrison's *Little Leaders: Bold Women in Black History*, Black beauty and grooming products like Bonita Afro Balm, and t-shirts printed with the names of civil rights heroes like Malcolm X and Martin Luther King, Jr.

Preserving the legacy of MLK and Black history more broadly has been at the center of the Black cultural patronage of FedEx. Along with being a million-dollar donor to NMAAHC, the multinational delivery corporation has been a long-time supporter of the National Civil Rights Museum (NCRM) in Memphis. NCRM is located at the site of the Lorraine Motel where King was assassinated. FedEx was also a million-dollar donor to the Martin Luther King, Jr. National Memorial in Washington, DC. FedEx uses PR related to

each of these Black cultural initiatives to reinforce their image as committed to diversity.

In 2002, NCRM was undergoing a $10 million expansion, and FedEx contributed $500,000 toward the effort. In a press release about the gift, David J. Bronczek, then president and CEO, said, "We at FedEx strongly believe there is a time and place for diversity—all the time and every place."[60] In 2011, when the Martin Luther King, Jr. Memorial was being built in Washington, DC, FedEx put out a press release about their support. The statement declared, "FedEx believes in diversity and inclusiveness" and pointed out that "more than 26% of management personnel" and "more than 40% of all FedEx employees" are minorities.[61]

FedEx promoted their support of NMAAHC and these other Black cultural initiatives in an online feature about diversity and inclusion at the company. One bullet point in a list of "Success Stories" in the feature is "Celebrating history by sponsoring the King Memorial, honoring Dr. Martin Luther King Jr., helping to fund the National Museum of African American History and Culture, and being a long-time supporter of the National Civil Rights Museum."[62] This post links to FedEx's 2019 diversity report where there is a section on "Celebrating History."[63] This section features sponsorship of NMAAHC, the National Civil Rights Museum, the King Memorial, and other Black cultural initiatives like the Birmingham Civil Rights Museum, the Mississippi Civil Rights Museum, and the Center for Civil and Human Rights in Atlanta.

The online feature on diversity and inclusion is accompanied by a video titled "Citizenship Investment in Diversity and Inclusion." The video features images from the company's diversity activities and is accompanied by a voiceover, which begins: "To meet the needs of a diverse customer base FedEx reflects that diversity within our organization, and we celebrate it in the communities we serve."[64] NMAAHC, along with NCRM and the MLK Memorial, are featured in the video.

Altria, a corporation that owns the tobacco brand Philip Morris, has promoted its status as a founding donor of NMAAHC since the 2010s. Continuing a longstanding tradition of cultural patronage by Philip Morris,[65] the Fortune 500 corporation gave a $1 million gift to help construct NMAAHC. In a 2014 Smithsonian press release, a vice president of corporate affairs at Altria Client Services notes that "countless stories about the African American experience . . . haven't been told or fully appreciated" and highlights how the company is "proud" that their "investment will help give a voice to these stories

for generations to come."[66] Six years later the seven-figure NMAAHC gift was promoted in "Altria's Diversity & Inclusion Heritage," a document marking the company's equity milestones from 1933 to 2020. The brochure begins by emphasizing how "for nearly a century," Altria companies "have supported numerous efforts to champion equality for and conduct business with diverse people and teams."[67] The timeline begins with the year 1933 where it is noted that the Philip Morris manufacturing center in Richmond, Virginia, "integrates its labor force with Black employees." The next four featured years—1935, 1945, 1954, and 1956—spotlight how Philip Morris was the "first tobacco company to hire Black salesmen," "financially support[ed]" civil rights groups like the NAACP, published an accommodations and dining guide for African Americans traveling through "the then-segregated South," and refused to change its "equal employment and civil rights policies" even when boycotted by the "White Citizens Council in the South," respectively.

The company's ethnic community support, cultural and otherwise, is highlighted in more detail in subsequent years. For example, the company's patronage of the Alvin Ailey American Dance Theater, including a $1.25 million gift, is highlighted in 1981, 1998, and 2003. Leading the year 2013 is the donation to NMAAHC. A color photo of the museum's distinctive façade is featured by this diversity milestone. A $500,000 gift to the Black History Museum & Cultural Center of Virginia is also listed that year. On the last page of the timeline, the logos for Philip Morris along with the other Altria operating companies, service companies, and strategic investments are featured.

Corporate Branding and National Patrimony

In this chapter we have seen how companies, such as AT&T and Exelon, used gifts to NMAAHC to bolster their images as caring about diversity and African Americans. Due to NMAAHC's status as a signifier of Blackness, PR and advertising texts that simply mention gifts to NMAAHC reinforce corporate images of valuing diversity. Diversity framing in PR and ads about NMAAHC donations further burnish the reputations of businesses as caring about inclusion and African Americans.

The use of corporate patronage at the Smithsonian to portray a positive image is widespread. Diversity framing is also used in PR and ads for the National Museum of the American Indian. On the other hand, patronage of "mainstream" culture at the Smithsonian, such as gifts to support the National

Air and Space Museum or to the National Museum of American History for restoration of the Star-Spangled Banner, are used to reinforce images related to the specific symbolic meanings of those forms of culture. For example, PR announcing donations to NASM paints a portrait of companies like Boeing as being key players in the aerospace industry, and support of the Star-Spangled Banner at NMAH is used by Ralph Lauren to reinforce the American heritage of the brand.

The Smithsonian relies on corporations for constructing the national identity that it projects. In return for their largesse, corporations receive a symbolic benefit. Corporations use their gifts to craft positive images that fit with their interests, such as displaying their faithfulness to inclusive values. In this way, while corporate patronage at the Smithsonian does good, it also allows corporations to do well as it aligns with their reputational interests.

In a legal and social context where corporations are expected to value diversity, NMAAHC patronage allows companies to project this image. Black cultural patronage in the aftermath of a corporate racial image crisis is a topic taken up in the next chapter. We will examine how one company—Denny's—engaged in Black cultural patronage to refurbish its reputation in the aftermath of major racial discrimination lawsuits.

3

Racism Rehab

THREE YEARS AFTER the National Museum of African American History and Culture (NMAAHC) opened, Lonnie G. Bunch III, the director of the museum at the time, penned a book chronicling the years leading up to its creation. Reflecting on the pursuit of corporate donors, Bunch recalls how specific businesses were targeted, such as those with a diverse senior leadership team and a large base of Black consumers. However, Bunch admits that another type of corporation was also sought out to give to what would become the first Black museum on the National Mall: "[C]andidly, corporations whose image would be improved by embracing this museum."[1] Although Bunch doesn't clarify the specific corporations falling under this last category, one can imagine that a gift to NMAAHC would appeal to companies in need of "art washing" or the purification of a spoiled imaged via cultural patronage. In recent years, art washing has received considerable media attention as activists have staged protests at cultural institutions; for instance, the British Museum was criticized for accepting donations from oil companies, and the Whitney Museum of American Art and the Metropolitan Museum of Art were protested for having trustees and donors who earned their wealth making products such as military supplies and addictive prescription drugs.[2]

Sociological literature acknowledges that corporate art patronage is sometimes motivated by a desire to reduce organizational stigma,[3] but in-depth analysis of how image recuperation actually takes place through supporting the arts is sparse. This chapter casts light on how companies use art patronage

as a tool of impression management when they face a reputational threat. It examines these processes through looking at Black cultural patronage to counter a racial image crisis. More specifically, this chapter investigates how Denny's, a large restaurant chain based in the United States, uses its support of the National Civil Rights Museum (NCRM), an African American museum in Memphis, Tennessee, to combat its image as discriminating against Black and other ethnoracial minority customers.

While cultural patronage alone is a symbolic act that improves the reputations of corporations, the promotion of cultural patronage in owned media, recipient media, and paid media further bolsters the positive images of companies. In these promotional texts, companies' cultural support is framed as an indicator that they are good moral actors. These promotional texts often include statements from high-level executives that proclaim their company's commitment to socially responsible principals. Recipients also play an important role in the framing process. By simply accepting a gift from a corporation with a tarnished image, recipients like NCRM help to legitimize these businesses. However, their role in the image recuperation process does not end there. Promotional texts often include statements from recipients who affirm the company's good character. Moreover, recipients promote patronage by corporations in their own media channels (i.e., recipient media), such as on their websites.

This chapter also highlights how companies use patronage to cleanse their reputations in the short run, as well as long run. Right around the time that a donation is made, companies frame it as indicative of their goodness in PR texts. However, even decades after a gift is made, companies may draw on it to convey that they are still ethical actors.

Finally, this chapter considers how the process of using cultural support as a tool to restore credibility involves the sanitation of social reality. Or, in cases where businesses are supporting cultural initiatives that involve history, PR texts may highlight positive aspects of the past that help to boost corporate images. For example, if a company is supporting a history museum focused on an ethnoracial minority group, PR about the company's support may put a spotlight on the more palatable aspects of that group's history.

In the case of Denny's, in 1993 two class action lawsuits alleging discrimination against Black diners tarnished the company's image. Several years after the lawsuits and settlement, Denny's gift to NCRM was promoted in various media channels to highlight its image as a company whose alleged racist past was long behind it. The promotion of the gift included statements from

Denny's executives that the company valued diversity. In a similar vein, the NCRM director served as a character witness testifying to how Denny's was a good corporate citizen. In the ensuing years, Denny's has continued to face accusations that it discriminates against Black and other ethnoracial minority customers. Write-ups of these accusations in the media not only link the company to discrimination in the here and now, but they also often bring up the 1993–1994 discrimination lawsuits and settlement. Over the years, and even today, Denny's PR around the NCRM gift has functioned as a counternarrative that positions the company as a champion of diversity. PR about the donation to NCRM not only cleanses Denny's image, but it has also sometimes presented a sanitized version of the civil rights movement. This airbrushed version of civil rights history links the Denny's brand to an uplifting narrative of racial progress in the United States.

Organizational Stigma

Denny's support of NCRM to cleanse its racial image can be best understood by placing it in the context of stigma management by organizations. In his research on the self, Erving Goffman outlines how individuals use various strategies to manage stigmatization.[4] For example, individuals may stop interacting with others, or they may attempt to cover the shame. While Goffman theorized that stigma was a state faced by individuals, other researchers extended his approach to stigma management to collectivities such as corporations.[5] For example, firms that are targeted with consumer boycotts attempt to change their negative public image by issuing press releases describing their involvement in prosocial activities like philanthropy.[6] Firms that face boycotts that receive higher levels of media attention make even more claims about activities benefiting society than those that are the targets of boycotts that get less scrutiny by the press. As Mary-Hunter McDonnell and Brayden King explain, "media attention simultaneously draws attention to the disparate image claims made by activists and implicitly legitimates those claims by recognizing them as worthy of the public's interest."[7]

Research on support for the arts asserts that cultural patronage is one of the impression management tactics used by corporations to manage reputational threat. Paul DiMaggio and Michael Useem make this claim: "As public confidence in large corporations has eroded, numerous anti-corporate groups have challenged company practices. . . . One response to these image problems is for

corporations to affiliate themselves with prestigious cultural institutions."[8] Similarly, Victoria D. Alexander argues that corporate patronage operates within a gift-giving system whereby companies who support the arts also receive a return for their support, such as an image boost. As a cultural policymaker explains, "If you are looking for ways to rehabilitate yourself in the public eye, then supporting things that really matter to society like the arts is an excellent thing to do."[9]

While we know that cultural patronage is a practice used by corporations to cleanse dirty images, the processes through which image recovery takes place are not as clearly outlined. As we'll see with Denny's, a donation to NCRM was a performative gesture signaling that the company valued diversity and was nondiscriminatory. In addition, discourse in paid, recipient, and owned media about the donation framed the gift as exemplary of Denny's commitment to racial equity and inclusion. In this case, funding the legacy of civil rights was a tool to rehabilitate the image of a company whose alleged civil rights violation was history making itself.

Denny's Under Fire

Denny's was founded in Lakewood, California, in 1953. Its first iteration was as a donut shop, but over the 1950s the restaurant evolved into a coffee shop and by 1961 Denny's officially became a full-service diner. By 1981, there were over 1,000 Denny's restaurants in the United States.[10] In 1993, Denny's was accused of a practice that was made illegal by Title II of the Civil Rights Act of 1964—refusing service to Black diners.[11]

Class action lawsuits claimed that Denny's provided different terms and conditions of service for African American customers (in comparison to white diners), treated African American customers in a less favorable manner, and even discouraged African Americans from visiting their restaurants.[12] For example, in one incident a group of Black high school students was allegedly asked to leave a restaurant and told that there were "too many of you people here."[13] Along with removal from restaurants, Black customers claimed that they were required to show identification before entering restaurants,[14] required to pre-pay for their meals, and in some instances even pay a cover charge. Black diners also asserted that they were subjected to long waiting times and denied special promotions.[15] After the original consent decree was issued, other reports of racial discrimination surfaced. For example, six African American

secret service agents claimed that they waited for almost an hour to be served breakfast at a Denny's restaurant in Annapolis as their white colleagues were served promptly.

Denny's reputation was spoiled by these accusations. As Jim Adamson, CEO of Advantica Restaurant Group, Inc., the parent company of Denny's from 1993 to 2002, recalls, it was a time when Denny's "became an icon for racism in the United States."[16] Discriminatory claims about Denny's made it popular fodder for late night comedians. For example, late night host Jay Leno joked that "Denny's is offering a new sandwich called the Discriminator. . . . It's a hamburger, and you order it, then they don't serve it to you."[17]

Denny's restaurants, and their parent company, then named Flagstar, denied that there was systematic discrimination against Black diners. However, they did acknowledge that in some cases individual workers may have treated Black customers unfairly. On this basis, the company settled the class-action suits for $54 million, which was the largest sum of money paid in a federal public accommodation law dispute up to that point in time.[18] The consent decree required that all diners at Denny's be treated equally, such as not denied service or offered lesser service on the basis of race, color, or national origin.[19] Denny's also agreed to implement a diversity training program for employees that involved activities such as screening a video about diversity called "What Color Am I?"[20]

In line with the consent decree, Denny's implemented a range of policies designed to reduce discriminatory treatment of Black customers. In that same period, the company also addressed other types of racial inequality. After an incident at a restaurant in another chain owned by Flagstar, the company was approached by the National Association for the Advancement of Colored People (NAACP) to implement the Fair Share Program at its restaurant groups.[21] Established in 1981, the Fair Share Program involves the NAACP making agreements with corporations to "invest" in the African American community by such means as using Black vendors and hiring Black managers. Beginning in 1993, Denny's agreed to implement policies to address managerial diversity, supplier diversity, professional service diversity, and diversity on the corporate board, over the next seven years. For example, Denny's agreed to appoint an African American to the board of directors and to direct at least 10 percent of marketing and advertising dollars to minority-owned advertising agencies.[22]

In the years following the consent decree and the Fair Share agreement, diversity at Denny's increased across a range of measures. For example, between

1993 and 2002, Black franchisees grew from 1 to 64.[23] Similarly, by 2000 the company was doing over $100 million dollars in business with racial and ethnic minority suppliers, and over one-third of the board were racial and ethnic minorities.[24] In some channels, Denny's was becoming recognized as an exemplar of corporate diversity. For example, in 2001 and 2002, Denny's was designated as the "Best Company in America for Minorities" by *Fortune* magazine.[25]

While Denny's was making changes that measurably increased diversity, and it was becoming recognized as a good place for minorities to work among some stakeholders, the company continued to be plagued by accusations of discriminating against minority customers. For example, in 1999 two African American men filed a lawsuit against the restaurant chain alleging that they were denied service at a Denny's in West Virginia.[26] In another lawsuit that was decided in 1999, a group of Black and white correctional officers claimed that they were seated at a Denny's in Miami, but were told that the restaurant had run out of food.[27] In still another lawsuit in 1999, two Black men claimed that they received slower service than a nearby table of white diners.[28] Two years later, an African American family in Los Angeles sued the company, asserting that they were refused service after visiting a restaurant in Crenshaw.[29]

When customers brought racial discrimination lawsuits against the business, the company's public image took a hit. Media reports on the incidents almost inevitably mentioned the 1993 lawsuits and 1994 settlement. For example, a news story about the West Virginia incident notes that, "In 1993, the failure of a Denny's restaurant to promptly serve six black Secret Service officers in Annapolis, Md., led to a series of lawsuits and a Justice Department investigation."[30] Similarly, an article about the Crenshaw discrimination lawsuit includes the following passage: "Denny's, which signed a 1994 consent decree with the United States Justice Department pledging 'there will never again be selected service or denial of (it) to African Americans,' has reportedly been sued at least ten times since then and plaintiffs have received at least $54.4 million in damages."[31] References to past lawsuits and settlements in articles about new claims of discrimination painted the company as one with a longstanding legacy of racism.

As the media continued to resuscitate Denny's image as discriminatory, Denny's leadership admitted that the company needed brand repair. Adamson reflected that while Denny's racist image had been generally rehabilitated, it still plagued the company: "Things like this never get totally fixed, but we've come a long ways."[32] Similarly, in 2001 Denny's chief diversity officer admitted

that the brand continued to suffer from a reputation of being racially biased. As she explained, "We find that we are constantly having to defend ourselves against the perception [of discriminating against minority customers]."[33] Partly as an attempt to help counter the association of the Denny's brand with discrimination, the company made a gift to NCRM, an institution at the heart of the civil rights movement.

The National Civil Rights Museum

NCRM is located at the site of the Lorraine Motel, the place where Martin Luther King, Jr. was assassinated in Memphis, Tennessee. In the 1960s, the Lorraine Motel was distinguished by the fact that it was one of the few places in segregated Memphis where African Americans could stay overnight. Memphis, like other cities in the Deep South, was marked by Jim Crow segregation where laws prohibited African Americans from having equal access to public accommodations, such as hotels and motels. Musicians associated with nearby Stax Records—such as Aretha Franklin, Ray Charles, and Otis Redding—often stayed at the Lorraine. During his visits to Memphis to participate in the sanitation workers' strike, Martin Luther King, Jr. was also a frequent guest.

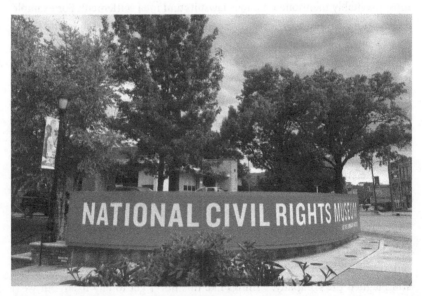

Figure 3.1 Sign outside National Civil Rights Museum, Memphis, Tennessee.

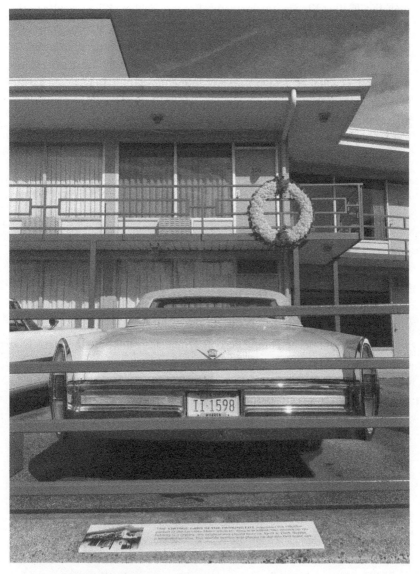

Figure 3.2 Balcony where Martin Luther King, Jr. was assassinated, National Civil Rights Museum, Memphis, Tennessee.

NCRM was established in 1991. The main building at the museum complex is the motel building, which is preserved to appear just as it did on April 4, 1968, the day that King was assassinated. Room 306 where King stayed, and the balcony outside of this room where he was shot and killed, are frozen in time. Classic cars, like a 1959 Dodge Royal, are parked in the lot beneath the balcony.

Around a decade after NCRM was founded, the staff and trustees embarked on a capital campaign to renovate the museum.[34] They were charged with raising over $10 million for the effort. In the end, Denny's gave $1 million toward the expansion project. For NCRM, the donation from Denny's provided needed resources to expand the facilities. However, the museum was not the sole beneficiary of this exchange of funds. Denny's also profited from its own largesse. The company used its own media channels, as well as paid and recipient media, to frame the gift as evidence that Denny's was now a corporation deeply committed to racial equality.

"Re-ignite the Dream" Campaign (2002)

The approach that Denny's used to make their NCRM donation is *cause-related marketing*. In a cause-related marketing initiative, a company links a product or service to a cause that its customers care about. By pairing the product and the cause, the product and brand become symbolically linked to the cause. One common iteration of a cause-related marketing campaign is that a certain percentage of a product's sales are donated to a nonprofit that supports the cause. In Denny's NCRM campaign, named "Re-ignite the Dream," a portion of the profits from the restaurant's All-American Slam meal was donated to the museum's expansion effort. Denny's promoted the campaign in various media channels.

When the campaign launched, it was discussed in the company's annual report. The opening letter in the report penned by Nelson J. Marchioli, then Denny's CEO and president, mentions the campaign in the context of the company's recent recognition as a good place to work for minority professionals:

> In 2001, Denny's was named by Fortune magazine the "Best Company in America for Minorities" for the second consecutive year. We are proud of our role as a leader and corporate model in cultural diversity, and, in 2002, we launched another important initiative to promote human and civil rights. Throughout the year, participating Denny's restaurants will donate 20 cents from the sale of each All-American Slam entrée to the National Civil Rights Museum in Memphis, Tennessee.[35]

The last page in the annual report, which has the logos of NCRM and Denny's stamped at the top, is entirely dedicated to the campaign. Near the bottom of the page is a photograph of a couple in a Denny's restaurant. The duo is standing next to a display with an informational poster about the "Re-ignite the Dream" campaign. Beneath the NCRM logo at the top of the page, it reads, in part: "What qualifies a business to be called the best Company in America for minorities? That's how Fortune magazine has characterized Denny's for two years running. It relates in part to Denny's employment and workplace practices that rise toward the goal of Reverend Martin Luther King, Jr.'s dream of equality and fair treatment for all people."[36]

Denny's also used other owned media channels, such as press releases, to promote the campaign.[37] One press release draws on several techniques to frame the gift as an articulation of the company's valuing of diversity. First, it includes statements from Ray Hood-Phillips, then the chief diversity officer for Denny's. Incorporating statements from her, and mentioning her job title, helps to publicize that the company has an executive dedicated to diversity. In addition, Hood-Phillips's statements contextualize the campaign as part of Denny's broader commitment to diversity by linking company values to those represented by NCRM. In the press release, Hood-Phillips comments that "Denny's has been committed to diversity for years. As a leader in cultural diversity and inclusion, we are delighted to become involved with the National Civil Rights Museum in a significant way to further our shared vision of equality and freedom for all people."[38]

The work of framing the campaign as evidence of Denny's good corporate citizenship was not accomplished solely through statements by Hood-Phillips, a paid manager. It was also done by the museum's then executive director Beverly Robertson, who is quoted in the same press release as saying, "We approached Denny's to assist us in our $10 million expansion program and were overwhelmed by their initiative to help us deliver our strong, credible message and reach millions of people that might not otherwise be aware of the Museum's mission." In making this statement Robertson stands as character witness of sorts, testifying to Denny's good corporate citizenship.[39]

In addition to promoting the NCRM gift in press releases and the 2001 annual report, the company publicized the gift on its website. In the "Community Outreach" section, the gift was touted as an exemplification of the company's commitment to human and civil rights. In a recurring theme, the gift is mentioned alongside the Fortune magazine ranking as a good company for

minorities. This section also asserts that when it comes to diversity the company takes its "leadership role seriously, whether it is to provide equality and justice for all employees, or to help ensure it for all Americans in all communities, nationwide."[40]

The "Re-ignite the Dream" campaign was also promoted on the museum's website. During the campaign, the "News & Events" section on the museum's home page teased a feature on the campaign. It included an image of the Denny's logo along with the headline, "Denny's and National Civil Rights Museum have launched a national fundraising initiative dedicated to promoting human and civil rights."[41] Clicking the Denny's logo brought website users to a special page about the campaign. This page was anchored at the top left and right corners by the logos for NCRM and Denny's. The page featured a series of questions and answers about the campaign. Consistent with messaging in other media, the answers emphasized how the campaign reflected Denny's commitment to racial equity and African Americans. For example, the question, "Why is the National Civil Rights Museum partnering with Denny's?" is answered, in part, with: "The National Civil Rights Museum fosters change. Denny's continues to demonstrate that they are changing by embracing diversity—externally and internally."

The diversity framing on the NCRM website departs from some of the other framing of the campaign by not entirely glossing over Denny's fraught relationship with African American customers. The answer to the question, "Is this an African American focused campaign?" receives the following reply:

> It is true that Denny's has made a conscious effort to reach out to African Americans with respect to past issues regarding African Americans and their experiences with Denny's restaurants; however, Denny's is strongly committed to the fair and equitable treatment for all and demonstrates this not only in word but also in deed through this national campaign. Because of the past issues with Denny's and African Americans, African Americans in particular, are encouraged to support this effort as a way to reestablish confidence in Denny's customer service goals, while also benefiting the National Civil Rights Museum.[42]

Although this statement nods to the 1993–1994 racial discrimination lawsuits and settlement, it emphasizes how discrimination at the restaurant chain is an issue of the past rather than the present. This claim serves as a counternarrative to the media portrait of the company as having a longstanding and continuing problem with discrimination.

Another section on the museum website also frames the campaign as an articulation of Denny's commitment to equality and African Americans. This page features campaign text overlaid with black-and-white images of Martin Luther King, Jr. and civil rights marchers. The top of the page features Denny's logo along with the headline, "Join Us As We Re-ignite the Dream By Raising $1 Million for the National Civil Rights Museum." Along with providing information about how consumers can participate in the effort, text about the campaign mentions Denny's awards for diversity. A list of bullet points in this section highlights other diversity achievements at the company such as that "48% of Denny's employees are minorities," "39% of Denny's franchise restaurants are minority owned," and "36% of Denny's board of directors are people of color and women." The bottom of the page invites readers to find out more about Denny's commitment to diversity by visiting the company website or calling "1-800-7-DENNYS."[43]

Denny's also promoted the NCRM campaign through paid media channels. One such effort involved an advertisement about the campaign that was placed in Black media such as the magazines *Ebony*, *Jet*, and *Black Enterprise*. The advertisement shows a close-up image of a brown hand holding a coffee mug next to a shiny white plate. In the middle of the plate, it reads: "We invite you to join us in re-igniting Dr. King's dream of equality and freedom for all people. Denny's will contribute $1 million to the National Civil Rights Museum, which beckons us to remember the valuable lesson of America's struggle for human rights." On top of a thin brown stripe that circles around the plate is the Denny's logo followed by the statement, "Ranked the 'Best Company in America for Minorities' by Fortune Magazine, 2000 & 2001."[44]

Denny's also produced a commercial promoting the campaign. The commercial, narrated by a male voice, begins with this:

> Dr. Martin Luther King, Jr., 39, of Atlanta, Georgia, died on Thursday, April 4. He is survived by an 87-year-old man who makes his opinions known, by a woman eating lunch with her friends, and by children who have yet to hear of segregation. His legacy is celebrated at the National Civil Rights Museum. Denny's is proud to donate one million dollars to the National Civil Rights Museum. Stop by to help. Reignite the dream.

As the voiceover speaks, images on the screen appear of an older Black male waiter at a restaurant, a Black woman and white woman laughing and sharing a cup of coffee, and Black and white children playing outside. Then the screen

flashes to an image of the NCRM logo followed by an image of the Denny's logo with "Re-ignite the Dream" written beneath it.

"Re-ignite the Dream" Campaign (post 2002)

Denny's used the NCRM gift as a tool to distance itself from the image as a racist restaurant chain. However, allegations of discrimination by Black and other ethnoracial minority customers continued after the donation. In 2003, a group of Black and Latinx men claimed that a waitress refused to serve them and referred to them as "you people." The customers contacted a local NAACP branch to complain about their treatment.[45] In 2005, seven men of Middle Eastern descent filed a discrimination lawsuit against Denny's, claiming that they were given inferior service and referred to by an ethnic slur after they complained.[46] That same year a group of Romani diners filed a discrimination lawsuit against Denny's alleging that they were told that the establishment "does not serve your kind."[47]

As in earlier periods, media that reported on these newer discrimination claims almost inevitably brought up the 1993–1994 class action lawsuits and settlement. For example, a story about the 2003 incident involving the group of Black and Latinx men included the following passage: "The Denny's chain has been trying to improve its image on racial issues since 1993, when several lawsuits were filed against the chain by patrons who claimed they were denied service because of their race."[48] Similarly, an article on the 2005 case brought by the Middle Eastern men included this segment: "Denny's settled a 1994 lawsuit for $54.4 million that accused the chain of asking blacks to prepay for meals. Since then, it has faced at least six more discrimination lawsuits filed by African-Americans and Hispanics and has been investigated in at least two cases involving discrimination against people of Middle Eastern descent."[49]

Denny's history of discrimination was excavated in other types of news stories as well. In a 2005 story on segregation in Kansas City, the author shares an experience of a friend who claims that in the 1980s he was dining with an interracial couple who were harassed by other customers and told "That sort of thing isn't done here." "None of the restaurant's staff did anything. They condoned that behavior by their silence," the article reports.[50]

These more recent news stories recounting past and present racial discrimination stained the company's image. Hood-Phillips admitted that, at the time, some African American consumers still linked Denny's with discrimination.

"When we started tracking in 1996, nearly half of all African Americans had a negative image of Denny's and associated us with discrimination. . . . The latest statistic is 12%. Of course, 12% is still a significant proportion."[51] To combat this negative image, the company reminded stakeholders of the NCRM donation from a few years earlier.

In one instance, a public relations manager for Denny's in Spartanburg, South Carolina, brought up the donation in a letter to the editor, referring to the article on discrimination in Kansas City: "I read with great interest Charles Ferruzza's June 30 article 'Separate Checks'. . . ."[52] The PR director claims that the Denny's of today is a new restaurant franchise with a commitment to fostering a diverse and inclusive environment for customers, workers, suppliers, and others. And she ends the letter by mentioning the NCRM donation: "Working with the National Civil Rights Museum and the King Center, Denny's has raised over $4 million in the past three years to support the cause of human and civil rights. I hope this information demonstrates that Denny's is passionate about doing the right thing, learning from the past and moving forward."[53]

As the PR manager was writing that letter and invoking the NCRM gift to counter the company's image as racist, the NCRM gift was also being promoted on the Denny's website on the "Community Outreach" page. This section begins by assuring visitors to the website that "Denny's commitment to service extends beyond its four walls to each of the communities it serves."[54] After this statement there are a series of buttons to click directing website users to themed areas of giving back, such as "Hispanic Initiatives," "Asian-American Outreach," and "Human/Civil Rights Initiatives." Clicking the last button takes users to a section where a photograph of Coretta Scott King—civil rights activist and widow of Martin Luther King, Jr.— is displayed, wearing a red suit and a pearl necklace. The Denny's donation to NCRM (at that time, three years in the past) is mentioned there.[55]

Moving forward to 2006, Denny's was still touting the NCRM donation on its website as proof that it was a good racial citizen. Now, the donation was promoted in a special section of the website headlined with "Diversity Facts." Among the "diversity facts" is that "Denny's contributed nearly $4 million from 2001 through 2004 to support the cause of civil and human rights. The National Civil Rights Museum was the first-year recipient, receiving over $1.2 million in 2002 to complete an expansion project."[56] By 2008 the layout of this section had changed and now featured a different design. However, the NCRM gift continued to be leveraged as concrete proof that the company values diversity.[57]

Another promotional vehicle that Denny's used to promote the NCRM gift long after it had been made were special diversity reports. The company's diversity reports provide an overview of the inclusion and equity initiatives with which the company is involved. The middle of the 2010 diversity report includes a "Diversity Timeline" with a series of photographs of façades of Denny's restaurants across the years. The timeline itself lists important moments in Denny's history of diversity. This history begins with the "Settlement Agreement" in 1993–1994. Each moment indexed after this development is a diversity milestone including the listing in the 2000s for "'Re-ignite the Dream' Campaign $1 million to support Human & Civil Rights."[58] The NCRM donation serves as evidence that the company has been committed to diversity in the years after the settlement.

In 2019, another complaint of racial discrimination at Denny's was reported by the media. This time a group of African American women in Michigan alleged that a group of bikers was loudly using racial slurs, even asking a waitress to "serve them (racial slur) some T-bones." When the women complained to a manager, he reportedly told them, "No, I cannot ask them to leave. It's a freedom of speech," and later called the police. The women filed a complaint with the Michigan Department of Civil Rights.[59] As in other reports about discrimination at Denny's restaurants in the post-1993–1994 era, news stories about this incident also brought up the earlier class action lawsuits and settlement. Providing context for the biker incident, one story reminds readers that "In 1994, Denny's settled several discrimination lawsuits for $54 million where black patrons had been refused service, made to wait longer or charged more than white patrons."[60]

As news stories about customer discrimination at Denny's continue, the company keeps relying on the NCRM donation, now almost two decades old, to bolster its image as caring about diversity in the present. In 2021, the donation is listed on a special downloadable diversity fact sheet on the company's website. The sheet begins by affirming that diversity is a fundamental value of the company, and it notes, "We have built a diverse and inclusive workforce and demonstrate our commitment by making diversity top-of-mind and celebrating it every day." The remainder of the fact sheet lists the company's diversity initiatives. The ninth bullet point in a section describing community partnerships is "National Civil Rights Museum Expansion/Reignite the Dream Campaign."[61] The company's ongoing use of the donation to polish its racial image

demonstrates the long-term investment value of Black community support. It's the gift, as they say, that keeps on giving.

Cleansing the History of Civil Rights

The NCRM donation has been used by Denny's as a short- and long-term PR tool to rehabilitate the company's racial image. In the process of doing so, at times the company has engaged in a historical airbrushing where the take on civil rights that it presents to the public is a generally inspiring and triumphant narrative. This is evident in the commercial produced by the company to promote the "Re-ignite the Dream" campaign.

Let's recall that the commercial mentions that King "died" and then presents images of his legacy decades later—an older Black man who has the right to speak his mind, African Americans and white Americans who dine together, and children of all races who play with one another. In one respect, the commercial visualizes King's hopes described in his "I Have a Dream" speech. However, triumph is only one part of the civil rights legacy. In King's "I Have a Dream" speech, in the same passage that he speaks of Black and white children being able to join hands with one another, he also speaks of Alabama "with its vicious racists."[62]

This aspect of King's legacy, and other uglier parts of the civil rights struggle in the United States, are not recalled in the Denny's commercial. And while the less palatable aspects of King's legacy are not referenced in the Denny's campaign, they are part of the history told at NCRM. In the same period that the Denny's commercial aired, a fuller portrait of the civil rights struggle in the United States was presented on NCRM's website. There, in the online "Gallery/Exhibits" section, visitors could flip through a series of images and texts about the struggle for racial equality in the United States. Unlike the version of civil rights that is presented in the Denny's ad, difficult and ugly aspects of this history are rendered in the online exhibitions. For example, a section on the civil rights acts in the late 19th century discusses the Ku Klux Klan Act of 1871 and shows an image of a white Klan robe and hood. Another section focuses on Jim Crow laws and explains that "Racial segregation, called 'Jim Crow,' excluded blacks from public transport and facilities, jobs, juries, and neighborhoods." This section is illustrated with a white sign indicating that restrooms for people who are "White" and "Colored" are in opposite directions. Other more challenging images in the online exhibitions are photographs of King's

jail cell where he wrote "Letter from a Birmingham Jail" and an image from a re-creation of the hotel room, where on its balcony, King was assassinated.

In Denny's NCRM commercial, none of these less palatable aspects of civil rights history are chronicled. Instead, a sanitized version of civil rights history is presented to the public and made part of the collective memory. In the commercial King is described as having "died" rather than been assassinated, and there are no direct references to the virulent racism that he and other civil rights activists were trying to strike down.[63] Of course, highlighting the uglier aspects of history in this ad would not have served Denny's purpose of cleaning up its racial image. Instead, it would have associated the Denny's brand with precisely what the company was trying to distance itself from—racism. This ad illustrates a less rosy side of Black community support by corporations more generally. Some aspects of diversity branding related to ethnic community support are at odds with the public good.

In the next chapter we delve deeper into art washing by investigating Black cultural patronage in the tobacco industry. The Kool brand of cigarettes cleansed its image by sponsoring the Kool Jazz Festival in the 1970s and 1980s. Whereas with NCRM we see how the media at times undermined Denny's efforts to rehabilitate its image by reminding the public about the company's discriminatory past and present, in the next chapter we will see how some segments of the media bolstered corporate efforts to paint the Kool brand as socially responsible.

4

Cultivating Consumers

IN NOVEMBER 2019, Governor Charlie Baker of Massachusetts signed the first statewide sales ban of menthol cigarettes. Just two months prior, the Los Angeles County Board of Supervisors passed a similar ban making it illegal to sell menthol cigarettes in their jurisdiction. This state and city legislative activity came after the US Food and Drug Administration proposed a national ban on menthol cigarettes sales in the fall of 2018. The proposed ban was heralded by the NAACP, a leading civil rights group, as "long overdue to protect the health of African Americans."[1] Like many other supporters of the proposed ban, the NAACP sees it as a policy measure that will help to remedy a racial health crisis. Menthol cigarettes, which may be especially harmful to health,[2] are disproportionately preferred by Black smokers. Close to 85 percent of Black smokers, as opposed to around 30 percent of white smokers, use menthol cigarettes.[3] As a health policy advocate in Minneapolis remarked, "When you look at the staggering numbers of African Americans smoking menthol, it's so hurtful that no one is taking a stand."[4] The link between race and menthol cigarettes was also highlighted in 2021 when the FDA announced a continued commitment to ban these tobacco products. "For far too long, certain populations, including African Americans, have been targeted, and disproportionately impacted by tobacco use," the director of the FDA's Center for Tobacco Products remarked about the proposed national ban.[5]

How did menthol cigarettes become so popular among Black smokers? One explanation is that Big Tobacco companies engaged in "predatory marketing"

where they advertised in Black media to target Black consumers.[6] Targeted advertisements for menthol cigarettes in Black media outlets like *Ebony* and *Jet* contributed to "the African Americanization of menthol cigarettes."[7] These targeted ads were part of a racial marketing strategy that created an especially active market for menthol cigarettes in the Black community that has continued to the present.[8]

Even though it's true that targeted advertisements played a key part in popularizing menthol cigarettes in the Black community, what is largely overlooked is the role that earned Black media played in cultivating Black acceptance of this product. Unlike advertisements that are produced by companies and require payment, earned media, such as newspaper articles, is created by independent actors like journalists.[9] To more fully understand the role of Black newspapers in the value chain of menthol cigarettes, it is critical to examine both sides of media promotion—advertising *and* editorial content.

Although earned media is idealized as "a conduit of neutral information," in practice it is influenced by corporations and other organizations.[10] Newspapers reprint messaging, such as statements from press releases, created by corporations, government entities, and nonprofits. For example, a Pew study of local news in Baltimore found that most stories "simply repeated or repackaged previously published information." In particular, official press releases were often reprinted "word for word" in news outlets though their original sources were not acknowledged.[11] Another study found that television broadcasts, both local and cable news, put video press releases on the air without noting them as such.[12] Organizations like corporations influence the media through various tactics such as holding press conferences and creating press packets that they distribute to journalists. When editorial coverage in the media reproduces corporate messaging, stories are in essence free advertisements.

The case of the Kool Jazz Festival (KJF) provides a striking example of Black media promoting, through paid and earned messaging, content that originated from tobacco giant Brown & Williamson (B&W).[13] In the 1970s and 80s, B&W started sponsoring the Kool Jazz Festival as part of a deal to promote their Kool brand of menthol products. As a result, a slew of paid media appeared in Black newspapers promoting the cigarettes. Alongside these ads were stories that favorably reflected the same themes as B&W ads—in some cases containing verbatim or lightly paraphrased quotes pulled directly from press releases.

Coverage of the B&W festival in Black newspapers addressed two critical needs of the company: to increase awareness of the brand among Black

consumers and to promote positive meanings about the brand to this market. Coverage of the Kool Jazz Festival in Black newspapers accomplished these ends indirectly and directly. Indirectly, they were achieved through promoting awareness and positive meanings around the festival itself. Given that cultural consumption is spurred by positive assessments of cultural products and services from "independent" sources such as newspapers,[14] it is likely that positive write-ups about the festival, as well as stories that provided detailed information about how to attend, encouraged Black consumers to buy tickets to the festival. While there, attendees were a captive audience for the product brand name and logo visible all around. They were given free products to sample and inundated with positive messaging about the brand.[15] At the same time, since the Kool brand name is actually part of the festival name itself, every story about the festival exposed readers to the brand. Newspaper articles also directly framed the company in positive terms, highlighting that it gives back to the community and has a "commitment" to music.

The editorial content in the Black media didn't merely complement the company's paid ads; these stories were arguably superior in effectiveness because readers saw them as objective. Newspaper stories asserting that the Kool Jazz Festival was a must-attend event were likely more convincing to readers than paid advertisements making the same claim. Additionally, unlike newspaper articles, advertisements inevitably included a brand-tarnishing element. Federal laws required that cigarette advertisements, including those technically advertising the Kool Jazz Festival rather than Kool cigarettes themselves, incorporate a conspicuous label warning that cigarettes are harmful to health. Thus, even though Kool Jazz Festival ads may have framed the event in positive terms and indirectly promoted positive meanings of the brand, they also included a polluting element that directly cast the products in negative terms.

Promotion of the Kool Jazz Festival in Black newspapers not only offers insight on the continuing popularity of menthol cigarettes in the Black community but also on how other types of tobacco products are marketed to racial and ethnic minorities. While the Master Settlement Agreement (1998) and Tobacco Control Act (2009) now restrict music and other sponsorships by cigarette brands, these limitations do not extend to other tobacco products such as e-cigarettes and little cigars and cigarillos (LCCs).[16] Major manufacturers of LCCs, which are especially popular among African Americans,[17] utilize hip-hop artists in their marketing. For instance, Swisher Sweets, an LCC brand that manufacturers cigarillos in flavors such as grape, blueberry, and chocolate,

sponsors the Swisher Sweets Artist Project where they host events by popular hip-hop artists such as Cardi B and Gucci Mane.[18] Earned media about cultural sponsorships like this may be a mechanism through which tobacco products like LCCs are promoted to racial and ethnic minority consumers and others today.

Taking a close look at promotion of the Kool Jazz Festival also provides fresh insight on Black newspapers. Social science research on the editorial side of Black newspapers emphasizes them as a counter-hegemonic force or an entity that critiques the existing status quo. As a major fixture in the struggle for racial equality in the United States, such as the abolition of slavery and the civil rights movement, the Black press rightly earns the moniker of being an institution comprised of "soldiers without swords."[19] But it is equally important to acknowledge that the Black press has been an institution that, at times, represented the interests of the dominant corporate sphere in its editorial pages. Like the press more broadly, Black newspapers have not been immune to the extensive and well-organized PR tactics of corporations to influence coverage. In the case of the Kool Jazz Festival, editorial coverage in Black newspapers at times reproduced complementary corporate messaging, rather than putting a spotlight on the known health hazards of cigarettes or raising questions about Big Tobacco claims about being good for the community.

B&W Meets Festival Productions, Inc.

B&W's origins date back to the 1890s when George Brown and Robert Williamson started manufacturing smoking and plug tobacco in Winston-Salem, North Carolina. Kool came to market a few decades later in 1933.[20] Kool menthol cigarettes—a cigarette laced with menthol, which is a compound derived from mint plants like spearmint and peppermint—dominated the menthol market from the 1930s to the 50s. In the early years of the product, branding was centered around "Willie the Penguin," an amiable cartoon figure. By the 1960s and 70s, racially specific campaigns targeting Black consumers were devised. Kool ads, "delivered in Black Vernacular by [an] announcer," were played on Black radio stations.[21] In addition, the brand "had a heavy schedule in Negro magazines" in the 1970s.[22] These ads featured Black models. In this period, Kool's share of the Black market (ages 15+) ranged from around 33 to 38 percent.[23]

While B&W was pursuing means to protect their share of the Black smoking market, George Wein, a white jazz promoter, was steadily working on

producing his latest music festival through his company Festival Productions, Inc (FPI). Since 1954, Wein had helped to produce the Newport Jazz Festival in Rhode Island. Most of the concerts that Wein produced, such as the Ohio Valley Jazz Festival in Cincinnati, were managed in partnership with Dino Santangelo, a white music promoter, as well as Joyce Wein, an African American executive in FPI and George's partner in marriage. Over the years, the FPI stable of festivals grew to include festivals in Hampton (Virginia), Atlanta, Oakland, Houston, and Kansas City (Missouri). While jazz was a constant feature in the shows and greats such as Dizzy Gillespie, Duke Ellington, and Thelonious Monk performed in various years, over time they expanded to include popular rhythm and blues acts such as Al Green and Teddy Pendergrass.

In 1974, a call between Santangelo and Leo Bell, a Black executive at B&W, would transform the corporation's marketing efforts. Bell, who had previously attended the Ohio Valley Jazz Festival as a regular patron, approached FPI about a possible collaboration. The festivals' wide reach, at that time around 500,000 patrons, and disproportionately Black demographic, ranging from 50 to 80 percent in various cities, made sponsorship an attractive proposition for the corporation. A few months after meeting, a sponsorship deal between FPI and B&W was signed.[24]

With the sponsorship agreement settled, the concert series was officially renamed the "Kool Jazz Festivals" in 1975. Before B&W ended its sponsorship with Wein in the late 1980s, cities such as Milwaukee and Washington, DC, were added to the national tour. At different points, FPI and B&W renegotiated their contract. For example, when B&W wanted to add additional cities in 1976, FPI requested more money. According to Wein, the two parties ultimately agreed that B&W would pay a fee of $200,000 to FPI for each festival.[25]

From Wein's viewpoint, the partnership was a "win-win arrangement."[26] The Kool sponsorship was beneficial for FPI because it provided guaranteed funds to the company and helped to keep down the costs of ticket prices. For B&W, the festivals were an effective marketing tactic. Along with other targeted marketing efforts during this period—such as a gift with purchase "collector print" of the Buffalo Soldiers, an all-Black cavalry regiment, by African American artist Ernie Barnes—the Kool Jazz Festival was initiated to retain and increase B&W's share of the Black smoking market.[27] The festival's value in locking in the Black menthol market was seen as unmatched. As one B&W marketing report concluded, "We know of no other available marketing vehicle that is able to hit half a million Blacks directly and have awareness of millions

more."[28] This sentiment was also expressed by Roger M. Kirk, vice chairman at B&W, in remarks he made at the 1979 National Association of Market Developers conference. In a speech to members of this Black public relations organization, Kirk acknowledged that the Kool Jazz Festival was the company's "most popular and enduring" specialized program to engage Black consumers.[29] The specific cities where the festival toured—such as Hampton (Virginia) and Cincinnati—were seen as especially valuable for this effort because of their "significantly large black population[s]."[30]

"Everywhere you turned, you saw or heard about 'KOOL Jazz,'" Wein recalls.[31] One strategy that both organizations used to ensure that "KOOL Jazz" was everywhere was to employ the media as a third party in public relations. Wein was well versed in using the media as a tool for free publicity. In his view, "grassroots promoting" was partly responsible for the success of the Ohio Valley Jazz Festival that FPI had produced since 1962.[32] To promote that festival, Wein and Santangelo visited nightclubs across Cincinnati and neighboring cities. They also handed out press releases to disc jockeys and television personnel and "plug[ged] the festival" to "whichever newspapermen would talk to [them]."[33] For the Kool Jazz Festivals, FPI and B&W public relations staff used a variety of tactics to reach out to the media at large, and specifically to the Black media. The Black press, which from its inception was dedicated to cultivating an African American readership, was specifically targeted by B&W for their unique potential to lure and keep Black smokers engaged with the Kool brand.

Black News

Just as other major institutions in the United States, such as education and religion, developed along segregated lines, so did the press. The Black press is a parallel institution that is differentiated from the mainstream media by its predominately Black readership and disproportionate employment of Black journalists, editors, and other staff.[34] Further, the Black press diverges from the mainstream media by the topics and angles of stories. Unlike the mainstream press that historically neglected the Black community, the Black press has always featured Black people and issues in news coverage. Describing the void filled by the Black press, one journalist remarked:

> We didn't exist in the other [mainstream] papers. We were neither born, we didn't get married, we didn't die, we didn't fight in any wars, we never

participated in anything of a scientific achievement. We were truly invisible un-
less we committed a crime. And in the black press, the negro press, we did get
married. They showed us our babies being born. They showed us graduating.
They showed our Ph.D.'s.[35]

Coverage in the Black press has not only diverged from the mainstream
press by its topical focus, but it has also differed in its framing of stories.[36]
Historically, when Black people and topics were covered by the mainstream
press, they were often covered in a way that reinforced an ideology of white
superiority and Black inferiority. In contrast, the Black press has often taken a
counter-hegemonic stance and emphasized Black advancement and liberation.
Centering Black voices was a priority to the founders of *Freedom's Journal*, the
first African American newspaper in the United States. As sociologist Ronald
Jacobs reminds us, though the northern press in the antebellum period was
typically anti-slavery, stories in the mainstream papers "favored the voices of
white politicians over black abolitionists," even the famous Black abolitionist
Frederick Douglass.[37]

In the first issue of *Freedom's Journal*, published March 16, 1827, the edi-
tors wrote: "We wish to plead our own cause. Too long have others spoken
for us. Too long has the publick [sic] been deceived by misrepresentations, in
things which concern us dearly." They promised that the newspaper would be
a "medium of intercourse between our brethren in the different states of this
great confederacy: that through its columns an expression of our sentiments,
on many interesting subjects which concern us, may be offered to the publick
[sic]." Along with addressing concerns relating to the free Black community
in the United States, the editors committed to covering "useful knowledge of
every kind, and everything that relates to Africa" and "our brethren who are
still in the iron fetters of bondage."[38]

Freedom's Journal was not the only Black newspaper born in the antebel-
lum period. Others—such as the *North Star, Anglo-African*, and *Colored
American*—were also founded during this time.[39] In this first era of the Black
press, newspapers mainly relied on support "from (mostly white) fraternal, re-
ligious, and abolitionist groups" rather than advertising and subscriptions.[40]
This would change in the coming years.

During the golden age of the Black press, around 1910 to 1950, newspa-
pers in many urban areas thrived as the Black populations increased. By 1915,
the *Chicago Defender*, which was founded in 1905, had a circulation of over

200,000.[41] Newspapers such as the *New York Amsterdam News* (sometimes called the *Amsterdam News*) and the *Los Angeles Sentinel* also flourished. Following this period of rapid growth, between 1950 to 1960 they started to experience a decline. The *Amsterdam News*, which had a circulation of over 70,000 in the mid-1960s, by 1986 had just over 37,000.[42] Similarly, though the circulation for the *Los Angeles Sentinel* was close to 35,000 in 1966, by 1986 it had fallen to just over 25,000.[43]

The decline of the Black press was accompanied by a degree of increasing coverage of African Americans in the mainstream press, but Black underrepresentation in the general news remained a reality. As Jacobs concludes, along with Black journalists being underrepresented in majority newsrooms, "News about African-Americans and African-American issues has also stagnated or declined since 1970, never surpassing four percent of total column inches."[44]

While the Black press has been lauded as a valuable institution for challenging the existing racial order, public health research tells a more complicated story. These newspapers eventually came to serve as vehicles for reinforcing the position of tobacco companies in Black communities. In a common public health narrative about how menthol cigarettes became so popular among African Americans, Black media are an ally. Black media, such as *Ebony* magazine, ran advertisements promoting menthol cigarettes to Black readers. For example, Phillip Gardiner notes how "Ebony carried twice as many cigarette ads . . . as did [the mainstream magazine] *Life*" in a period in the 1960s.[45] Although public health research asserts that the advertising side of the Black media promoted tobacco corporate interests, we know much less about corporate influence in the editorial pages of the Black press.[46] By the time of the Kool Jazz festival, corporate interests had a hand in what got printed by the Black media.

Media Cultivation Tactics

B&W turned to Black newspapers to help promote the Kool Jazz Festival and the brand more broadly to Black consumers. In particular, the company sought advance publicity in Black media through paid advertisements and earned coverage about the festival. As a 1979 sales plan noted, special Kool Jazz Festival ads were to be placed in "All national Black magazines and local Black newspapers."[47] Along with purchasing ads in national Black periodicals, such as *Ebony* and *Jet*, ads were placed in local Black newspapers like the *Indianapolis Recorder, Atlanta Daily World, Los Angeles Sentinel,* and *New Journal and Guide.*[48] B&W

viewed earned media as a complementary promotional strategy. In fact, the company calculated the economic value of newspaper and other media stories noting their "estimated value" in publicity reports.[49] B&W did not leave getting media attention for the KJF to chance. Instead, it executed a well-organized plan using the assistance of PR firms like Ketchum Public Relations.

One of the main tactics the company used to spur positive press attention was holding press conferences with invited local journalists.[50] Journalists were encouraged to attend with a promised first look at festival dynamics. For example, a memo about a 1976 press conference urged promotional staff to "Relate to your press contacts that this conference will not just be an announcement of dates and artists, but we will be announcing our grant program, new technical innovations, and other festival related items."[51] Press conferences were highly staged events: Details such as who would greet guests upon arrival and what order company representatives would speak were planned ahead. The first three steps listed in the "Event Outline" for a Kool Jazz Festival press conference in Atlanta are "Upon arrival, guests are greeted by a corporate representative and a FPI representative," "Meal served or reception starts," and "FPI representative to serve as master of ceremonies and welcome guests, formally, at the outset of the structured program." Talking points with specific messaging were also prepared.[52] The event outline instructs the "corporate representative" to "give examples of direct community benefits associated with the concert."[53]

Press kits were another resource that B&W promotional staff used to influence the media. Along with being handed out at press conferences, press kits were mailed to members of the media. For the 1980 festival at the Hampton Coliseum June 27–28, over 200 "press personnel" were sent mailings in the days preceding the concerts.[54] Press kits typically included items such as a press release; background information about, and photos, of artists; a fact sheet about B&W; and information about the concert series.[55] Arrangements were made to schedule media interviews before and after press conferences.[56]

Press parties were another event that the B&W promotional team used to court the media. In 1975, special invitations were sent out to press to attend parties in places such as Atlanta, Hampton, and the San Francisco Bay Area. Invitations featured the Kool logo with white intertwined "O's" and provided basic information about each event. For example, the Hampton press party was a luncheon that took place at the Hampton Coliseum. Events in other cities served meals such as "cocktails and hors d'oeuvres," a "buffet luncheon," "brunch," or "cocktails and buffet luncheon."[57] One invitation to an Atlanta

event included the representative salutation: "You are cordially invited to attend a Press Party to announce the 4th Annual Atlanta Kool Jazz Festival."[58]

As a 1978 festival marketing plan outlines, another tactic to influence press coverage was inviting journalists to the concerts. Among the various objectives listed in this publicity plan was to "Invite the editors of Black publications and music oriented publications to a Jazz Festival as guests of B&W. The objective would be to impress them with the quality of the production and to encourage a national feature or mention in their publications."[59]

B&W staff sought media influence through pitching festival-related stories to journalists as well. One internal memo from 1981 outlines a "National Media Contact Program" where editors and other media were communicated with in order to "interest them in interviewing KOOL/FPI spokespersons and covering the KOOL Jazz Festival-New York."[60] Staff doing the outreach were given a list of "suggested discussion topics and feature angles" to offer media staff. Included among the list of 10 topics were "Brown & Williamson's longstanding commitment and preemptive sponsorship on nationally recognized jazz, soul, country and middle-of-the-road programs" and "How music festivals like the KOOL Jazz Festival-New York serve to introduce new talent on the American Jazz scene."[61] Festival PR staff arranged interviews between artists and journalists to encourage positive coverage too.[62]

While the PR team attempted to gain media attention through delivering specific information to journalists about the festival and the company, there was always an element of unpredictability to the company–press interactions. The company could script these interactions, but journalists could always veer off-script. Journalists could ask company representatives about topics that were not favorable to their image, such as the ill-health effects of cigarettes. Ketchum Public Relations, a PR company for B&W, attempted to maintain control over these potential script deviations by designating one person to handle them. In a Kool Jazz Festival "publicity manual" prepared in 1982, company representatives were instructed "UNDER ALL CIRCUMSTANCES" to direct "any questions relating to smoking and health, pending lawsuits and Brown & Williamson financial support" to Wyatt Wilson, B&W director of corporate affairs.[63] Scripted answers were provided for making referrals to Wilson. For instance, if questions were raised about smoking and health, PR representatives were directed to "be courteous but unyielding to those asking the questions" and respond as follows: "My area of expertise is the production of Jazz events (or whatever appropriate function), and I am simply not knowledgeable

enough about smoking and health to be able to provide a complete answer. Please contact Mr. Wyatt."[64]

Festival PR staff closely monitored the media to determine the effectiveness of their efforts to influence coverage. They collected press clippings and produced press reports. As one such report for the Hampton festival concluded,

> The newspaper articles once again reflected the effort expended against public relations. All articles were in depth and favorable to the KOOL JAZZ FESTIVAL concept. Over 32,000 lines ran in coverage of the Festival with an estimated value of $20,244. Total readership is estimated to be nearly 5,000,000.[65]

Indeed, as the remainder of this chapter will show, press coverage of the Kool Jazz Festival often did reproduce positive corporate messaging.

Advertisements in Black Newspapers

To fully reap the rewards of their investment in the jazz festivals (i.e., to engage Black smokers and other members of the Black community), B&W needed a third party: the Black press. Without the Black press that provided a direct avenue to reach Black consumers, the tobacco giant would have had a much more difficult time accomplishing this task. To that end, B&W placed Kool Jazz Festival ads in Black magazines and Black newspapers. For example, a B&W letter outlining promotional activities for the 1979 concert in Hampton notes, "All national Black magazines and local Black newspapers will carry the KOOL Jazz Festival ad with a free KOOL Jazz Festival T-Shirt offer."[66] Ads in Black newspapers offered advance publicity that likely helped to drive traffic to the events. At the same time, the ads were a vehicle that helped to indirectly and directly promote the Kool brand. By emphasizing the positive features of the festivals, ads indirectly established the value of Kool. Festival ads also directly promoted the brand, as I describe below.

Much of the copy in ads was dedicated toward providing information about the festivals in each locale. This was an important function of the ads, because as Mukti Khaire, a scholar of cultural markets, reminds us, "A good has value in a market only if it is visible to potential consumers."[67] One mechanism through which the ads helped to create awareness of the festival series was by featuring a special Kool Jazz Festival logo.[68] In some earlier ads, the festival logo incorporated the Kool brand symbol with the phrase "Jazz Festival" written below it in similar all-capital font.

Festival ads created awareness of the concerts by providing information about the "who, what, and where." Information about the artists performing at the concerts was communicated through text and in some cases images. For example, a 1976 ad in the *Atlanta Daily World* lists the names of the performers in bold, capitalized text. Next to the list of names are photos of three of the acts including the Spinners, Al Green, and Marvin Gaye.[69] Along with providing information about artists performing at the festivals, ads often noted that Wein was the producer. For instance, "George Wein presents" is written in small type at the top of an ad for the 15th Annual Ohio Valley Festival in the *Indianapolis Recorder.*[70]

Ads also typically included information about the event venue, start time, and days that each artist was performing, as well as where tickets could be purchased and the price. For example, an ad appearing in the *Afro-American*, a newspaper based in Baltimore, noted that tickets were priced at "$10, $8.50, $7.50, $6.50 per person, per concert" and could be purchased from "All Ticketron outlets."[71] Some ads included phone numbers to call or addresses to write to purchase tickets. Information about paying for tickets with a credit card, group discounts, the time of ticket sales, and accommodations was sometimes included as well. On occasion ads had phone numbers to call to receive festival brochures.[72]

Most of the copy was presented in an objective manner. Or, it was purely factual information, such as the performance venue and times. However, other text in the ads was slanted to communicate that the Kool Jazz Festival was a worthwhile event to attend. For example, the text describing the technology at the festivals typically painted it as impressive. Several ads included the descriptor "giant" to highlight the use of closed-circuit television screens at the festival: "6 GIANT CLOSED-CIRCUIT TV SCREENS."[73] Another ad used the adjective "spectacular" to describe a light show: "SPECTACULAR LASER LIGHT SHOW."[74]

Ads described the benefits of particular technology as well. One ad noted that "6 Giant TV Screens" will "Bring You Close-Up to The Artists."[75] Punctuation, such as exclamation marks, was used to communicate that the technology at festivals was special. For example, in the ad noting the "spectacular laser light show," copy noted that the technology is "NEW AND EXCITING THIS YEAR!"[76] Other informational text communicated that the festivals were worth the effort to attend. One ad promoted the festival as "LIVE! IN PERSON!"[77] Another described how the festival would take place over "TWO GREAT NIGHTS."[78]

Emphasizing its musical value promoted the festival and brand too. For example, one ad encouraged readers to, "Reserve your seats now for the greatest music event of the year."[79] Another ad highlighted the quality of music and the two-stage setup, informing readers that "fans will be able to savor once again great sounds on not one, but two stages. Along with the excitement on the Main Stage, a second stage has been added on the grounds of the Performing Arts Center which will assure Festival-goers a wonderful musical option."[80] The quality of music was highlighted in ads by emphasizing the stature and popularity of artists. For example, one ad encouraged readers to "Be there when America's music greats hit town!"[81] and another informed readers that the event will showcase "TOP SOUL ARTISTS."[82] Still another ad assured readers that the festival would be "Featuring America's greatest music stars in person, on stage."[83] Yet another ad included the phrase "Back by Popular Demand" next to the name of one performer.[84]

The social value of the festival was on full display in some ads. Internal B&W documents reveal that sales staff and others viewed the festivals as an important Black social event. For example, a sales letter describes how "The KOOL Jazz Festivals have grown to be collectively the largest Black social event in the Country."[85] Ads emphasized the social aspects of the festival with copy such as, "THE PARTY EVENT OF THE YEAR!"[86] One ad actually signaled that the most worthwhile aspect of the festivals was their social value, rather than artistic features. Other than "Jazz" in the festival title, the ad made no other references to music. Not even festival performers were mentioned in the ad.[87] Instead, the ad showed a young stylish Black couple dressed in fitted white jeans, white shoes, and white "Kool Jazz Festival" t-shirts. The woman has one hand casually placed on the top of her head, while the other grasps her partner's hand. They look on trend and fun. Readers could dress like this modish pair by sending in two cartons of Kool cigarettes to a special post office box in Maple Plain, Minnesota. In return, they would receive a "fantastic KOOL Jazz Festival T-shirt" to give them "the look of extra coolness."

In addition to all of this, ads directly provided information about the Kool brand. Some ads included the name of Kool's parent company, B&W, in the context of recognizing festival sponsorship. For example, an ad for the 1983 Cincinnati Jazz Festival included the following copy to the left of the festival logo: "Brown & Williamson Tobacco Corporation presents the."[88] By virtue of the brand name being part of the festival title, ads provided awareness of the Kool brand. Some ads contributed to product awareness by including images

of Kool cigarette packets. A 1982 ad for the Kool Jazz Festival in Los Angeles included the image of a pack of Kool "Filter Kings" in the bottom left-hand corner.[89] Other ads placed this image of the "Filter Kings" pack in more conspicuous places, such as the top of the ad[90] or even in the center of the ad.[91]

"Filter Kings" were not the only product line pictured in KJF ads. Other ads included images of "Milds," a lower tar cigarette. A 1980 Kool Jazz Festival ad featured two cigarette cartons standing next to each other. The carton on the left had three cigarettes peeking out of the top and read "Filter Kings" in cursive writing. The box on the right had "Milds" written across its front.[92] Other Kool Jazz Festival ads included an image of a carton from the "Super Lights" line, an even lower tar version.[93] A full-page ad for the 1981 New York Festival in the *Amsterdam News* featured a carton of "Filter Kings," "Milds," and "Super Lights." The tar level of each product was written above the carton: "Original," "Low tar," and "Ultra low tar."[94]

Kool Jazz Festival ads not only shaped awareness of Kool cigarettes by including images of products; they also promoted particular meanings of the products by including taglines by the product images. For example, a central goal of the Kool sponsorship was to promote the brand's association with music.[95] A tagline placed next to a "Filter Kings" box in one Kool Jazz Festival ad reads, "There's only one way to play it."[96] Other taglines next to cigarette cartons in the festival ads helped readers to learn about the claimed distinctive characteristics of particular products. For example, "KOOL MILDS . . . Mild but not too light" is written beside a carton of "Milds" in a 1980 ad for the Cincinnati festival.[97] Still, other taglines in Kool Jazz Festival ads promoted the cigarettes as a superior product for reasons such as taste ("c'mon on up! to the coolest taste around" and "KOOL . . . Full taste menthol satisfaction")[98] and market position ("Nothing satisfies like KOOL. No Wonder It's America's #1 Menthol").[99] The taglines and images of the cigarette cartons were strategically added in part because of concerns by marketing personnel that some earlier ads for the festivals included no explicit "brand sell."[100]

Tar and Nicotine Disclosures and Surgeon General Warnings

Some aspects of the Kool Jazz Festival ads that provided product information and constructed brand meaning and value were entirely under the discretion of B&W. However, other ad components, specifically tar and nicotine disclosures and Surgeon General warnings, were monitored by the federal government.

With growing scientific evidence that smoking was a health hazard, cigarette companies began to advertise their products as low in tar and nicotine in the 1950s. During this "tar derby," tobacco companies made "a multitude of inconsistent, noncomparable claims" about the tar and nicotine levels in their cigarettes.[101] This practice ended in 1960 when the Federal Trade Commission (FTC) and the tobacco industry agreed that advertising would no longer include tar and nicotine product content. Then, in 1966, the Public Health Service released a report concluding that lower tar and nicotine cigarettes were less hazardous to health. Following that, the FTC revoked the advertising ban and created a standardized procedure for testing tar and nicotine levels. By 1970, the FTC proposed a rule requiring cigarette companies to disclose this information in advertisements. After negotiations, several companies voluntarily agreed to impart this information in ads.[102] Consistent with this agreement, Kool Jazz Festival ads, like a 1978 ad in the *Atlanta Daily World*, included a statement in tiny print at the bottom that listed tar and nicotine levels reported to the FTC.[103]

While the FTC tar and nicotine label relayed objective facts about Kool cigarettes, the Surgeon General's smoking warning provided damaging commentary about the products. In 1964, Surgeon General Luther Terry issued a "Smoking and Health" report that led to changes in cigarette advertising. The report, based on an analysis of over 7,000 scientific articles, concluded that smoking was a probable cause for lung cancer in women and a definitive cause for lung and laryngeal cancer in men. The report also determined that smoking was the most significant cause of chronic bronchitis. A year later, the Federal Cigarette Labeling and Advertising Act was passed by Congress. The act required that cigarette advertisements include a label warning of the dangers of smoking: "Caution: Cigarette Smoking May Be Hazardous to Your Health."[104] Four years later Congress passed the Public Health Cigarette Smoking Act, requiring that the health warning on cigarette advertisements be amended to the following: "Warning: The Surgeon General Has Determined that Cigarette Smoking Is Dangerous to Your Health."[105] The latter warning had the added authority of the Surgeon General. Consistent with this requirement, Kool Jazz Festival ads included this statement in a white box, typically at the bottom of the ad.

The Surgeon General warning was reputation damaging. Even if Kool Jazz Festival ads touted Kool cigarettes as "the coolest taste around," providing "full taste menthol satisfaction," a conspicuous white box nearby warned that the products were a health hazard. There was no way around this stigmatizing messaging in the festival ads since it was regulated by the law. However, news

coverage about tobacco-sponsored cultural events were not, and still are not, subject to FTC regulations surrounding the adverse health effects of smoking.[106] Stories in Black newspapers directly and indirectly promoted the Kool brand. Often, these editorial stories were without any reputation-damaging elements related to smoking or otherwise.

Editorial Coverage in Black Newspapers

As an impression management strategy, one intended goal of the Kool Jazz Festivals was to promote a positive image of the brand to Black smokers. Consistent with the ethos of corporate social responsibility that was growing more popular among corporations in the 1970s, marketing staff sought to present B&W as a company that was doing good. Stories about the Kool Jazz Festivals in Black newspapers reinforced corporate messaging of B&W as a virtuous brand.

Presenting B&W as committed to the arts and heritage was one way that stories about the festivals painted B&W as an upstanding brand. For example, in the *Atlanta Daily World*, an article described the festival as "part of a continuing commitment to music by the KOOL Cigarette Company, manufacturers of KOOL, menthol cigarette."[107] This passage is remarkably similar to a segment from a B&W press release promoting Kool Country on Tour, a country music festival sponsored by B&W: "KOOL COUNTRY ON TOUR is part of a continuing commitment to music by the Brown & Williamson Tobacco Company—USA."[108]

Some news stories promoting B&W's support for the arts directly reinforced corporate messaging about the significance of Kool cigarettes by incorporating a product tagline. In 1977, Kool advertisements began using a tagline including the phrase "America's #1 Menthol."[109] For example, a generic 1977 Kool advertisement depicts a wooden cabin in the forest surrounded by a flowing stream. The copy written below a package of "Filter Kings" and a carton of "Super Longs" reads "No wonder its America's #1 menthol."[110] Soon thereafter, and certainly by 1978, it was recommended that ads for the Kool Jazz Festival incorporate this phrase.[111] As one marketing staffer recommended, "Since the current K.J.F newspaper ad already carries the Surgeon General's warning and a tar/nicotine statement (but no brand sell) we strongly recommend that a package shot be included along with the copy 'The Kool Jazz Festival is sponsored by Kool cigarettes—America's #1 Menthol.'"[112] As noted earlier, this suggestion was

taken up, and Kool Jazz Festival ads incorporated a direct "brand sell." Some news stories promoting the company's "commitment to music" included this explicit brand sell as well. For example, a 1981 article in the *Los Angeles Sentinel* included the following segment: "Now in its 7th year, the San Diego KOOL Jazz Festival is part of a continuing commitment to music by KOOL, America's number one menthol cigarette."[113] Similarly, a 1979 article in the San Francisco-based *Sun Reporter* had the following passage: "The KOOL Jazz Festivals are a part of a continuing commitment to music by the KOOL Cigarette Company, manufacturers of KOOL, America's number one menthol cigarette."[114]

Editorial coverage in Black newspapers promoted an image of B&W as a socially responsible company through reproducing company messaging around its "commitment to music." News stories in the Black press also positioned the company as a generous firm through reprinting and paraphrasing corporate texts about B&W's support of community members where jazz festivals were staged. One of the marketing goals of the Kool Jazz Festivals was to convey to stakeholders that by subsidizing the cost of the events, B&W was providing cost-saving entertainment to community members. Listed under "Publicity Objectives" in one festival report was "Inform the public of KOOL's role in sponsoring the festivals and the positive effect KOOL has on ticket prices and talent."[115] Some news stories included passages with this theme.[116] For example, an article on the 1976 festival in Oakland, California, stated:

> The Festival is pleased to announce a continued affiliation with Kool Cigarettes. This type of corporate sponsorship assures that the Festival will continue to bring high-quality entertainment to the Bay Area at reasonable ticket prices. In this day of spiraling costs, KOOL's sponsorship has helped to keep ticket prices at a level that still makes the Festival the best entertainment buy in America today.[117]

This passage closely resembles a statement from George Wein included in a 1975 Kool Jazz Festival press packet: "I am happy to have KOOL Cigarettes and the Brown & Williamson Tobacco Corporation as a sponsor of our Festivals this year. . . . In this day of spiraling costs, we will be able to keep our ticket prices at a level that still makes our Festivals the best entertainment buy in America today."[118]

Other articles emphasized the fact that the Kool subsidy covered the large number of artists that patrons got to see at the festival for one price.[119] For example, one article included the line that "KOOL has enabled the Festival to bring six great artists each night at a bargain price," while another highlighted

that the sponsorship "enables the festival to present many major artists each night, at a price patrons would be happy to pay to see any one of these great artists."[120] These articles characterized the subsidy in a fashion that echoed a statement by Wein in a Kool Jazz Festival press packet: "In effect, what it [the KOOL sponsorship] means is that for the price of what you, as the public, would normally pay to see one artist, we can give you five major artists."[121]

Kool's claims of providing discounted access to the arts were touted in editorial coverage of their free military concerts. An article in *The Skanner*, a Black newspaper out of Portland, Oregon, included the following passage: "During 1982 KOOL also is sponsoring free concerts at major military bases across the country. The military program was initiated during the summer of 1981, and played at 10 bases." The article then lists some of the tour dates for 1982: "Chicago—August 30–September 5" and "New Orleans—September 15–19."[122] This section appeared almost verbatim in a 1982 press release titled, "KOOL JAZZ Festivals to Be Presented in Major Cities in 1982."[123] The only difference between the passage appearing in the press release and the newspaper article is that some of the cities on the tour list were different.

Along with emphasizing that Kool was a benevolent cultural patron because of a "commitment to music" and providing discounted access to concerts for festivalgoers, editorial coverage promoted the company as a protector of Black heritage. An article in the *Oakland Post* about the 4th Annual Bay Area Festival in 1975 included a statement about Black heritage attributed to Lenny Lyles, who is described as a "Former 49er and Baltimore all-pro footballer" and "the Director of Equal Opportunities Affairs for Brown and Williamson Tobacco Co."[124] A 1975 Kool Jazz Festival press packet included comments about Black heritage credited to B&W President Charles I. McCarthy. While the McCarthy statement commented on B&W's Black cultural patronage more extensively and specifically addressed Black performers and Black audiences, both men were quoted as saying that the festivals "would not only help to contribute to the Black Cultural experience, but one that would continue and expand upon this great heritage."[125]

Editorial coverage of the Kool Jazz Festival also promoted the "caring capitalism" of B&W by reporting their direct financial support of nonprofit organizations in non-cultural fields.[126] As a B&W marketing report explained, a main objective of Kool Jazz Festival PR was to "Generate informative, positive local press for KOOL as a responsive leader in the Black community in the weeks surrounding the Jazz Festivals."[127] Press cultivation was indeed successful, and

some news stories specifically promoted B&W's donations to Black commu-
nity organizations. An article about the 1976 festival in Memphis publicized the
company's support of the NAACP:

> The Weins also announced that the 1976 Kool Jazz Festivals will award a series of
> special grants to worthy community service organizations in the 11 cities where
> festivals are scheduled this summer. Included in these grants is a major commit-
> ment to all 11 local NAACP chapters, and the national headquarters organiza-
> tion in New York.[128]

With the exception of the addition of "US" in front of "cities" this passage ap-
peared word-for-word in a 1976 press release about the Kool Community Rela-
tions Program.[129]

A 1977 story in the same newspaper promoted B&W's donations to com-
munity organizations in a similar fashion. This article included the following
passage: "A standard feature of the annual music festivals, [t]he grant program
will represent a significant increase over the 1976 donation of $39,000 in nine
festival cities. George Wein, producer of the series said the festivals have be-
come one of the most important events of the year '[sic] in each city where we
appear. 'We feel these donations are an expression of gratitude for the support
we have received from each community.'"[130] The company press release had a
similar passage but it was Joyce Wein, rather than George Wein, who was cred-
ited with the quote about gratitude.[131]

Editorial coverage about the Kool Jazz Festival promoted B&W's largesse to
the public through framing the company as a patron of the arts and highlight-
ing its donations to non–arts-related community organizations. This coverage
directly positioned Kool as a positive brand. Articles indirectly promoted Kool
as a good brand through favorable messaging about the festival itself. One as-
pect of the festivals that editorial coverage promoted was technological innova-
tions.[132] For example, a story about the forthcoming 1975 festival in Oakland
applauded the visual and sound technology: "The Bay Area KOOL Jazz Festival
will again add four giant closed-circuit screens flanking the stage to enhance
the patron's visibility. The Concert TV Close-up and the sound will again be
provided by McCune Sound Service."[133] This passage closely resembles a section
of a 1975 press release for the Oakland festival: "The Bay Area Jazz Festival will
again add four giant closed-circuit screens flanking the stage to enhance the
patron's visability [sic]. The Concert TV Close-up and the sound will again be
provided by McCune Sound Service."[134]

A 1978 article also touted the latest technology at the festivals:

The giant color TV screens will bring closer-than-front-row views to the entire audience. Everyone will be able to see even the subtlest artists' expressions and gestures that make for an intimate musical experience and, for the first time ever, in color. In between performances, there will be a laser light show. Lasers have recently swept the country as a medium for entertainment. Nothing compares to laser lights. Beams no wider than a pencil travel for infinity, producing colors that are pure, and creating patterns of amazing complexity.[135]

This passage appeared almost identically in a 1978 festival brochure touting "giant COLOR television screens . . . [that] will bring closer-than-front-row views to the entire audience" and "a thrilling LASER LIGHT SHOW" featuring "Beams no wider than a pencil."[136] Other news stories from 1978 tout the "spectacular laser light show" and "color tv" at festivals.[137] These specific technological innovations were promoted in the exact same language in advertisements for the 1978 festivals.[138]

The stage setup at the festivals was another aspect of the festivals that was trumpeted in editorial coverage. For example, stories lauded the festival's "movable platforms" and "giant stage."[139] An *Atlanta Daily World* article alerted readers to the fact that "a new giant stage with a system of movable platforms will be used to keep artists' set-up time to an absolute minimum."[140] Similar language was used in festival PR material such as a 1979 ad promoting the festival's "GIANT STAGE" in bold letters[141] and a pamphlet from that year that highlighted the "new ENLARGED STAGE with movable platforms."[142]

Stories on participating artists were another way that editorial coverage directly promoted the festival and indirectly promoted B&W. A 1981 article about the New York festival appearing in the *Philadelphia Tribune* described the festival line-up in rich detail. For example, readers learned that "'Women Blow Their Own Horns' will be devoted to the longstanding contributions that women have made to jazz."[143] This passage, and almost the entire article, appear nearly word for word in "Program of Kool Jazz Festival New York Announced," a 1981 press release detailing the concert line-up.[144]

Along with providing information about artists' backgrounds, editorial coverage emphasized the stature of artists. An article on the upcoming 1978 festival in Memphis spotlighted the accolades of the R&B group, the Spinners. For example, it noted that "During the 21 years that the Spinners have been in existence, they've won followers around the globe for their distinctive

blend of talent, professionalism, and expert showmanship."[145] The article also directs attention to other performers such as musician and composer George Duke, noting that "'Reach for it' his new Epic LP, like his new band, show-cases the vocal aspect of Duke as both composer and performer. While vo-cals are prevalent on the album, instrumental expertise is the message." Both passages appeared nearly verbatim in a section of a 1981 promotional booklet describing the backgrounds of artists performing at the festivals. In the PR booklet, the segment about the Spinners appeared in the first part of a lon-ger paragraph about the group.[146] The section about Duke's "instrumental expertise" appeared in the middle of a longer segment about the artist in the PR booklet.[147] In addition to placing attention on the stature of artists, articles directly promoted the quality of the festival. The 1981 *Philadelphia Tribune* piece, and the press release "Program of Kool Jazz Festival New York Announced," both described the New York concert as "the internationally acclaimed festival."[148]

The Kool Jazz Festival in Hindsight

In some cases, post-festival editorial coverage painted a wholly positive portrait of the festivals and brand. An exemplar of this type of coverage, a 1979 review in the *New Journal and Guide* began, "A master at playing the guitar and syn-thesizer, Ramsey Lewis began what would end up being the hottest jazz con-cert to hit the Hampton Roads area in quite some time."[149] More typical among post-festival rather than pre-festival coverage, this article does not appear to contain verbatim or paraphrased passages from B&W PR texts. A 1983 article in the *Atlanta Daily World*, "Jazz Legends Played It Kool at the Fox," however, directly incorporated B&W messaging.[150] The review begins, "When you think of cigarettes, there is only one way to smoke it. When you think of music, there is only one way to play it. KOOL JAZZ." This passage included a paraphrased version of a Kool tagline used in festival ads and other advertising for the brand that year: "There's only one way to play it . . ."[151]

 In general, there was more criticism about the festivals after the fact. Over-whelmingly, critiques focused directly on the festivals, rather than B&W or products. A common pattern was a generally positive review with a small criti-cism thrown in. The most common complaint was that the festivals included genres other than jazz or were not in classic jazz form. Though generally ef-fusive with praise, a reviewer of the 1982 festival in Washington, DC, admitted

that Miles Davis's performance "was much to[o] rock-fusion oriented for mainstream tastes."[152]

Other critiques contradicted B&W promotional claims around superior technology and other aspects of the festivals. A review of the 1980 Atlanta festivals lambasted promotional claims surrounding the wait in between acts: "First of all, promoters boasted about the cut in layover time between each performance. Well, it wasn't cut. Even though entertainment was provided in between many of the acts, there was still a lot of toe-tapping spent waiting for the stage hands to set up the next act."[153] Though this review was critical, it ended on an upbeat note praising the festivals for their positive impact on Black audiences and performers:

> It gives the black public a chance to view top rate black performers on a mass scale. It is a big production and it adds prestige to black music. Next year, I'll probably be back in the first row again, because it represents black success and I'm sure with time the wrinkles will be ironed out.[154]

While critiques of festival performances and logistics indirectly "spoiled" the image of Kool, it was strikingly uncommon to find direct critiques of the Kool brand. One deviation from this pattern was a scathing commentary surrounding the 1983 festival in Philadelphia. "How Cool Is Kool?" in the *New Pittsburgh Courier* castigated B&W for doing business in apartheid era South Africa. The article began, "Jazz fans in Pittsburgh are riding high on the euphoria generated by the visit of the globe-trotting Kool Jazz Festival. But a cloud hangs over the future of the all-star event."[155] The article then describes how artists headlining the festival had recently performed in South Africa and details B&W's involvement with the apartheid nation:

> The Brown-Williamson Tobacco Co., which finances the touring Jazz gala, is part of a multi-national corporation with extensive investments in the economy of the Union of South Africa. As such, it indirectly supports the abhorrent activities of that regime. . . . But perhaps the greatest irony lies in the fact that corporations such as Brown-Williamson Tobacco Co. which are supportive of the South African regime actually employ JAZZ—the product of Black American culture—as a public relations tool. The question arises: Should Jazz be used to smooth the path of the most violently racist regime on our planet?[156]

The piece ends by calling forth the health hazards of B&W products:

Kool Jazz Festival sponsor, the Brown-Williamson Tobacco Co., is a leader in the industry which has historically been the greatest exploiter of Blacks in America. The plantation mentality remains the rule of law in today's Union of South Africa. Can the Brown-Williamson Tobacco Co. and its family of cancer-causing carcinogens continue to be considered KOOL by Jazz fans? In this case, where there's smoke there's fire![157]

Another rare article that directly criticized B&W was a review of the 1976 festival in Oakland that appeared in the *Sun Reporter*. This piece, which actually began on a fairly positive note calling the festival "an evening of sheer delight and entertainment," concluded by blasting the company for its "insult[ing]" donations to Black community organizations.[158] Unlike other coverage of the festival that simply reproduced B&W commentary surrounding donations to community organizations, this article quoted and then critiqued company PR. It decried the "piddlings" donated to community nonprofits like the NAACP:

> Would you believe $750 a piece? That's all it was—totalling [sic] a mere $3,750. . . . Any first-grader, without a calculator—could have figured out that the lousy $3,750 was less than one-half of one percent of the dough they raked in from the "Community," which I mentioned before was mostly Black. According to a press release I got last March at a luncheon I attended when Festival promoters were looking for community support, they said: . . . "We who produce the Festivals feel that these donations are an expression of gratitude for the support we have received from each community . . ." KOOL Jazz promoters didn't have to give the community groups a dime—and they almost didn't, but to run that age old rip-off game in 1976 is an insult to Oakland's Black community.[159]

The fact that these articles are exceptions to the general rule of positive editorial coverage of the festival and company suggests that B&W's press cultivation tactics were often effective. In fact, even after the *Sun Reporter* article appeared, festival staff contacted the reporter to tell their side of the story. A letter from Wein to the reporter indicates that there was a phone conversation about the piece and that Wein hoped to reverse the view that the Kool Jazz Festival donation was paltry and exploitive.[160] His letter, dated October 8, 1976, began, "Dear Ms. Austin: I have had a lengthy discussion with my wife and my associates since our telephone conversation. We have decided not to write you a letter for publication. Perhaps, after you absorb the following information, we

can meet sometime in the future and discuss how we can improve our public relations in the Oakland area and perhaps correct some of the mistakes we have made in the past."[161]

By the late 1980s, B&W's sponsorship of the Kool Jazz Festival had ended. In the ensuing years, the company (which merged which RJ Reynolds in 2004) would try its hand at other music sponsorships, such as the Kool Nu Jazz Festivals featuring hip-hop artists like Erykah Badu, Common, Lauryn Hill, and the Roots, to promote Kool cigarettes in the Black community.[162] The Kool Jazz Festival also marked part of the beginning of Wein's long career of producing music festivals. Soon, he would become involved in what would become the biggest Black music festival in the United States—the Essence Festival in New Orleans. This iconic festival featuring Black music would become a successful tool for cultivating Black consumers into the new millennium.

5 The Party of the Year

IT'S JULY 5, 2019, and I am getting into a taxi at the Louis Armstrong Airport in New Orleans. When I tell the cab driver that I am headed to a hotel in the historic Warehouse District, an area where the convention center is located, he warns me that the drive will take a little longer than usual. He's right. Once we get close to the hotel, traffic is bumper to bumper, and there are large crowds of tourists walking the sidewalks. Like myself, they are among the over 500,000 visitors in town for the 25th anniversary of the Essence Festival. The Essence Festival, hosted by the magazine for African American women, is one of the largest music festivals in the United States. In 2019, more than 100 artists are performing at the oft-called "party of the year." Rappers—such as Nas, Missy Elliott, and Pharrell—and rhythm and blues singers—like Mary J. Blige, H.E.R., and Musiq Soulchild—will take the stage that weekend. But, the Essence Festival is not just a cultural affair. It is also a corporate affair. Big companies like Coca-Cola, AT&T, Ford, and McDonald's help to sponsor the event. For these companies, the over half a million attendees, mostly African American, present a prime marketing opportunity. While it is well known that concerts like the Essence Festival are a "marketer draw" because of their potential for cultivating customers,[1] it is less clear how consumers actually become engaged with companies at these events. We also know little about how Black festivals like Essence specifically cultivate African American consumers. This chapter starts to answer these questions by focusing on the ways that music influences social life.

Rather than standing apart from the social, music is a force that shapes individual and collective behavior.[2] It "afford[s] perception, action, feeling . . . [and] corporeality."[3] In other words, music is a part of the environment that influences how we move, think, and feel. Aware of the capacity for music to influence action, consciousness, and emotion, marketers strategically employ music to shape consumer behavior.[4] For example, the Saturday playlist for a trendy clothing store in the United Kingdom includes "brighter, funkier" songs to bring up the spirits of weekend shoppers.[5] Other store managers play fast-paced music to encourage "fast shopping."[6]

While music is generally used to orchestrate consumer activity, it is important to account for how "ethnic" music configures ethnoracial minority consumers in marketing environments as well as how their presence in these spaces shapes branding. The capacity for music to influence actions and moods, and thus its effectiveness as a marketing tool, is closely tied to race and ethnicity. For example, playing music that is aligned with the taste culture of a specific ethnoracial minority group is likely to be especially effective at drawing them into marketing environments and positively influencing their emotions and behavior once there. At the same time, ethnoracial minority consumers who are drawn to marketing environments by virtue of the music being played there serve as co-creators of brand meanings. Through their presence and their collective emotions and behaviors in these spaces, they can project an image of brands as celebrating and being connected to ethnic communities.

Music, Mood, and Movement

Music influences actions that increase consumers' exposure to brand names, logos, messaging, and products.[7] Music also affords behavior that can create positive experiences and emotions within branded environments. Music is a pied piper that attracts consumers to, and holds them within, branded environments where they are inundated with brand logos and messaging, and they are exposed to products. Once in these branded spaces, consumers bond with others and experience feel-good emotions as they collectively sing along and dance to the music. How does race matter in these scenarios? Given that music consumption varies across race and ethnicity, certain genres of music should be more or less effective in attracting particular racial and ethnic groups to branded environments as well as inducing them to move and experience particular emotions once there.

Musical production and consumption vary along racial and ethnic lines.[8] African Americans are more likely than other groups to report that they enjoy and consume historically Black forms of music. For example, the 2012 Survey of Public Participation in the Arts, a national survey cataloguing arts engagement in the United States, found that "African Americans were most likely to attend jazz, hymns, blues, and rap music [performances], and non-Hispanic whites were most likely to attend country, pop, and rock music [performances]."[9] The greater likelihood of African Americans enjoying and being familiar with historically Black genres of music means that they should not only be more likely than other racial and ethnic groups to be attracted to marketing environments featuring this music, but once in these environments they should be more likely to collectively sing, dance, and move in other ways along to it. The latter should be more likely among Black consumers not only because they are more likely to enjoy Black music, but also because the capacity to sing along with Black music lyrics and engage in choreography and other movements typically done to specific Black songs and Black music genres depends on prior encounters with the music, which is more likely among this group.

Black music—typically R&B, rap, hip hop, and gospel—played at corporate booths at the Essence Festival attracts festivalgoers, who are almost exclusively African American, to these branded environments. Once there, it is common for festivalgoers to sing and dance along to the music while having fun and bonding with others. In these ways Black music is an effective marketing tool for companies: It lures Black consumers to branded spaces where they are deluged with brand names, logos, messaging (often specifically Black messaging), and products. Once in branded areas, music also facilitates Black consumers having positive experiences and emotions. The presence of Black consumers in these spaces, along with their shared emotions and behaviors, help brands to convey an image of being connected to and valuing African Americans. The Essence Festival developed organizationally in such a way that has made it a perfectly primed instrument for corporate cultivation of Black consumers and Black branding.

From Magazine to Festival

In May 1970, the first issue of *Essence* was published after four African American men—Edward Lewis, Clarence O. Smith, Cecil Hollingsworth, and Jonathan Blount—founded Essence Communications Inc. (ECI), a publishing

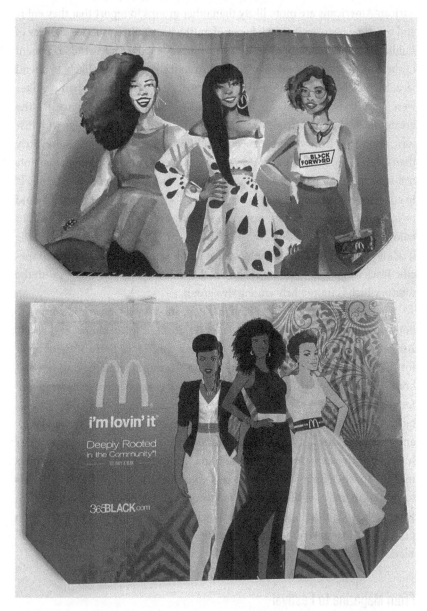

Figure 5.1 Branded tote bags handed out at the McDonald's stage over the years, Essence Festival.

company two years prior. By the 1990s, *Essence* had become the world's largest lifestyle magazine for African American women.[10] To celebrate the magazine's 25th anniversary in 1995, Lewis wanted to do "something major."[11] Meanwhile, George Wein, whose company Festival Productions, Inc. had produced the Kool Jazz Festivals for over a decade in the mid-1970s to late 1980s, was looking for another venture. In 1993 Wein was working on a project with entertainer Harry Belafonte to "create a celebration of African-American contributions to world culture and the American way of life."[12] Though Wein and Belafonte had a series of meetings with potential sponsors, plans for the weeklong festival fell through.[13] When Lewis happened to mention to Wein, whom he had met earlier through a mutual celebrity acquaintance, his ambitions to celebrate *Essence*'s 25th year in grand style, Wein responded, "Did you ever think of doing a music festival in New Orleans over the Fourth of July weekend?"[14] From that conversation, the Essence Festival was born.

In July 1995, the inaugural festival was held in the New Orleans Superdome. Popular R&B acts like Boyz II Men, Mary J. Blige, and Earth, Wind & Fire headlined the successful concerts that drew an audience of 145,000 and "netted $500,000 in profit."[15] As Lewis reflects, while ticket sales and sales of vendor space in the nearby convention center helped to make the first festival a profit-making venture, corporate sponsorship was "key to the concert being profitable."[16] In return for underwriting the festival, corporate sponsors like Coca-Cola received, in Lewis's words, "huge brand exposure."[17] As the festival is organized today, corporate sponsors receive brand exposure in a variety of ways, such as features in *Essence* magazine in the months prior to the festival and in recorded and live segments during nightly concerts at the Superdome. However, arguably the most extensive contact that corporate sponsors have with potential customers is at the convention center.

Located on the banks of the Mississippi River, a few miles from the Superdome, the New Orleans Ernest N. Morial Convention Center is the home base for corporate sponsors over the three-day festival. There, each major corporate sponsor hosts a booth that typically includes a main stage where popular musical artists like Tevin Campbell, Brandy, Tamar Braxton, and well-known DJs like DJ D-Nice and DJ Scratch perform. Branded products specially made for the Essence Festival, such as tote bags and posters with a Black theme, are handed out along with samples from regular product lines. In 2019, the major sponsors (including Coca-Cola, AT&T, State Farm, McDonald's, Walmart, Disney, and Ford) occupied booths in the central part of the convention center.

Coca-Cola, the lead sponsor, had a slightly larger booth that was more centrally located than the other sponsors. As festivalgoers moved around the convention center, passing by different booths, music played a key role in capturing their attention.

"Dream in Black"

In the early evening of July 6, Tamar Braxton sashayed onto the AT&T "Dream in Black" stage to the first chords of "All the Way Home," a song that peaked at number 8 on the R&B charts in 2014. Wearing a long curly platinum-blonde wig that covered her recently shaved head, and a blue-and-gold Baroque jumpsuit, Braxton moved across the stage and crooned "Oooh, Oooh," along to the song's first beats. "Damn, I need a minute, so baby keep your distance," Braxton sang. "All the Way Home" is a love song involving a couple who break up and later get back together. The breakup and makeup lyrics of "All the Way Home" have a wistful tone, and some audience members quietly mouthed the lyrics to themselves. A group of Black women walking past the AT&T booth stopped when they heard Braxton singing. "This is my song," one said enthusiastically. "Girl, me too," another replied. They smiled, took out their phones to film, and listened to the rest of her set.

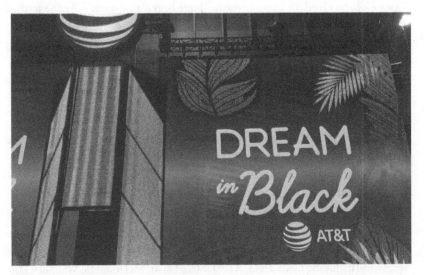

Figure 5.2 AT&T "Dream in Black" stage, Essence Festival, 2019.

After "All the Way Home," Braxton sang a few more songs and then left the stage. Many in the audience quickly dispersed, but some hung around to check out the other attractions in AT&T's "Aftropolis," an Afrofuturistic fantasyland of "tech and culture-inspired wonder."[18] AT&T's "Aftropolis" booth was darkly lit. At various times, bluish-purple neon light emanated from huge screens across the main stage that was the focal point of the booth. A black-and-white version of the company's globe logo was featured prominently on top of the stage. A booth where festivalgoers could take photographs was set up to the left of the stage. The back of the photo booth featured the phrase "Dream in Black" in white neon lights. "AT&T" and the company logo were in neon lights below the tagline. Light purple and white flowers cascade down the booth's back wall. On top of a neo-traditional rug was a purple velvet settee where festivalgoers could sit for a portrait. The "Dream in Black" tagline was also featured on black t-shirts worn by AT&T staff.

"Dream in Black," an AT&T marketing campaign that launched in 2018, targets Black consumers. The campaign has its own hashtag (#DreamInBlack), website (dreaminblack.att.com), and gifs (such as a brown-skinned woman with gold triangle earrings winking and two brown hands clasped in a handshake). Braxton reinforced the company's Black messaging during her performance when she shouted to the audience, "This is Essence Festival! It's all about Black people elevating to the next level."

Braxton's work to promote the AT&T Essence booth also took place online. A few days before the festival, she placed a "sponsored" post on Instagram: "Screaming** #DREAMINBLACK Honey yasss! Ya girl will be giving life to the @att stage in the Ernest N. Morial Convention Center this year at #EssenceFest. Stop by and follow #dreaminblack! Let's go! #attpartner." The post featured concert footage of her singing "All the Way Home."

"Reign On"

Braxton was just one of the singers performing at the convention center that weekend. On Sunday morning gospel singer Jonathan McReynolds drew festivalgoers to the Walmart stage. "Since we are at church service, don't mind if I do churchy things," said McReynolds, as he placed his guitar strap around his neck. The star gospel artist, whose albums *Life Music: Stage Two* and *Make Room* reached number 1 on Billboard's Top Gospel Albums chart, was part of a gospel singing extravaganza at the Walmart stage. Taking place on Sunday

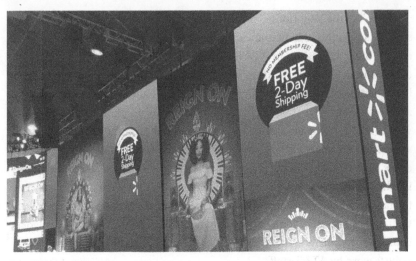

Figure 5.3 Walmart "Reign On" stage, Essence Festival, 2019.

morning, the concert featured artists such as gospel star Tamela Mann and contestants in the annual Walmart "Next Gospel Superstar" contest. The crowd in the Walmart sponsor area was tightly packed and overflowed into the adjacent walkways in the convention center. The throngs of people packed in the area were so tight that it was almost impossible to pass through.

McReynolds, dressed casually in a white t-shirt and matching dark gray jeans and a jean jacket, looked over to his band and said, "Give me a good C sharp. I'm going to show you how they sing in my church, 'cause I missed out this Sunday morning." "Mmmmm, mmmmm, Oh Lord," he sang as the music started. "Alright, alright," some crowd members responded. "This is what they sing in my church," McReynolds said before he started snapping his finger and sang, "I woke up this morning with my mind and . . ." Instead of finishing the verse to this old African American spiritual, he pointed to the audience, which responded, "It was stayed on Jesus." "Come on, sing it," McReynolds said. As the song continued, the audience sang the refrain with McReynolds joining in at various times, until he put his hand up signaling the band to stop playing. "What about," he said and paused. "Can't nobody," he sang. The band joined in, and the audience started clapping and singing along to the popular gospel song "Can't Nobody Do Me Like Jesus."

The crowd was joyful, and as they sang and clapped along in the African American tradition of call and response, their eyes fixed on the stage. While

their attention might be focused on McReynolds, Walmart branding was in their eyesight. The large screen behind McReynolds featured "Walmart" written in large white letters. There were two huge images of African American women flanking the left- and right-hand sides of the stage. One image featured different shades of green and showed a Black woman sitting on a "throne" composed of weights and other fitness equipment. The second image, in blue tones, showed the same model, Wanaki Shores-Navata, with her legs crossed in a yoga pose. Both images featured the phrase "Reign On," a tagline for one of Walmart's recent African American marketing campaigns. The royalty theme was carried through by the golden crown affixed atop the model's head in both images.

When festivalgoers watched Bryson Bernard, a Black millennial R&B singer, perform on the 2019 Walmart stage, the Black queen images were in their line of sight too. Bernard, who is better known by his stage name Cupid, was decked out in his signature wide-brimmed hat, black t-shirt, gold chain, and sleeveless jean jacket. He came to fame with his 2007 hit "Cupid Shuffle," which climbed to number 21 on the Hot R&B/Hip-Hop Songs chart. Although Bernard hasn't had a national hit since then, "Cupid Shuffle" and the accompanying line dance are a staple at Black events like family reunions and Greek picnics. "To the right, to the right, to the right, to the right / To the left, to the left, to the left," Bernard sang. As he belted out the words, the crowd stepped to the left and right in spontaneously formed lines. "Now kick, now kick." Following along, the line dancers alternatively thrust their left and right feet in front of them on the floor. As Bernard sang the last part of the chorus, "Now walk it by yourself," the crowd turned to the side and changed direction. As festivalgoers danced, some put a unique flavor into the moves, shimmying their shoulders and snapping their fingers to the beat.

Some of the concertgoers might have caught Bernard's Instagram post a few days earlier urging his followers to "Keep an eye on the Walmart Stage . . . #WalmartShuffle I'll be gracing the Walmart Stage as well!!! @walmart A Party ain't a Party Less I come through #DancePartyKING."[19] The mention of #WalmartShuffle in the post was a reference to Bernard's promotion with the corporate giant several months earlier. In September 2018, Bernard issued an "International VIRAL Dance Challenge" inviting people to do the Walmart Shuffle, a "New Version of the Cupid Shuffle with a Twist!"[20] The winners of the challenge, workers at a Walmart in Huntsville, Alabama, got to perform in a special video where Bernard sang "The Walmart Shuffle." Along with a wide-brimmed hat and matching denim jacket and pants, Bernard wore a blue

t-shirt with the Walmart Shuffle hashtag. As he sang a customized version of the song—including lines such as "Save money, live better, and do the Walmart Shuffle"—a mostly Black crowd of workers danced along.[21]

At the 2018 Walmart stage, festivalgoers enjoyed a performance of another song released in 2007—Marvin Sapp's "Never Would Have Made It." Wearing black jeans and a black t-shirt, Sapp clasped the mic in one hand and gestured along with the music with the other: "Never could have made it, without you." As Sapp sang, several audience members lifted up a hand in praise, a common gesture done in accompaniment to gospel songs that signifies reverence and surrender to God. Audience members were turned toward the stage where a white Walmart logo glowed against an LED screen with flashes of sparkling colors. To the sides of the main screen were three mural-size images of African American women. Each graphic featured the "Reign On" tagline written in block lettering above the portrait of a Black woman wearing a sparkling crown. One image featured a model with long curly black hair in front of a backdrop of colorful fruits and vegetables. Another image showed a Black model with long braids in front of a blue-and-gold themed backdrop evocative of African symbols. The third panel featured a Black woman with brown hair in an updo in front of a backdrop featuring metallic time pieces.

That year, the "Reign On" messaging was promoted through a selfie wall on the far left-hand side of the Walmart booth. In this photo area, festivalgoers could take a photo against one of two backdrops. One backdrop featured a deck of cards theme and included a "Queen" card with a golden crown. #ReignOn was written on the top of the card. and the Walmart logo was featured in the border of the left-hand side of the card. The other side of the selfie wall featured an actual throne for festivalgoers to sit on. The throne was covered in dark purple velvet fabric and supported by a golden base. A golden crown, the Walmart logo, and the #ReignOn hashtag, were featured on the LED wall behind the throne.

The Walmart marketing team chose the "Reign On" theme to communicate to "African American Moms" that "We see you. We hear you. We understand You. We respect you." As a campaign text explained, the marketing effort was designed to link idealized representations of Black womanhood to Walmart:

> Black women are the queens of their households. Royalty is pervasive in African-American culture due to historic influences and religious beliefs. It is the ultimate expression of empowerment and respect. Walmart's app-based

services enable every queen to reclaim her day and seamlessly #ReignOn in every way, every day.[22]

At the other end of the Walmart booth was another photo area featuring an uplifting theme—"I AM." In this portrait area, visitors stood in front of a white backdrop featuring "randomized positive words" such as "Queen," "Fierce," "Soulful," and "Strong." After the photo was taken by a "brand ambassador," it was e-mailed to the festivalgoer.

LED screens in the Walmart booth played videos that featured Walmart delivery services. The videos highlighted features of the service such as "Free 2-Day Shipping," "No Membership Fee," and "Free Curbside Pickup." The videos continued the royalty theme by encouraging consumers to use the service and "Rule on your time" and "Summon groceries to your car." The booth also featured an interactive *Endless Aisle Runner* game where festivalgoers would play the role of a Walmart associate through an avatar on a screen in front of them. Running in place on a pressure-sensitive pad, consumers moved their hands to grab items off the screen.

In the eyes of the Walmart marketing team, the booth was a success. Summarizing the campaign, a marketing report concludes: "8 out of 10 Essence Festival attendees reported a positive opinion of Walmart. The sponsorship increased attendees' likelihood to consider purchasing from Walmart and recommend the brand's products to others."[23]

The 2019 Walmart booth didn't feature an interactive video game but it did have royal-themed photo opportunities. Like 2018, one royal throne had purple velvet fabric and an ornate golden base. Another throne was composed of white leather fabric and a gilded silver base. An LED screen behind the thrones featured "REIGN ON" written in large capital letters. The Walmart logo and the #ReignOn hashtag were written in small type in the right-hand corner of the screen. "Reign On" goods were distributed to consumers at the Walmart stage. To receive the products, festivalgoers had to wait in line, sometimes for several minutes.

Standing in line, in the roped off area alongside the edge of the booth, customers could hear music emanating from the Walmart stage. When a live artist wasn't present, a DJ rocked the stage playing rhythm and blues and hip-hop hits. As customers waited, they bopped and sang along to songs such as Experience Unlimited's hit "Da Butt." The song was made famous from Spike Lee's 1988 film *School Daze* about life at the fictional HBCU Mission College. The movie, along with the song's video, popularized Da Butt dance whereby

dancers jump to the side, bend over, and shake during the song's refrain "Doin' the butt." The song and dance were a favorite during late 1980s and early 1990s house parties. Since that time, the song and dance are often played at Black social events such as sorority and fraternity conferences and family reunions.

In the Walmart line, some festivalgoers sang along to the song, snapped their fingers, and swayed back and forth to the beat. At the end of the line festivalgoers were greeted by Walmart staff wearing dark blue t-shirts printed with the Walmart logo, the #ReignOn hashtag, and the phrase "MIND BODY SOUL." They were also handed a large blue shopping bag featuring an image created by Gerald Ivey, an African American artist. Ivey's paintings are diverse, ranging in style from pure abstraction to figurative portrayals of African Americans. Many of Ivey's figurative works are in the Black Romantic tradition where African Americans are represented in an uplifting manner. While Black Romantic artists are generally not considered fashionable in the exclusive "high" art world, some find commercial success among a broader group of Black middle- and upper-class art buyers who seek out positive portrayals of African Americans.

The Walmart bag incorporates Ivey's signature in white in the upper-right-hand corner and features images of a Black woman in the Black Romantic tradition. The imagery on the tote bag is divided into four squares that each feature a different shade of blue in the background. The subject of each square is the same stylized image of an attractive, caramel-colored Black woman; her brown hair is gathered in an elaborate updo, and her full lips are shaded in deep-red lipstick. Her shoulders peak out from an emerald-green top, and her neck is adorned with an intricate necklace composed of brightly colored stones, pearls, and silver amulets. One side panel of the bag features the Walmart website address with the Walmart spark logo in place of the dot in front of "com." The other side panel features the #ReignOn hashtag in white.

Inside the bag is an accessory that helped festivalgoers personally embody the "Reign On" theme—a crown. Worn like a headband, the crown is composed of gold-colored plastic. Thin sharp spikes protrude from the band. Clear, pink, blue, and green plastic gems run along the base. Many festivalgoers wore the crowns as they posed on the white-and-purple Walmart thrones in the "Reign On" photo booths. The crowns and bags were common accessories among women festivalgoers as they wandered through the convention center visiting other booths. As real-life Black queens, these customers brought Walmart's "Reign On" theme to life.

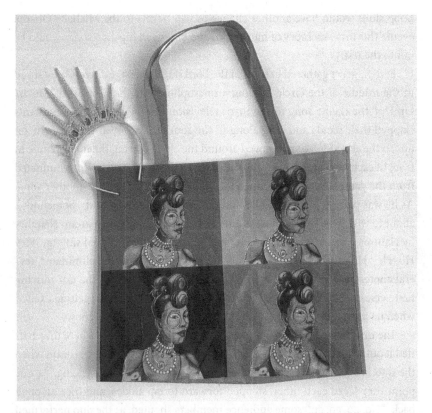

Figure 5.4 Free branded tote bag and crown handed out at the Walmart stage, Essence Festival, 2019.

"Paint the Future Proud"

Across the convention hall, festivalgoers in Ford Motor Company's "Paint the Future Proud" booth were spinning hula hoops around their waists, arms, and necks to the beat of Rob Base and DJ E-Z Rock's 1998 rap hit "Joy and Pain." The objective: To win tickets to hear journalist Gayle King interview former First Lady Michelle Obama later that evening. The festivalgoer who kept the hula hoop spinning the longest would claim the prize. "Who wants to see Michelle Obama tonight," actor and entertainer Jason "J Boy" Carey, the emcee for the Ford booth, said as he walked among the contestants. As the music changed to a song with a slower rhythm, hula hoopers adjusted their movements to accompany the new beat. A few moments later, festivalgoers with limited hula

hoop skills would have another chance to win tickets to the Michelle Obama event. This time, memory of hit rhythm and blues and hip-hop songs would be put to the test.

Festivalgoers gathered in front of the Ford stage in a large circle. Carey stood in the middle of the circle holding a microphone. As the DJ played "Movin' On Up," the theme song to the 1970s television hit *The Jeffersons*, contestants clapped their hands and sang along to the soundtrack: "Well we're movin' on up, To the east side." Carey moved around the circle placing the microphone in front of each person. Anyone who didn't know the words was swiftly eliminated from the game. Every few seconds the DJ changed the music to another song. As he was playing DeBarge's 1982 soul hit "I Like It," the DJ said, "Somebody's about to win these tickets tonight" and changed the song to rap group Naughty by Nature's 1992 song "Hip Hop Hooray." Circle members started singing "Hey Ho, Hey Ho" and moving their hands back and forth. Carey eliminated several contestants in a row when they didn't know the words to the fast-moving first verse. The crowd gathered around the outside of the circle, getting excited when he moved to contestants who confidently belted out the lyrics.

The final two contestants joined Carey and the DJ on stage where they battled it out to determine the winner. The audience roared with enthusiasm when the duo broke into old school dances to accompany their lip syncing. At one point they faced each other, stepped forward to tap ankles, and then stepped back. "Go, go, go, go," some audience members shouted, as the duo performed the dance made famous in the 1990 film *House Party*.

After the winner of the lip sync battle was decided by audience cheers, more fun and dancing ensued. As the DJ played the first chords of the 1988 hit "If It Isn't Love" by R&B group New Edition, Carey walked back and forth across the stage and said to the audience, "Look around, I need you to find me Ronnie, Bobby, Ricky." When he identified a group of Black male festivalgoers to impersonate each New Edition member, he invited them to the stage where they proceeded to dance and sing along to the group's classic hits. Later, Carey and another staffer led the audience in a series of line dances like the Electric Slide. Forming a series of makeshift lines, they glided back and forth across the purple carpeted floor in unison.

The dark orchid-shaded floor complemented the huge banners flanking each side of the Ford stage. The panels had a white background colored with lavender and lilac. "Built Ford Proud" and "#MyFordFam" were written across the top of the panels in dark blue type. Next to the stage was a "Caraoke" station

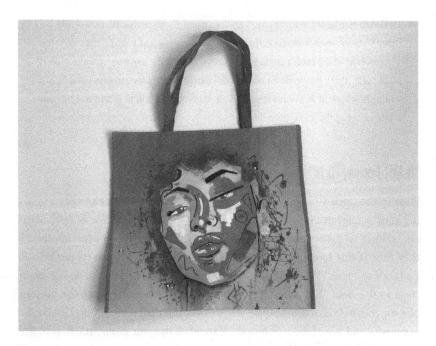

Figure 5.5 Branded tote bag handed out at the Ford stage, Essence Festival, 2019.

where festivalgoers packed into a shiny Ford F-150 Platinum Edition with their companions and belted out the words to R&B songs like Ella Mai's recent chart-topping hit "Boo'd Up" and TLC's 1990s classic "No Scrubs."

At the registration station across from the Ford booth, festivalgoers were gifted with a tote bag if they filled out a Ford marketing study with questions such as: "What is your overall opinion or impression of Ford on a scale of 1 to 10, where '1' is Poor and '10' is Excellent?" and "When do you plan to purchase your next vehicle?" and "For your next vehicle purchase, how likely are you to purchase a Ford vehicle?" The plastic tote bag has magenta-colored canvas handles and features the face of a Black woman rendered in brilliant splashes of color. "My Ford Proud" is written in white lettering across the fuchsia-colored side panels of the bag. The artistic character of the bag is tied into the Ford booth's "Paint the Future Proud" theme.

The huge mural on the outside of the booth (22 feet by 10 feet) conveyed this theme too. Painted by Sydney G. James, a Detroit-based African American artist, the mural featured the face of a chocolate-toned Black woman surrounded by a mass of thick, fluffy dark hair. Reflecting on the mural, James commented:

I painted her how I want them to see us, when they see any Black woman. . . .
I don't care if she's homeless, if she's a CEO, if she's just middle management.
Whatever she is, I want people to look at her like she's a queen or some type of
regal entity that's just walking here on the earth. I want them to experience pride
when they look at it. I want them [Black women] to look at it and feel her and
relate to her at the same time.[24]

"If Not For My Girls"

Over in the Coca-Cola booth with cherry-red carpet, two Black women wear-
ing shorts and tank tops stood in the front of an informal line of festivalgo-
ers waiting to take a photo in "The Girlfriend Collection" photo booth. As
they waited, one looked in her purse while the other danced to rapper Boosie
Badazz's 2007 hit "Wipe Me Down," being played by DJ D-Nice on the main
stage to the right. The pair stepped up on a platform that formed the bottom
of a super-sized Coca-Cola bottle. Before they put their arms around each oth-
er's waists and posed for a photo, the dancer in the pair did a little bop to the
beat. Two Black men in khaki shorts accompanying the pair took out their cell
phones and snapped photos. The duo was posed with their outer arms on their
hips and their outer legs turned in at an angle. Behind them, to the left and
right sides of the Coca-Cola bottle in the photo booth backdrop, were two large
photographs of Black women holding Coca-Cola bottles.

In the photo on the left, one model held a classic Coke bottle and sipped
from a red-and- white striped straw. The woman in the other image rested the
tip of her glass Coca-Cola bottle on her forehead. Beside one image was a panel
that included a statement describing "The Girlfriend Collection," a series of
photographs featuring Black women exhibited in the Coca-Cola booth across
from the main stage. The photographs, according to the statement, "uplift and
celebrate the bonds of sisterhood." The statement also included background
information on Melissa Alexander and Delaney George, the Black women pho-
tographers who shot the images, and invited festivalgoers to post their per-
sonal photos from the Coca-Cola backdrop online using the brand's hashtag
#IfNotForMyGirls.[25]

Nearby, on the other side of the photo exhibition area, entertainment exec-
utive Kenny Burns, DJ D-Nice's partner and emcee in *The Nice & Burns Show*,
stood on the Coca-Cola stage and shouted, "I see the Deltas over there. I see the

Deltas." In the middle of the crowd dancing in front of the stage, a small circle had formed. "Oo-oop, Oo-oop," the women in the center of the circle sang. "Oo-oop" is the greeting call for sisters in Delta Sigma Theta (DST), the second oldest sorority among the Divine Nine, the major African American Greek letter organizations in the United States. As DJ D-Nice transitioned into rapper Webbie's song, "Independent," the DST sorors threw their arms in the air and flashed the DST hand sign—a triangle formed by bringing the thumbs and tips of their fingers together. As Webbie rapped, "I-n-d-e-p-e-n-d-e-n-t," the Deltas danced, flashing the DST hand sign.

As they grooved to the song, a loud "Skee Wee" emerged from outside the circle. "Skee-Wee" is the greeting call for Alpha Kappa Alpha, the first sorority in the National Pan-Hellenic Council, or Divine Nine. The AKAs and Deltas have a friendly rivalry that was on display as a group of AKAs moved into the circle. As Webbie rapped, "When you call her on her cellular, She tell you she don't need not a got d— thang," AKAs sashayed around the circle singing "Skee Wee" with their pinkie fingers held up to the sky. This is the group's signature hand sign that is trademarked with the United States Patent and Trademark Office.[26] The sorors transitioned into an AKA "stroll," where they turned to the right and left thrusting their upturned pinkies to each side. Turning back to the left, they placed their hands on top of each other, facing inward, to form an ivy leaf, the AKA's official symbol.

Strolls like this are a longstanding ritual in black Greek organizations. During strolls members of a Greek-letter organization form a line and move forward while doing choreographed moves to typically R&B or hip-hop/rap songs. Each organization in the Divine Nine has signature strolls. Some are specific to particular chapters, while others are common across the organizations as a whole. It is not unusual for sorors and frats to break out into strolls at Black social events.

As the AKAs ended their stroll and moved back into the group standing around the circle, they smiled and high-fived one another. Burns encouraged the sisterly bonding. "AKAs said they was in here too," he remarked. At that, the AKAs raised their pinkies and let out a resounding "Skee-Wee." DJ D-Nice played rapper Lil Wayne's 2004 hit "Go DJ," and Burns screamed, "Go DJ, go D-Nice, go DJ, go D-Nice." As rapper Mannie Fresh sang his first verse, the Deltas took over the circle again. As they moved forward, leaning left and right and flipping their hands into the triangle hand sign, they chanted "Oo-Oop." When DJ D-Nice started playing Atlanta rapper Unk's "Walk It Out," Burns gave a

shout out to more members of the Divine Nine: "All my Deltas, all my AKAs, all my Kappas, all my Ques. All my sororities, what's up."

Minutes later DJ D-Nice and Burns encouraged a different type of intra-group solidarity—place-based bonds. "I need to know where y'all from in here," Burns said to the crowd. "I need you to represent your city." Amidst the festivalgoers shouting out their city, a sole woman shouted out, "Toronto." "Oh Toronto," Burns repeated. "She's from Toronto." Moving over to the other side of the stage, Burns recognized other cities, "ATL in that thang. Philadelphia. Chicago. Where's Chicago at?" "Let's go to Chicago," Burns said while walking over to D-Nice's turntable. When their city was shouted out by Burns, several Chicagoans cheered and raised their hands. D-Nice began playing Chicago Rapper Chief Keef's 2012 song "I Don't Like." As the first verse of the song played, most audience members swayed lightly to the beat or stood without moving at all. The enthusiasm from a group of Chicagoans made up for this somewhat muted response, as they moved their arms up and down to the beat and rapped along to the lyrics.

In the middle of the song Burns pointed to an audience member: "Birthday girl. She said she was from Philly. Philadelphia in the building?" Burns queried the audience. A few Philadelphians cheered and waved their hands. "New York City in the building," Burns continued. An even louder cheer filled the area. Burns walked over to the DJ booth and said, "D-Nice, let's do it for that Philly-New York crew." Philadelphia rapper Meek Mill's voice blared from the speakers: "Ain't this what they've been waiting for? You ready?" As D-Nice spun Meek Mill's 2012 song "Dreams and Nightmares," Burns said, "Cut the light low, cut the lights low. Ya'll ready. Ya'll gotta sing it though. Everybody." The most enthusiastic response was from the Philadelphia contingent. Two women who waved both hands when Burns repped Philadelphia turned toward each other and rapped the lyrics word for word. When the beat picked up in the middle of the song, the audience got more excited with some people swaying side to side. The women rapping to each other picked up their movement. One moved her hands to mimic counting money and driving as she rapped along to the line, "That Lambo, my new b——, she don't ride like my ghost."

When "Dreams and Nightmares" faded out Burns asked the audience, "Washington, DC, Maryland, Virginia?" This shout out got the loudest response from the audience. "Let's do it," Burns said as DJ D-Nice began to play "Over Night Scenario." Hearing the beat to the old school classic by DC-based go-go band Rare Essence, festivalgoers from the DMV (DC, Maryland, Virginia)

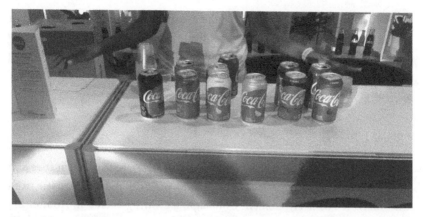

Figure 5.6 Drink samples served at the Coca-Cola stage in the convention center, Essence Festival, 2019.

immediately started singing along. Two men in hats who pumped their arms when the DMV was shouted out sang the lyrics out loud in full force.

As the crowd responded to DJ D-Nice's and Kenny Burns's regional tributes, they were immersed in a world of Coca-Cola. Flanking the screen to the left and right were huge portraits of two African American women giggling as they shared a Coke. Two tasting booths were set up next to each side of the stage. There, Coca-Cola staffers dressed in white slacks and white t-shirts emblazoned with the cherry-red Coca-Cola logo served drink samples. After festivalgoers chose their drink of choice—Coca-Cola Classic or a newer formulation such as Vanilla Coke, Cherry Coke, or Coke Zero—staffers poured a sample in a small plastic cup with the Coke logo. Behind the tasting booth, bottles of Coca Cola were arranged in a white display case. A giant photograph of a Black woman sipping a Coke was displayed next to the tasting area. The image was reminiscent of the full-page Coca-Cola advertisement in the main festival brochure. Appearing inside the front cover of the guide, the advertisement showed two Black women, one with long straight hair and the other with curly natural hair, sharing a Coke. These images were part of the company's "If Not For My Girls" campaign, designed to "showcas[e] the power of friendship and sisterhood," among Black women.[27]

As the Essence Festival's longest-running main sponsor, Coca-Cola has used the event to market to this consumer segment for 24 years. Helen Smith Price, Coca-Cola's vice president of global community affairs, described how

Ingrid Saunders Jones, at one time the company's senior vice president for community affairs, saw the potential of the festival as a marketing opportunity when she attended the first festival in 1994: "Our competitor was the marketing sponsor that first year . . . Jones . . . decided we should check it out for community engagement."[28]

"Black & Positively Golden"

In between a food kiosk serving classic McDonald's fare like french fries and Chicken McNuggets and a stand giving away promotional merchandise from the "Black & Positively Golden" campaign, a crowd gathered in front of the stage in the McDonald's booth. They were waiting for Jazmine Sullivan, a Grammy-nominated R&B star, to grace the stage. As they waited, Los Angeles-based DJ R-Tistic (aka Ronald Turner II) and entertainer Leslie Segar ("Big Lez") kept the crowd hyped. As R-Tistic spun rapper Lil' Kim's 1990s hit "Crush on You" featuring Lil' Cease, Segar, who is well known for her dancing and choreography with acts such as Michael Jackson, Mary J. Blige, Whitney Houston, and Salt-N-Pepa, said, "I was in this too," referring to the video, and broke into a dance move. When the soundtrack got to Lil' Kim's second verse, the audience sang along. Segar handed the mic to a woman in the audience wearing pink shorts, a black t-shirt, and sunglasses atop her long, braided hair. Holding the mic in her left hand and moving her right hand to the beat, she completed the verse rapping into the mic. As she rapped the last line, "But don't blush, just keep this on the hush," she held her fingers to her lips pantomiming keeping a secret. "You turned up today," DJ R-Tistic said to the audience member as she handed the mic back to Segar. "We Black and beautiful," Segar said to the crowd. "You know this," R-Tistic replied. Their exchange is right on brand.

As the audience watched Segar and DJ R-Tistic, they were staring at three large McDonald's logos that were part of the backdrop to the stage. The large screen behind the stage was composed of three panels. The largest middle panel showed the yellow Golden Arches logo. Underneath the panel, "Black & Positively Golden" was written in bold, capitalized yellow-and-black letters. Two narrow side panels showed a smaller version of the image. A large Golden Arches logo that alternated with an image of the "Black & Positively Golden" slogan flashed across the front of DJ R-Tistic's turntable. A wall-sized image of a young Black man wearing a yellow t-shirt and sunglasses hung

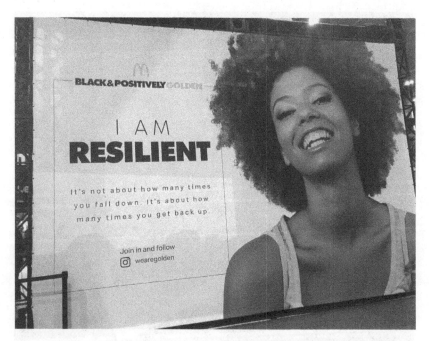

Figure 5.7 "Black & Positively Golden" sign outside of the McDonald's booth, Essence Festival, 2019.

stage right. "I Am Bold" was written next to his image below the "Black & Positively Golden" tagline.

To the right of the stage, a white, wall-sized mural showed two Black women, arm in arm. The mural included a Golden Arches logo, the "Black & Positively Golden" tagline, and an uplifting mantra: "I AM BRILLIANT. Brilliance means more than just smarts. It's how your light radiates upon others." Underneath the empowering mantra was an image of the Instagram logo along with the statement "Join in and follow wearegolden."

"You got that Method Man and Mary J cued up?" Segar asked DJ R-Tistic. "Hold up, hold up, hold up, hold up, hold up, let me see about that," he replied. "You know, we all been there, that's that thug love, right?" Segar asked the audience. "We've got to take it right there. I'm in there. Oh, I'm in there. I don't care," R-Tistic said. "Like sweet morning dew," R&B/hip-hop singer Mary J. Blige's voice blared from the speakers as R-Tistic spun her 1994 hit, "I'll Be There for You / You're All I Need to Get By" featuring rapper Method Man of the Wu-Tang Clan. "Who knows the words?" Segar asked as she danced across

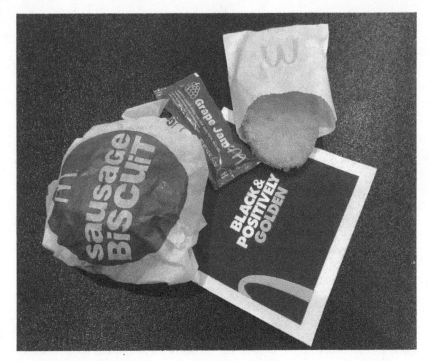

Figure 5.8 Free McDonald's breakfast handed out at the McDonald's stage, Essence Festival, 2019.

the stage. She handed the microphone to a Black man in the audience wearing jeans and a white t-shirt. He stood and rapped along to Method Man's verse, gesturing with his hands to the rhythm of the beat. Before sitting down, he did a one, two step dance move. "We just rockin' out, playing those old school hits that you all remember," DJ R-Tistic said as the song faded out.

As DJ R-Tistic spun more old school Mary J. Blige songs, Segar reminded audience members to sample the McDonald's fare at the booth. "It's being served— for free. We got you fries, nuggets," she said. The serving area, reminiscent of an outdoor food truck, was located along the back wall of the McDonald's stage. Festivalgoers lined up in a roped off area to the side of the booth to sample the food. The outer walls of the kiosk were decorated with images of classic McDonald's fare like french fries. Signs hanging in the serving window with the "Black & Positively Golden" tagline and the side profile of a Black face listed the current menu offerings.[29] Earlier that day sausage biscuits, hash browns, and grape jelly were served. Now, in the afternoon, staffers who wore white t-shirts stamped

with "Black & Positively Golden," passed out french fries, McNuggets, and Tangy BBQ Sauce to festivalgoers for free. Along with each meal, they handed out small square napkins. The napkins had a black background and white border. The bottom left depicted half of a golden arch and "BLACK & POSITIVELY GOLDEN" was written in bold letters across the middle.

Before Jazmine Sullivan came on stage, DJ Scratch, a Grammy-nominated disc jockey who debuted on the hip-hop scene in the 1980s with rap group EPMD, switched places with DJ R-Tistic. As Scratch set up, the screen behind the stage flashed a giant image of Big Lez and one of her recent social media posts inviting her followers to the McDonald's booth. It read:

> Hey y'all, if you're at Essence, make sure you come kick it with me at The Mc-Donald's Black & Positively Golden Experience! Performances, games, give-aways, we have it all. We're changing the narrative of what Black Excellence means and I want to see YOU there. Oh and don't forget to join in and follow wearegolden #BlackandPositivelyGolden.

As the screen changed to a series of Instagram images linked to the hashtag #BlackAndPositivelyGolden, Segar introduced Sullivan. Referencing Sullivan's 2008 breakup revenge anthem "Bust Your Windows," she said, "Fellas you better start being nice to these ladies before they smash your windows too. This woman has voice, she has stories. She writes her material. She is that chick. Ladies and gentlemen, Jazmine Sullivan."

"All the ladies and all the fellas put your hands in the air right now for Jazmine Sullivan, all right. Looking beautiful out here. Here we go," Scratch said as Segar walked off the stage. As the first chords to "Bust Your Windows" played, two backup singers wearing skin-tight black spaghetti-strap dresses walked out. Sullivan followed. Her dark brown hair was styled in a shoulder-skimming bob, and she was dressed in a flower-printed dress-like top with matching pants. "I bust the windows out ya," Sullivan sang. Instead of singing "car," the last word in the opening verse, Sullivan mimicked a driving move with her right hand. Audience members, who were singing along, completed the verse and crooned "car." When Sullivan got to the chorus, she sang, "I what," and then turned the mic to the audience to join in. As they sang, "I bust the windows out ya car," she moved her hands in a conductor-like fashion. Joining back in, Sullivan leaned into the audience and tapped her foot: "I'm glad I did it cause you had to learn," she sang. As the song ended with the sound of cracking glass, Sullivan shouted, "Ladies, help me sing." "I bust the windows out ya," she

sang and then turned the mic to the audience for them to complete the song. "Car," the audience sang in unison and then cheered. Looking around, Sullivan joked, "I see the men looking mad. Y'all mad? I see you. Stay mad, though."

Between songs Sullivan continued her banter with the crowd. "I heard it was a hot girl summer, whassup," she said referring to then-newcomer rapper Megan Thee Stallion's collaboration "Hot Girl Summer" with veteran rapper Nicki Minaj. During this interlude, Sullivan referenced the "Black & Positively Golden" campaign. "I want to thank McDonald's and Black and positively wonderful, everything, for having me here today," she said. "Do we have any Jazmine Sullivan fans?" she asked the audience as they let out a loud cheer and waved their arms. "So you guys should be able to help me sing this next song," she told the crowd. Sullivan continued her set with her 2008 hit "Lions, Tigers & Bears" and then performed other songs like "Let It Burn," "Forever Don't Last, and "Insecure."

As the instrumentals to "Need U Bad," the last song in her set, faded out, Sullivan placed her right hand on her heart and bowed to the crowd. She turned around to acknowledge her backup singers and then left the stage. The

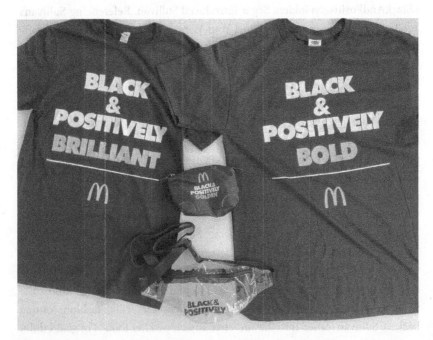

Figure 5.9 "Black & Positively Golden" promotional products handed out at the Mc-Donald's stage, Essence Festival, 2019.

crowd in the area behind the roped-off stage began to thin. Segar reminded festivalgoers that free food and t-shirts were still available. "We got food still, until 4:30. Food, french fries, and nuggets, until 4:30." "T-shirts . . . right now," she continued, pointing to the give-away station.

Following Segar's suggestion, some in the lingering crowd walked over to the giveaway station to the left of the stage. There, staffers passed out free McDonald's promotional products like black t-shirts with the "Black & Positively Golden" tagline. The variously designed t-shirts all had "Black & Positively" written in bold capital letters across the top and a small McDonald's logo at the bottom. Some had "Brilliant" written in bold, capital, yellow letters in the middle, while others featured terms like "Bold."

The giveaway station was the next destination for some in the Sullivan audience. Other stragglers from Sullivan's performance headed over to the food station or photo area before leaving the McDonald's booth. The photo area, located across from the food kiosk, was a huge makeshift studio. The backdrop was a large gray tarp that hung from floor to ceiling. The gray backdrop and floor were lit up with the phrase "I AM BOLD" in green neon light. A white exit sign with the "Black & Positively Golden" tagline directed festivalgoers out of the photo area.

Other festivalgoers lingering after Sullivan's performance stuck around as DJ B-Hen, "Hollywood's Champion of New Sound," started his set. Soon, a group was doing the Electric Slide, a line dance popular at Black social events, to Beyoncé's 2019 remake of Frankie Beverly and Maze's "Before I Let Go." Forming a line along the yellow carpet that was lit up every few minutes with the McDonald's logo and the word, "BOLD" in bright lights, the group stepped back in unison, dipped forward, and then turned left. As Beyoncé sang the song's hook, the group repeated the move, this time facing a set of white tables with festivalgoers eating Chicken McNuggets and fries. If the dancers happened to look up, they would see a white rectangular panel with the McDonald's logo and the "Black & Positively Golden" tagline. Four portraits of Black faces were suspended from smaller square panels nestled inside the rectangle jutting out from the ceiling.

McDonald's launched the "Black & Positively Golden" campaign" in 2019.[30] As Lizette Williams, the head of cultural engagement and experiences at McDonald's explains, the campaign is designed to cultivate Black customers:

> Prior to launching the Black & Positively Golden campaign, we spent time with
> our African-American customer base and heard from them on what's most

important. We are leveraging this platform to shine a brilliant, powerful light on Black culture and excellence in a way that matters most to our consumers. This is the largest African-American campaign we have launched in 16 years and it continues to demonstrate our longstanding commitment to this community.[31]

Music at the McDonald's Essence Fest booth is a useful tool for executing this campaign. Music helps drive festivalgoers to the McDonald's booth where they are inundated with brand messaging and given free food to sample. Music also contributes to the positive experiences that festivalgoers have with the brand as they dance and sing together to their favorite songs. At the same time that Black festivalgoers receive McDonald's brand messaging, they also co-create the company's racial branding. By singing and dancing with one another in the McDonald's booth and experiencing joy, Black festivalgoers bring to life the brand tagline that the company is "Black & Positively Golden."

Race, Music, and Marketing

There is nothing inherent in the Black music played at the Essence Festival that automatically makes it an effective marketing tool for Black festivalgoers. Instead, Black attendees are engaged by the music because they have a prior taste for it and have been exposed to the lyrics and typical dances performed to it before attending the festival. Thus, the music speaks to them as, specifically, Black music consumers. How people respond to music depends on what they bring to it.[32] In this case, many festivalgoers come to the corporate booths with an existing preference for the Black music as well as familiarity with the words of compositions and the commonly associated choreography.[33]

Once music attracts Black festivalgoers to corporate booths, they are exposed to racialized brand messages. At the same time, festivalgoers also co-produce the racial images of companies. By singing and dancing together in these branded spaces and experiencing joy, Black festivalgoers bring to life corporate messaging that certain sponsors, such as McDonald's, celebrate the African American community. In the next chapter, we'll learn more about how McDonald's brands itself as "Black & Positively Golden" by looking into the company's sponsorship of a major gospel festival.

6 Gospel and the Golden Arches

IT'S LATE MORNING ON JULY 28, 2019. Like most Sundays, Bishop Joel R. Peebles, Sr. is giving a sermon to the congregants of City of Praise Family Ministries, a Black church located outside of Washington, DC. As Bishop Peebles preaches about "defeating destructive impulses," he invites congregants up to the altar: "I am going to be free this day, in the name Lord Jesus, right now. When I count to three whatever that is, bring it to the Lord. One, two, three . . ." Congregants rise from their seats and walk to the altar at the front of the church. As they kneel, Bishop Peebles reaches down, places his hands on their heads, and prays.

Less than 24 hours before, Bishop Peebles was giving another prayer in this sanctuary. But, at that time, the people sitting in the pews were not present for a church service. Instead, they were attending a concert—the 13th Annual Inspiration Celebration Gospel Tour sponsored by fast food giant McDonald's. That year, along with the DC metro area (the DMV), the concert traveled to other communities including Atlanta, Chicago, Houston, Jackson (Mississippi), Tallahassee, and Orlando.

Although there is increasing scientific evidence that fast food compromises physical health, it remains popular among diners. On any given day, over one-third of adults in the United States consume fast food. Fast food consumption is especially common among African Americans with over 40 percent eating this fare on any given day.[1] Why does fast food remain a common dining choice among African Americans despite the evidence that it is unhealthy? One factor that public health scientists and other scholars pinpoint is targeted marketing.[2]

In their view, targeted marketing efforts, such as placing fast food advertisements in the Black media, is partly to blame for the popularity of fast food among Black diners.

Yet, one aspect of targeted marketing that has been largely overlooked is Black cultural sponsorships, or fast food companies providing financial support to Black cultural initiatives, such as Black music events. Through the lens of McDonald's Inspiration Celebration Gospel Tour, this chapter offers insight into how fast food is marketed to Black diners. This music event stands within a long history of gospel sponsorships such as the Kentucky Fried Chicken Gospel Music Competition and Burger King's support of the Super Bowl Gospel Celebration.[3]

Gospel, a genre of music grounded in the American Protestant tradition,[4] is especially popular among African Americans.[5] For example, in 2015 over 9 out of 10 African Americans had listened to gospel music in the past year.[6] As the popularity of gospel music among African Americans might suggest, African Americans also have relatively high levels of religiosity. For example, a higher proportion of African Americans in comparison to white Americans say that they believe in God with absolute certainty (83 percent versus 61 percent), agree that religion is very important in their lives (75 percent versus 49 percent), pray daily (73 percent versus 52 percent), and attend religious services at least once a week (47 percent versus 34 percent).[7] The high level of consumption of gospel music among African Americans, and the relatively high levels of religiosity in the group, mean that if a company wants to attract Black consumers, sponsoring a gospel festival is a good place to start.

As a genre of music that has largely been the province of Black artists, gospel music is an important component of Black cultural life in the United States. The Inspiration Celebration Gospel Tour is a form of "marketing blackness"[8] whereby gospel music and other Blackness representations are used to convey to Black consumers an image of McDonald's that is both Black and sacred. Drawing on participant observation at two legs of the Inspiration Celebration Gospel Tour—the DMV and Tallahassee, Florida—along with PR texts, such as press releases and online postings, this chapter outlines the mechanisms through which gospel music sponsorships are used as a marketing tool to draw in Black consumers.[9] More specifically, it elaborates the various processes through which brands are promoted to Black concertgoers, and the Black community more broadly, as sacred and caring about Black people.

The branding of McDonald's as Black and sacred takes place via the promotion of the concert series in owned media. Through the use of *diversity framing*

in press releases and other owned media about the concerts, McDonald's is presented as a company with a deep commitment to the Black community.[10] Similarly, via *gospel framing* in owned media about the concerts, McDonald's is given the appearance of a company with a strong connection to Christianity.[11] At the concerts themselves, promotional texts, rituals, and commentary also reinforce the image of the company as connected to Christianity and valuing Black people. As festivalgoers actively participate in rituals such as call and response, prayer, and the "offering," they are co-creators of these brand meanings. With their help, McDonald's projects an identity that stands in stark opposition to its critics who paint the company as offloading junk food to vulnerable Black consumers.[12] These processes can be best understood when viewed within McDonald's broader ties to African Americans and strategies to "give back" to the community.

McDonald's Gives Back

McDonald's origins date back to the mid-20th century when two brothers, Dick and Mac McDonald, opened drive-in restaurants in California. The McDonald's restaurants were distinguished by their "Speedee Service System" where competitively priced hamburgers were rapidly delivered to customers. In 1961 Ray Kroc, who had become a franchise agent for the McDonald's brothers, purchased their company McDonald's System, Inc. This company later became the McDonald's Corporation.[13]

The business model for McDonald's is franchising: Individuals or groups pay a fee to open a restaurant. Through the 1950s, there were no Black-owned McDonald's restaurants. However, this changed in the midst of urban unrest that swept across the United States in the next decade.[14] The uprisings were sparked by the assassination of Martin Luther King, Jr. and broader frustration with the oppressive racial order under which African Americans were treated as second-class citizens. During the uprisings, property, including some McDonald's restaurants, was vandalized and damaged. Partly as a strategy to protect McDonald's restaurants, African Americans were given the chance to purchase franchises in the inner city. The thinking was that Black-owned eateries would be less likely targets of urban residents during bouts of social unrest. It was also presumed that Black customers would be more inclined to dine at Black-owned, rather than white-owned, restaurants.[15]

Government officials also believed that Black business ownership in the inner city would help to curb urban unrest. To encourage entrepreneurship in

urban areas, the federal government guaranteed loans to small businesses via the Commerce Department and Small Business Administration (SBA). Many of the loans went to Black entrepreneurs seeking to buy into fast food franchises like McDonald's.[16] With these developments, the racial makeup of McDonald's owner–operators shifted.

In 1968 Herman Petty became the first Black McDonald's franchisee when he opened a restaurant in the heart of Chicago.[17] By the end of the next year, there were 12 Black-owned McDonald's franchises.[18] In the early 1970s, Black owner-operators formed a professional group, the National Black McDonald's Operators Association (NBMOA), to address the specific challenges that they faced.

One concern of NBMOA members was advertising. Like all owner-operators, Black franchisees contributed to a collective fund for national advertising. However, the ads paid for by this fund targeted the "general" or white market. Ads featured white models and messaging that was designed to appeal to this consumer segment. Generally located in Black urban neighborhoods with a Black consumer base, NBMOA members recognized that the ads that they were helping to subsidize would have limited success at building business at their franchises. Their advertising needs were addressed when Tom Burrell, a pioneer in advertising to Black consumers, was invited to a NBMOA convention.[19] At the convention, Burrell provided an overview of his innovative approach to marketing. In his view Black consumers required separate marketing appeals that presented African Americans in an authentic yet affirming fashion. He coined this approach "positive realism." Burrell reasoned, "If we could just show black life, portray it in a positive, realistic way . . . people will come to the product." [20] This pioneering approach was a stark contrast to the longstanding stereotypical depictions of African Americans in advertising.[21]

Along with lobbying the company to respond to their specific needs, such as developing national advertising that would appeal to their largely Black customer base, the NBMOA developed philanthropic programs aimed at inner-city communities. "Giving back" to communities was part of the McDonald's business ethos. As Kroc explains in his autobiography, "We've always encouraged our franchisees to become involved in community activities and to make donations to worthwhile charities."[22] One of the company's biggest areas of giving is to the Ronald McDonald House Charities (RMHC), a nonprofit that supports families with critically ill children. Although RMHC and McDonald's are independent entities, McDonald's is RMHC's biggest corporate sponsor, and RMHC and McDonald's share the same clown mascot Ronald McDonald.[23]

One area of giving that NBMOA members are involved with is the sponsorship of gospel concerts. Gospelfest (an event that includes competitions between local gospel choirs) and the Inspiration Celebration Gospel Tour (a traveling gospel concert featuring national gospel stars) are both initiatives supported by local NBMOA chapters. These initiatives are part of broader efforts by corporations to use gospel sponsorships to market to Black consumers.

Gospel Marketing

For decades, Black consumers have been targeted through gospel music. For example, in the 1980s, fast food chain Kentucky Fried Chicken (KFC) sponsored the National Gospel Festival and used ads in *Essence*, a magazine directed at Black women, to promote their support.[24] At the 1983 Kentucky Fried Chicken Gospel Music Competition in Washington, DC, concertgoers were given free fans stamped with the message "Kentucky Fried Chicken Salutes Gospel Music." "We felt that gospel music was a good way to get back in touch with black families, which is an important market segment for us," a PR director for KFC explained about the sponsorship.[25] Kraft—the manufacturer and processor of food products such as Ritz crackers, Oreo cookies, Velveeta cheese, and Oscar Mayer cold cuts—has also used gospel marketing to cultivate Black consumers. In the early 2000s, the company sponsored "The New Voices of Gospel Talent Search." Entrants for the contest could win a $25,000 grand prize, an appearance at the Essence Music Festival, and an audition for Sony Music.[26]

In 2007, Chrysler, a major automobile manufacturer, was also involved in gospel marketing when they sponsored R&B singer Patti LaBelle's 12-city concert tour: "The Gospel According to Patti." Concerts during the tour—which traveled to cities such as Philadelphia, Houston, Chicago, Dallas, and Atlanta—took place at Black mega churches like The Potter's House and New Birth Missionary Baptist Church. The sponsorship helped to promote the then-new 2007 Chrysler Aspen by hosting ride-and-drives at pre-concert events.[27] Explaining the sponsorship, a Chrysler brand manager commented, "If we are going to target the African-American consumer, we have to go where they go, rather than ask them to come to us, and the church is a major institution for that community."[28]

An annual gospel marketing event is the Super Bowl Gospel Celebration (SBGC), which coincides with the NFL's Super Bowl weekend. The event, which

has taken place since 1999, has featured gospel hitmakers such as BeBe & CeCe Winans, Fred Hammond, Mary Mary, and Marvin Sapp. In 2005 McDonald's ran an ad in *Ebony* magazine identifying the company as a "proud sponsor" of the SBGC. The ad features a drawing of a smartly dressed Black woman walking down a city street holding a McDonald's takeout bag.[29] McDonald's sponsorship of the Inspiration Celebration Gospel Tour also vividly illustrates how companies use gospel music to target Black consumers.

The Inspiration Celebration Gospel Tour

The Inspiration Celebration Gospel Tour, which began in 2007, travels across the United States and brings together gospel music stars. Over the years, musicians such as Fred Hammond, Kierra "Kiki" Sheard, Erica Campbell, and Jonathan Slocumb have performed. Gospel framing in owned media about the tour associates the brand with Christianity. For example, press releases use the term "love offering" to refer to donations made to the RMHC at the concert.[30] One press release explains, "As a part of each show, concertgoers will learn more about Ronald McDonald House Charities. . . . Attendees will also have an opportunity to participate in a love offering to support families served by the Charity, including those in their community."[31] By using the language of "offering," a term typically used to describe parishioners' financial gifts to the church, press releases deepen the association of the brand with Christianity.

Commentary about the tour in owned media not only furthers the association of McDonald's with Christianity, but also with Blackness. This is accomplished via diversity framing. One form of racial framing characteristic of press releases is contextualizing the Inspiration Celebration Gospel Tour as part of McDonald's more general celebration of Blackness. For example, press releases about the tour invite customers to visit 365Black.com.[32] "365 Black," a reference to celebrating Blackness 365 days a year, was a theme of McDonald's outreach to Black consumers from 2003 to 2018.[33] 365Black.com, McDonald's website directed toward the African American market, featured corporate social responsibility (CSR) efforts in the Black community.[34]

PR for the 2019 tour frames McDonald's as a company connected to Blackness by tying it to their new African American marketing campaign—"Black & Positively Golden." For example, one press release notes that "McDonald's Inspiration Celebration Gospel Tour is an extension of the brand's Black & Positively Golden campaign, an initiative designed to uplift communities and

inspire excellence."[35] Another press release about the tour ends by inviting readers to "Follow @WeAreGolden on Instagram for tour updates and join the conversation using #blackandpositivelygolden."[36]

While PR texts about the Inspiration Celebration Gospel Tour brand McDonald's as Black and sacred, developments that unfold at the concerts themselves also reinforce the company's image as caring about Black people and as connected to Christianity. The actions, interactions, and discourse of presenters and audience members at the events bring to life these aspects of the brand.

The Concert

It's July 27, 2019, at 8:30 in the morning at City of Praise Family Ministries. Typical of a July morning in the DMV, the weather is already hot and humid. Except for a few security guards driving around, some groundskeepers, and a group of churchgoers who have risen early to participate in a weekly Zumba class led by one of the parishioners, the City of Praise Family Ministries campus is quiet. The church is located on a large plot of land with several contemporary-style buildings that stand in the midst of large swaths of green grass and trees. The main church building is composed of white concrete. One panel of the building is emblazoned with the City of Praise Family Ministries logo—an orange heart with the outline of a family holding hands. Underneath the logo are the names of the lead pastors: Bishop Joel R. Peebles, Sr. and Pastor Ylawnda B. Peebles. "Jesus is the Lord' is written in large blue text on another part of the building. Throughout the campus there are a series of medium-sized fabric signs that blow in the wind. Each sign is embedded in the ground on a thin black stick. The fabric portion of each sign is orange and blue and reads "City of Praise Family Ministries."

Later that day at 5:30 p.m., signs announcing the Inspiration Celebration Gospel Tour dot the landscape surrounding the main chapel. One white sandwich board features the image of a Black girl with her hair styled in short twists. Another shows the image of a Black boy wearing a black blazer and tie. "Black & Positively Golden" is written at the top of the signs in white-and-yellow type. Both signs also feature an image of the Golden Arches logo jutting out from the bottom left-hand corner, as well as a series of yellow arrows pointing concertgoers to the church entrance where they can pick up tickets.

At the entrance to the main chapel, the logo for Dr. Pepper, a co-sponsor of the event, is prominently placed across several large coolers filled with ice and

Figure 6.1 "Black & Positively Golden" concert sign outside of City of Praise Family Ministries, Inspiration Celebration Gospel Tour, Landover, Maryland, 2019.

soft drinks. Staffers wearing red shirts with McDonald's Golden Arches logo on the sleeves hand out free cans of the soft drink to concertgoers.

As concertgoers wait in the lobby for the worship hall to open, Ronald McDonald, McDonald's clown mascot, suddenly appears. He smiles and stands with his arms spread widely and his left foot slightly forward. With his bright-red wig, jumbo-size shoes, and white makeup, Ronald McDonald is immediately recognized by the crowd. He is greeted warmly by children and adults alike. As he makes his way through the crowd, festivalgoers pull him aside to take selfies. Posing with one girl who wears maroon-and-white tennis shoes, blue jeans, and a pink baseball cap, Ronald McDonald leans forward, crouches down, and places his arm around her neck.

When ticketholders make their way into the sanctuary from the waiting area, staffers hand them a small package covered in clear plastic. Inside the package is a black rubber wristband that reads, "Black & Positively Golden" in yellow-and-white block lettering. The "Black & Positively Golden" tagline is also placed prominently on brightly lit digital screens at the front of the sanctuary.

At around 7 p.m., DJ Standout, the host of the "pre-show party," walks onto the stage wearing tennis shoes, blue jeans, a gray hoodie, and a baseball cap turned to the back. "Are y'all ready to have a good time tonight?" DJ Standout asks the audience. "Yeah!" they scream in response. As gospel singer Kirk Franklin's recent hit "Love Theory" plays in the background, the audience stands and claps along to the song.

"Okay DMV, I need you to put your hands together and welcome to the stage Ronald McDonald!" DJ Standout says. The audience applauds enthusiastically. "The gift, it looks good on you," Ronald McDonald sings as he walks onto the stage with a bouncing gait. The lyrics are from the song "The Gift" by Donald Lawrence who will perform later that evening.

"You guys look glorious on the outside, you guys feeling glorious on the inside too?" Ronald McDonald asks the audience. "Selfie time. Are you guys ready? Everybody's going to say 'Glory' on three. Here we go." Ronald McDonald turns to face the back of the stage and holds up his camera to take a selfie

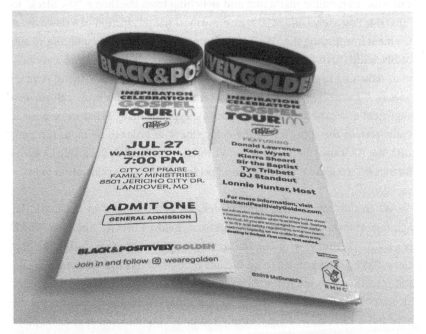

Figure 6.2 "Black & Positively Golden" wristband given to concertgoers as they enter the sanctuary, Inspiration Celebration Gospel Tour, Landover, Maryland, 2019.

with the audience. He counts down "One, two, three," and the audience finishes with "Glory" as he takes a photo.

After Ronald McDonald leaves the stage, DJ Standout reminds audience members that the concert series is part of McDonald's "Black & Positively Golden" campaign. "So, some of y'all don't know. . . . McDonald's has a campaign called the 'Black & Positively Golden' campaign. Can we make some noise for McDonald's for making a difference in our neighborhoods? Do we have any Black & Positively Golden people here tonight?" The audience cheers. "So, we got a theme song, and the way it goes is, 'Black and so excellent, Black and so excellent,'" DJ Standout begins to sing, gesturing with his hand for the audience to join in. As the catchy beat continues, Moses Houghton, the Black R&B singer who is featured on the "We Golden" track, sings over the loudspeaker, "Melanated we shine, So excellent and divine, yea we golden, golden, golden."

"We Golden" was commissioned by McDonald's in 2019 as part of what *Ad Age* reported as the "biggest overhaul" of "McDonald's African-American Marketing" in over a decade.[37] The effort involved a remake of the company's African American online marketing and switching from the theme "365 Black" to "Black & Positively Golden."[38] It also involved the production of a new advertisement introducing the "We Golden" song. The ad, featuring uplifting scenes of Black life (such as a child walking with a parent after school and a serviceman returning to his family), debuted during the 50th NAACP Image Awards telecast.[39] Describing the campaign, Lizette Williams, who leads cultural engagement and experiences at McDonald's, explains that, "What we've done is really refresh the approach to the engagement in order to be more resonant with the African-American consumer today. . . . [Black & Positively Golden] focuses on stories of truth, power and pride and really is a celebration of black excellence."[40]

When the "We Golden" track fades out at the concert in the DMV, DJ Standout transitions to Beyoncé's remake of "Before I Let Go." The song, which is a hit that summer, is among the secular songs that he plays during the pre-show party. Other secular songs include old school hits like Chaka Khan and Rufus's "Ain't Nobody," Montell Jordan's "This Is How We Do It," and Sister Sledge's "We Are Family." "There's so many Black & Positively Golden people here today . . . can we have a family reunion?" DJ Standout says as he plays "We Are Family." After this set of secular songs, DJ Standout puts on a series of gospel tracks including the 1997 hit "Stomp" featuring Kirk Franklin and the rap duo Salt-N-Pepa.

When DJ Standout completes his pre-concert set, a countdown video plays on the two large screens to the left and right of the stage. The video shows a living room where a white man dressed in a t-shirt and jeans is dancing. As a disco beat plays in the background, he does a series of silly dance moves that reference Bible stories such as the Forbidden Fruit, the Lament, Jacob's Hip, the Abraham and Isaac, and the Pentecost. As he grooves, a digital timer overlaid across the screen counts down the minutes to the show. When this countdown ends, the main concert begins.

"What's up DMV," DJ Standout says to start the main show. The crowd cheers. "Are you guys ready?" DJ Standout yells again, "Washington DC, y'all can do better. Are you ready?" This time the crowd screams even louder. Music starts playing, and Standout says, "I want to welcome y'all. It's the 13th Annual McDonald's Inspiration Celebration Gospel Tour. Please put your hands together and welcome Donald Lawrence."

After short performances by Lawrence and other acts to warm up the crowd, DJ Standout introduces musician, radio host, and pastor Dr. Lonnie Hunter, the emcee for the evening. "How is everybody tonight?" Hunter says as he walks onto the stage, wearing a navy blue suit. "Anybody blessed and highly favored in the room?" Responding to this common greeting among some Black Christians, the audience cheers and waves their hands. "Oh man, I'm not talking to no church people up in here. Anybody blessed and highly favored in this room?" Hunter asks again with more emphasis. The crowd cheers even more enthusiastically. Hunter responds by sharing a Bible verse, Nehemiah 8:10. "That's what I'm talking about. 'The joy of the Lord is my strength.'"

Soon, Hunter's banter with the audience switches focus to McDonald's ties to the Black community. "I am so excited about what McDonald's is doing in the community. Let me tell you something. Listen to me real close. Listen to me real close," Hunter lowers his voice a bit. "They started a movement called, 'Black & Positively Golden.'" As Hunter says the last few lines, he moves his right hand for emphasis. "This movement is so epic that instead of just coming into a city and then leaving the city, they've been spending whole weekends in that city making a change and making things better for the African American community." The audience applauds. "So this movement has been a great, great chance, for us as a people, to show how we are doing great things in the community. I don't know about you, but I watch a lot of news and it's very seldom that you see us painted in a light that is anything other than negative." "That's right," some audience members respond.

Hunter continues:

> I am just crazy enough to believe that I am not the only brother out here doing
> something positive. I am just not the only one. . . . [I]f there's anybody else in
> this audience right now that is doing something positive, either in your family,
> in your church, in your community, at your job, you know you are changing
> the atmosphere when you walk into the room because of who you serve, come
> on and put your hands together and let's show the people right now that we are
> Black & Positively Golden. Lift up a praise in this place.

Hunter's voice crescendos as he says the last part of this statement. The audi-
ence erupts in applause, cheers, and an occasional whistle. "That's what I'm
talking about," Hunter says. "So tonight, you all are going to be my cohosts.
Every time I say, 'Black and,' you're going to finish it with, 'Positively Golden,'"
Hunter instructs the audience. After teaching concertgoers the marketing slo-
gan, Hunter seamlessly returns focus to praising the Lord.

"Now I see some of y'all looking down and looking depressed. . . . I don't
know what the situation is, but let me tell you something. When praises go up
in the midst of what you're going through right now, you can be guaranteed
that that situation that's got you feeling depressed has got to be shaken up by
the root. You don't understand what kind of power you are sitting up under
right now," Hunter preaches. As he talks, he shakes his right hand and points

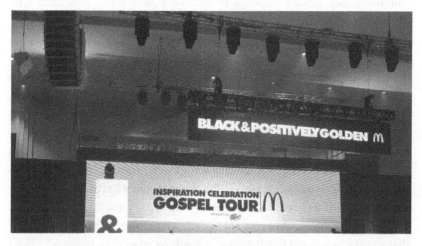

Figure 6.3 Inside of the sanctuary, Inspiration Celebration Gospel Tour, Landover,
Maryland, 2019.

his index finger for emphasis. He continues: "If you open up your mouth and use the power of life and death that lay in your tongue at your disposal, you can turn this frown upside down. Give God a praise," Hunter says as he jumps up for emphasis. The crowd cheers even louder, and people wave their hands in the air. Hunter smoothly transitions back to the catchy Black marketing tagline. "We are Black and," he pauses and then turns the mic toward the audience. "Positively Golden," the audience shouts in unison. "That sounds good for real," Hunter responds.

Hunter then asks the audience to take out their cell phones and follow @wearegolden, the official Instagram account for the "Black & Positively Golden" campaign:

> So what I want you to do is to take out your android, take out your iPhone, and go to Instagram right now. And follow us @wearegolden. Now let me tell you why that's so important. When we get ready to do this next year McDonald's is going to look at the engagement of each city. . . . Every city has got to follow us, so that when McDonald's looks at it, they'll say we need to go back to the DMV because they know what to do with what we're trying to give them in way of community economic funds and all of that kind of stuff. So follow us @ wearegolden. Everything you see tonight, use the hashtag #BlackAndPositive-lyGolden.

The night soon takes another highly religious turn when Hunter invites Bishop and Pastor Peebles to the stage to talk about their work in the community. "This Black & Positively Golden movement is shining a light on everything positive in the community. . . . I want you to just take a couple of minutes and tell us what that means when you say . . . shining the light on everything positive in the community," Hunter says to the Peebles. The pastors take a few minutes to describe their church's education programs and other community outreach efforts. Bishop Peebles ends with a prayer and reminds concertgoers that the evening is not just a musical event. It is also an occasion when God will deliver his followers from their troubles. "Come on everybody, put your hands up," Bishop Peebles instructs the crowd. "I believe that the Bible says that holy men should lift up holy hands everywhere, and I believe there's a grace that's going to fall on this place. I believe there's a spirit of authenticity that God is going to bring—not just enjoy good music and good concert, but I believe that God is a God of deliverance." "Amen," the audience responds. Bishop Peebles continues: "And so I speak a spirit of healing upon this church, upon

your life. . . . You will not walk out of here broken the way you came in. . . . If you really love the Lord go ahead and give God your biggest praise. God bless you." As Bishop Peebles ends his prayer, the audience cheers loudly and stands.

After the Peebles leave the stage, Hunter welcomes Harry Thomas, Jr., a vice president at McDonald's. Thomas who is African American, opens by sharing that he is responsible for 1,300 restaurants and that he is also a pastor. Thomas takes this moment to provide an overview of McDonald's corporate social responsibility (CSR) initiatives and to praise God. "We're here this afternoon, first of all, recognizing our Lord and our savior Jesus Christ," he pronounces. After talking about McDonald's good works, such as offering "tuition assistance to our employees" and awarding scholarships to HBCU students, he returns to uplifting God. "Now that I've gotten all of the preliminaries out of the way, I want all sanctified believers in this house, that know God is able, to stand on your feet and give God a hand clap of praise." The audience stands and claps. "If you know that God will do all things but fail. If you know he woke you up this morning and started you on your way. If you believe that God has all power, to do all things but fail, I dare you to give God a handclap of praise in the building. Come on somebody. Tell God he will and he can." "God bless you and enjoy the night," Thomas concludes, as he walks off the stage.

After Thomas's prayer, the "We Golden" commercial plays on the screens at the front of the stage. As the commercial ends, Hunter walks back onto the stage and says, "We are Black & Positively . . ." "Golden" the audience says in unison. "Listen, empowerment is one of the fundamental pillars of the Black & Positively Golden movement," Hunter says as he introduces Sir the Baptist, the next performer. "And, when I think of empowerment, I think of this brother. . . . He is our Black & Positively Golden Artist of Empowerment. Put your hands together for Sir the Baptist."

After Sir the Baptist plays his set, followed by a performance from Kierra Sheard, Hunter returns to the stage to take a selfie with the audience. "If you having a good time being Black & Positively Golden tonight, make some noise," Hunter says. The audience cheers. "If you follow me on Instagram, you know that every city I go to, I show that city's love for McDonald's and the Black & Positively Golden campaign," Hunter shares. He explains how at each tour stop he takes a selfie video from the stage with the audience and then posts the clip on social media. To take the group selfie this evening, Hunter stands with his back to the audience and holds his camera in the air with his right hand. "Y'all ready? This is what it sounds like to be Black & Positively Golden in the DMV,"

Hunter shouts. As the audience cheers and waves, Hunter moves the phone around in a half circle and then slowly walks backward across the stage to film the entire audience.

When he is done shooting the short video, Hunter reminds concertgoers that after he posts it on his personal Instagram page they should share it with their followers. Hunter then introduces the next act: singer, songwriter, and producer Donald Lawrence.

> Y'all want some more music. This is what I want to do. I want to go and get this brother that's in charge of all of the music that you hear tonight. He is the musical director for the tour. He is Black & Positively Golden. He is a producer. He's a writer. He is an arranger. He is a singer. . . . He is our Black & Positively Golden Artist of Education. Put your hands together for Donald Lawrence.

After Lawrence's set, Hunter returns to the stage. Soon, audience members will be invited to give a donation to the local RMHC. The entire process is steeped in Christian rituals common in Black churches. Hunter and other presenters emphasize that a gift to the RMHC is an alms that will give glory to God and allow concertgoers to be blessed in return. At the same time, they invoke the secular principle of exchange value to encourage giving—the concert is "free" so a donation to the RMHC is an avenue for concertgoers to indirectly pay for it.

"This is the portion of the show family, that is so vital, and so important, and we wait on this portion every show because you get a chance to see more of what this whole thing is about," Hunter says as he transitions to this segment of the event. "We come in here for free, we praise and we worship. There's somebody who's counting on you to do a great work in the kingdom for their forward motion. Can I get a witness?" Some audience members shout "Amen."

Later, a Black McDonald's owner–operator (and also an at-large member of the RMHC) makes a pitch that invokes secular and sacred beliefs. On one hand, he encourages audience members to give because they did not pay any money to attend the concert. On the other hand, he encourages audience members to give as a means to enact Christian, Bible-based principles: "I stand here in front of you asking you to please donate to the Ronald McDonald House," he says. "All of us got in here for free. Is that right? Did anyone pay? Everyone's been having a good time? So now, I think what the Lord would want us to do—if we go to Luke 12:48, 'To whom much is given, much is required.' Right? So, we are asking each one of you to please dig deep. Give to the Ronald McDonald house."

After his short speech, a video featuring Sir the Baptist visiting the RMHC plays on the screens by the stage. When the video ends, Hunter returns to the stage. Hunter not only uses the term "offering" to describe this segment of the evening, but the process surrounding the giving is akin to the offering period at many Black churches: Leadership says a prayer and reminds those in the pews that giving is a Christian act; following, upbeat music plays while some walk to the front of the church to leave their money and ushers "pass the plate" to those who stay in the pews.

The giving ritual this evening starts with Hunter reemphasizing that a gift to the RMHC is a Christian act:

> We have been blessed as a people to be a blessing to God's people. I could give you great speeches. I could give you great things that you always hear during offering time. But the truth of the matter is, you are going to give what you're going to give. But let me tell you where the key of that is. Where you give, is where you get. Somebody missed it.

In call and response style, an audience member softly says, "Say it again." "Where you give, is where you get," Hunter repeats and then continues his appeal. "If you sitting on a blessing, and you don't give the blessing that God has already given you to give, you don't get anything in return for that. The Bible says that 'God loves a cheerful giver.'" As Hunter recites 2 Corinthians 9:7, some audience members say the verse with him. Hunter continues: "I need you to understand how you're really going to be blessed and take it to another level, another dimension." As Hunter encourages the audience "to take up a great offering," the large screens to the left and right of the stage flash information about how to give money by debit, credit card, and check.

Before any money exchanges hands, Hunter says a prayer:

> God, we thank you tonight for what you're about to do in this place. We thank you for allowing us to be blessed so that we can be a blessing. Now as we open our hands and we open our hearts, and we open our minds to give, we ask that you . . . allow us to experience great blessings, not only for us, but for what this is intended to do. In the name of Jesus we pray amen, amen.

As Hunter concludes, the audience repeats "Amen" in unison.

As music plays in the sanctuary, ushers pass red plastic buckets where audience members place their "offerings."[41] Concertgoers sitting in the balcony

form a procession and walk to the front of the sanctuary to give their money. After the "offering" ends, Hunter returns to the stage to introduce two Black McDonald's representatives along with a representative for the Thurgood Marshall College Fund, an initiative that supports HBCUs and other predominately Black institutions of higher learning. As she begins her presentation, one of the representatives opens with, "Praise the Lord, everyone." Then she talks about how the scholarship program supports HBCUs, which are, in her words, "Black & Positively Golden" institutions. She uses the marketing slogan again when two of the scholarship winners are invited to the stage.

"It is with extreme pleasure to present two $10,000 Black & Positively Golden scholarships to Alabama A&M University. Please give them a round of applause . . . Black & Golden. Black & Positively Golden," she says. The audience stands up and cheers as super-size checks are handed to the scholarship recipients. Everyone on stage crowds together in the middle where they hold the checks and pose for photos. The large screen behind them lists the name of each scholarship winner encased in a box with the "Black & Positively Golden" tagline.

After the scholarship recipients leave the stage, a short commercial for Dr. Pepper plays on the screens. Once the commercial ends, Hunter walks back on stage. He encourages concertgoers to post their photos from the event online. "I've been seeing a lot of people take a lot of pictures tonight. Do me a favor and use the hashtag so that all those pictures go to the same place—#BlackAndPositivelyGolden."

Keke Wyatt is the penultimate act of the evening. After Wyatt ends her set, which includes a rendition of the secular R&B hit "If Only You Knew," Hunter returns to the stage. He imitates Wyatt's celebrated high notes for comic relief and then reminds audience members that they can still donate to the RMHC. "Just in case you had a bladder control problem during the offering and you missed it, we're going to give you another chance to give," he jokes. A prerecorded segment of Sir the Baptist making an appeal to donate to the RMHC then plays on the screens above the stage.

After the on-screen appeal ends, Hunter introduces the final performer. "Well, the last artist is ready to go. Ya'll ready to do this thing? Grammy Award winner, Stellar Award winner, Dove Award winner, everything there is to win . . . He is our Black & Positively Golden Artist of Empowerment. Put your hands together for Tye Tribbett."

Branding Race and Religion

Hunter returns to close the show after Tribbett's performance. Underneath the glowing "Black & Positively Golden" banner that hangs above the stage, he says a brief prayer: "God, we thank you for what you've done in this place. Lord God, as we leave from this building, we ask that you place a hedge of angels around us. . . . Let us find our destinations better than we left them, and in the name of Jesus, we know we are already blessed. Amen." "Amen," the audience responds together.

Like so much else that unfolds over the evening, this moment helps to brand McDonald's as African American and sacred. The prayer links the company to Christianity, and the "Black & Positively Golden" signage associates the brand with Blackness. As promised, by the end of the night, Hunter has posted his on-stage video selfie on Instagram where the Black branding for the corporation continues. In the video, as Hunter shouts out, "This is what it sounds like to be Black & Positively Golden in the DMV," the camera pans across the sanctuary showing the almost all-Black audience screaming and waving their hands enthusiastically. Along with the post, Hunter wrote: "THE DMV IS LIT!!!!! @wearegolden McDonald's putting the spotlight on everything positive in the community and across the nation #EDUCATION #EMPOWERMENT #ENTREPRENEURSHIP."[42]

Social media is a key tool used to leverage the diversity image-making capacities of Black cultural patronage by corporations. Through the lens of Afropunk, a Black music event in Brooklyn, New York, the next chapter explores how festivalgoers' social media posts promote the image of corporate sponsors as African American and cool.

7

#AfropunkWeSeeYou

IT'S SATURDAY EVENING AT AFROPUNK, and hundreds of festivalgoers are gathered on the lawn in front of the Green Stage where bands like Hello Yello and Up-chuck performed earlier in the day. A mesh banner emblazoned with the Afro-punk logo runs across the top of the large black stage. The sides of the stage are flanked by giant screens that flash various social justice mantras including, NO SEXISM, NO RACISM, NO ABLEISM, NO HOMOPHOBIA, NO FATPHO-BIA, NO TRANSPHOBIA, NO HATEFULNESS, NO TRUMPISM. The anti-establishment tone of the evening is disrupted when attention turns to AT&T, one of the festival's main sponsors. In between acts, one of the hosts walks on stage wearing a purple hat, a shiny gold turtleneck, and a long flowing overcoat that sparkles under the stage lights. "Our theme this year is 'We see you and we want to see you next year,'" he says to the audience:

> You know, 2020 is our 15-year anniversary, and it's going to be amazing. AT&T is giving away an all-expense paid trip for a winner and three friends to go to [the] Afropunk Festival in Paris, Johannesburg, Brooklyn, Atlanta, London, and the newest one will be in Brazil baby. Oh yes, oh yes, you heard right. So make sure you go over to [the] AT&T Mural at the Red Stage . . . to rep your area code and find out how to enter.

This moment exemplifies a growing critique of Afropunk—that the festival, which started as a celebration of Black punk rock and Black counterculture more broadly, has been coopted by large corporations.[1] This critique is captured

in a review of the 2019 festival in Atlanta titled, "Why Target and Other Corporate Businesses Don't Belong at Afropunk," where the writer laments "seeing Target, AT&T, Budweiser and other juggernaut white-owned corporations setting up shop . . . [and] plastering their signs across the concert."[2]

Drawing on participant observation at the concert, social media posts by festivalgoers, and PR texts created by sponsors, this chapter provides insight on the commercialization of Afropunk by analyzing how sponsorship of the festival helps businesses to cultivate a Black and cool image. This image production takes place through a course of action that I term *prosumption promotion*. Prosumption promotion is a process whereby "prosumers," or those who both produce and consume goods and services, create social media posts that promote businesses. In the case of Afropunk, festivalgoers take digital portraits in photo areas sponsored by companies like AT&T and upload those images, along with corporate branded hashtags, to their personal social media accounts. While concert portraiture, which also takes place at music events such as the Essence Festival, is valuable for festivalgoers because it provides them with attractive images to post to their accounts, it is also valuable for corporate sponsors. Given that festivalgoers' portrait posts from Afropunk not only often feature Black people, but also Black people with an avant-garde style, the posts lend corporate sponsors an image of Blackness and coolness.[3]

By elaborating on how sponsorship of Afropunk helps companies to cultivate a Black and cool image, this chapter not only offers insight on the commercialization of the Afropunk festival, but also advances understanding of prosumption as well as subculture. While sociological research on prosumption provides perspective on how social media users benefit social media companies by producing content for these firms, analysis of promotional messaging by prosumers has been neglected. This chapter develops the concept of prosumption promotion to cast light on how social media users create value for brands by co-constructing their image. In addition, while the scholarship on subculture asserts that subcultural aesthetics often become absorbed into the mainstream and commodified, with the exception of rap and hip hop, there has been little analysis of this process among Black subcultures. By examining the commercialization of Afropunk, this chapter offers a richer understanding of how companies draw on Black subculture to convey an image of edginess and cool.[4]

Prosumption and Promotion

Although production and consumption have long been understood as distinct and separate phenomena, they are increasingly cast as interconnected. The concept of prosumption, or "the interrelated process of production and consumption,"[5] speaks to the interlinkages between these phenomena. According to George Ritzer, a proponent of the prosumption perspective, production and consumption exist along a continuum. On one end of the continuum is "prosumption-as-production," or p-a-p, and at the other end of the spectrum is "prosumption-as-consumption," or p-a-c. In the case of the former, an individual is mainly involved in production of a good, while in the case of the latter an individual is mostly involved in consumption of a good. "Balanced prosumption" falls in the middle of the continuum.[6] In cases of balanced prosumption, individuals are relatively equally involved in producing and consuming a good or service. Balanced prosumption takes place on social media sites like Instagram where users produce and consume posts.[7] As Melita Zajc concludes, "Regardless of the various approaches, scholars seem to agree on one distinct feature of social media, which is audience participation in the production of media content."[8]

One aspect of prosumption that has received little attention in sociological scholarship is promotion or forms of communication that "inform, persuade, and/or remind" consumers about products and services.[9] Historically, advertisements in mass media, such as newspapers and television, were a main promotions vehicle.[10] However, with the rise of social media, companies now also promote their products on platforms such as Facebook, Twitter, and Instagram. Today, companies spend more on digital than traditional advertising.[11] One segment of digital advertising involves social media "influencers" who are involved in "influencer marketing."[12] Influencer marketing is premised on the belief that social media users have the capacity to affect the consumption of their followers. Because they can drive the consumption of their followers, companies hire influencers to promote their products on social media. In exchange for money or free products, influencers place "sponsored posts" on their social media channels.

Originally, only social media users with large followings were seen as valuable to companies. However, more recently the tide has shifted, and there is a belief that social media users with smaller followings can shape not only the

perceptions and behavior of their followers, but that in some instances, they may be even more successful at these tasks. Thus, in the world of influencer marketing there are different tiers of influencers including "mega-influencers" with generally more than 1 million followers, "macro-influencers" with around 100,000 to under 1 million followers, "micro-influencers" from 1,000 to less than 100,000 followers, and "nano- influencers" with typically less than 1,000 followers.[13]

Influencer marketing is a form of prosumption promotion. Like prosumption on social media in general, prosumption promotion involves actors using social media and producing social media content. However, the posts produced in prosumption promotion specifically promote products or services. Although prosumption promotions can presumably be unsolicited by a company, as noted above there is an entire industry that is organized around identifying influencers to post "sponsored" content on social media. As we see in this chapter, part of this solicitation involves concertgoers and digital portraiture at festivals like Afropunk. Concertgoers are recruited by companies to create social media posts that promote their brands. Social media posts involving Afropunk festivalgoers provide brands with a coolness that is linked to what sociologists term a "subculture."

Subculture

A subculture is a group of people with a shared identity, a common set of practices and understandings of the world, and "a sense of marginalization from or resistance to a perceived 'conventional' society."[14] The last element, resistance to conventional society, is a topic of significant interest to cultural theorists. Key to understanding subcultural resistance is the idea of power operating through cultural hegemony. A cultural hegemony approach to power views dominant groups as maintaining their power not through force or coercion, but rather via their culture becoming accepted and internalized by subordinate groups.[15] Subculturalists engage in what is sometimes termed "semiotic resistance" by embracing styles and practices that conflict with dominant culture. By countering dominant ideologies, subculturalists may be viewed as undermining oppressive regimes.

Consumption as a form of resistance was studied by the Birmingham School, a group of researchers affiliated with the Centre for Contemporary Cultural Studies at the University of Birmingham in England. In case studies of

subcultures such as the teddy boys and punk rockers, scholars in the Birmingham School elaborated how working-class youth undermine the class system through rejecting hegemonic culture. For example, in his classic text *Subculture: The Meaning of Style*, Dick Hebdige describes how punk rockers appropriate safety pins by taking them "out of their domestic 'utility'" and wearing them "as gruesome ornaments through the cheek, ear or lip."[16] Other elements of the punk uniform include tattoos, hair styles such as shaved heads and mohawks, and clothing items like spiked dog collars and bracelets, ripped t-shirts and jeans, and combat boots.

The Birmingham School focused on subcultures undermining class oppression. However, subcultures also undermine other systems of power. In her book *Pretty in Punk*, Lauraine Leblanc examines how punk rock girls undermine dominant views of femininity. In Leblanc's view, punk girls articulate what she terms "trebled reflexivity" where they "sartorial[ly], vocational[ly], and behavioral[ly]" resist three types of norms: general norms of dominant culture, feminine norms of dominant culture, and feminine norms of punk culture.[17] Like men in punk culture, punk women style their hair in mohawks and wear combat boots, spiked arm bands, and torn jeans. However, since many punk girls use bricolage where they add traditionally feminine touches to punk styles—such as wearing black lipstick, fishnet tights, and mini skirts with Doc Marten boots and a leather jacket—they also subvert the "masculinist norms" of punk subculture.[18] This approach to self-styling counters dominant norms about how people across the gender spectrum should present themselves in public. At the same time, when women punks don these styles, they are challenging conventions of feminine propriety whereby women are to appear delicate, soft, and nonthreatening.[19]

Although subculturalists like punk rockers may challenge hegemonic ideas and practices through their lifestyle, the utility of rebellious style as a form of resistance is undermined by its absorption into the mainstream. When an element of subcultural style is diffused into the mainstream, it no longer disrupts conventional norms. As Hebdige writes, subcultural signs can be "converted" into "mass-produced objects."[20] More specifically, Hebdige asserts that "each new subculture establishes new trends, generates new looks and sounds which feed back into the appropriate industries."[21] This is a general principle that is evidenced by punk rock styles like black leather, safety pins, and studs being incorporated into popular fashion in the late 20th century.[22] Yet, subculture is commodified not only by being absorbed into capitalist culture industries, such

as high fashion, but also by being incorporated into prosumption promotions for companies across a wide range of industries. To understand how corporate sponsors coopt Afropunk style, it is important to briefly delve into the history of the punk and Afropunk subcultures.

Punk

The punk subculture grew out of New York City and London in the 1970s. It is a subculture defined by distinctive music, fashion, rituals, and in some cases politics. The unique elements of the punk subculture are captured by a *Time* magazine article written in the midst of its emergence: "Musicians and listeners strut around in deliberately torn T-shirts and jeans; ideally, the rips should be joined with safety pins . . . the hair is often heavily greased and swept up into a coxcomb of blue, orange or green, or a comely two-tone. . . . The music aims for the gut."[23]

In New York City, CBGB, a club in the then-raw and edgy Bowery District, was a central stomping ground for bands and musicgoers in the emerging punk scene. The club helped to launch the careers of performers who would later come to define the punk era such as the Ramones, Blondie, and the Talking Heads.[24] Across the Atlantic, bands like the Sex Pistols and the Clash were leading the punk scene. Like their US counterparts, the sound, fashion, and rituals of British punk rockers clashed with mainstream culture. British punk rock also had a political element. As a 1978 article about the Sex Pistols put it, "In Britain, punk is the voice (some would say vice) of working-class kids who cannot find jobs and care not a whit for the traditions of their homeland."[25]

Though punk style was originally a subversive aesthetic, over the years it has been commercialized and absorbed into the mainstream. In the 1990s, the commodification of punk by high fashion was evident when designer Gianni Versace created a pricy bondage dress composed of black leather straps and gold hardware in 1993.[26] The next year, another punk creation by Versace, a black dress held together on the sides by giant safety pins and worn by actress Elizabeth Hurley on the red carpet, also made it clear that punk was now conventional.[27] Fashion features in media, such as a 2003 piece in the *New York Times Magazine*, "Pretty in Punk,"[28] were proof that although punk style may have begun as a subversive aesthetic resisting the status quo, it was now a style that large companies were capitalizing on to turn a profit. The year 2003 was

also momentous for punk for another reason. It was the year that *Afro-Punk*, a documentary that would transform the punk scene, was first released.

Punk Becomes Black

Racially, musicians and fans in the punk scene have been mainly white. The isolation of Black punk rockers was captured in the 2003 documentary *Afro-Punk*. Directed by James Spooner, a Black hardcore punk rocker himself, the film follows the lives of Black punk rockers as they negotiate racial boundaries in the punk subculture. Racial isolation is a common thread running through their experiences. Describing this feeling of aloneness, one Black punk rocker featured in the documentary recalls how being the only African American at shows sometimes made him feel "weird" and wonder if he should be there.

Some Black punk rockers negotiate the racial divide in punk by deemphasizing their Blackness such as straightening their hair to embody the classic punk rock aesthetic.[29] However, others negotiate the color line in the subculture by defining themselves as specifically Black punk rockers and emphasizing how the punk aesthetic has Afrocentric roots. By defining punk style as growing out of Afrocentric style, these Black punk rockers situate their engagement with punk as not racially alienating, but rather as racially affirming—by being punk, they are going back to their African roots. For example, a woman in the film—who wears a silver lip ring, a silver horseshoe septum ring, two double silver nose studs, multiple ear piercings including a tragus piercing in front of her left ear canal, and African head wraps— describes her involvement in the punk scene as "reawaken[ing]" her sense of connection to a "traditionally African aesthetic."[30]

Afro-Punk spawned a message board to help build community among Black punk rockers. Soon after, Spooner, along with Matthew Morgan, one of the producers of the documentary, founded the Afropunk music festival. As Morgan explains, "We want to expose kids to the idea that there's a different option, a different way to be. . . . If everyone wears baggy trousers, and we all look the same, how rebellious is that?"[31] The festival debuted in 2005 at the Brooklyn Academy of Music. Now it takes place in nearby Commodore Barry Park in Fort Greene. The festival features punk rock bands with Black musicians such as Bad Brains, Ho9909, Body Count, and Fever 333. Many festivalgoers, most of whom are African American, also don a distinctively Afropunk aesthetic.

Figure 7.1 Vinyl banner near a festival entrance, Afropunk Brooklyn, 2019.

Afropunk style departs from traditional punk style in its greater incorporation of Afrocentric-inspired elements. However, it shares other aspects with traditional punk style. Like punk style more broadly, Afropunk style is characterized by bricolage (that is, combining "discrepant styles") and appropriation (taking styles from one cultural tradition and giving them new meaning).[32] Common elements in the Afropunk look include Afrocentric-inspired elements brought together with elements from other styles such as traditional punk.

Although the distinct aesthetic of many Afropunk festivalgoers is a form of style as resistance—that is, it disrupts mainstream cultural norms about appropriate forms of dress for people in general; resists racial norms about appropriate forms of style for African Americans; and disrupts traditional punk norms of appearance—the festival is increasingly cast as reinforcing the status quo. One critique along these lines is that the festival is being coopted and commodified by corporate America via sponsorships. For example, a post on the *The Rad Voice* critiques Afropunk for being sponsored by corporations "that actively fight against the values it claims to stand for" such as "women's rights, LGBTQ+ issues and more."[33] Commodification at Afropunk is especially evident in the corporate portraiture and prosumer promotion at the festival.

Afropunk Brooklyn, 2019

In 2019, as in the last several years, Afropunk was held at Brooklyn's Commodore Barry Park, located in the Fort Greene neighborhood. The festival is organized into three main areas, each with its own stage: an area running along Flushing Avenue that houses the Red Stage; an area alongside Park Avenue that is home to the Green Stage; and an area alongside N. Elliott Place that features the Gold Stage. Within, or just outside of these areas, are sponsor booths. The Red Stage area features an attraction by the personal care brand Shea Moisture. Other companies, including global telecommunications company AT&T, have designated spaces there. Just across from the Green Stage area and nearby Activist Row is a booth for the social media company Instagram.

Each sponsor area features a photo booth where festivalgoers can take portraits in front of intricate backdrops. Companies also provide special branded hashtags that festivalgoers can use when posting their portraits on social media. Corporations provide festivalgoers with distinctive and professional backdrops for their concert photos, and festivalgoers promote these companies on their personal social media channels. In essence, for the price of sponsorship, companies not only receive the opportunity to promote themselves to a very specific Black demographic who are physically at the festival—African Americans within and adjacent to the Afropunk subculture—but they also get the chance to use the likenesses of this demographic to promote their brands on social media.

#ShareBlackStories

Instagram, a brand that is valued at more than $100 billion and is now part of the Facebook empire, was founded in 2010 by two white male software engineers, Kevin Systrom and Mike Krieger. The photo- and video-sharing platform, which is especially popular among people under 35, has grown to become one of the most popular social media sites. By 2019 there were 1 billion registered users of the service. Like other social media sites, users consume and create content—in this case, posts that feature photos and videos along with brief text, such as hashtags.

At Afropunk, Instagram hosts a booth that is located in the middle of a vast field that encompasses the Green Stage area. To the left of the Instagram booth is the Afropunk store where official merchandise for the festival is sold. The store is housed in an all-black tent emblazoned with the white Afropunk logo.

In the store, a series of black-and-white cotton t-shirts, hats, canvas bags, and jackets with catchy resistant phrases such as "BLACK IDENTITY EXTREM-IST," "BLK(H)ACKERCULTUREVIRALIST," "WE SEE YOU," "THEY, THEM YOURS," "BLACKER," and "BLACK LOVE" are displayed against a metal cross-link fence. Some t-shirts bear messages that explicitly oppose the political leadership, including a t-shirt with the words "TRUMP," "STATUS QUO," and "APATHETIC" crossed out and replaced by "RESIST," "DISRUPT," and "MOBILIZE." Activism Row stands on the other side of the Instagram booth. Activism Row is comprised of a series of booths hosted mainly by nonprofits such as Color Of Change, an organization claiming to "help people respond effectively to injustice in the world around us."[34]

Amid this sea of socially conscious booths is the Instagram photo booth where festivalgoers can sit for portraits. From afar, the photo area looks like a small stage that has been dropped in the middle of the vast green field. The bottom of the stage is comprised of hardwood that is stained a light honey color. The external left and right walls of the booth are made of a golden metallic material. Attached to the front of each side wall is a golden column that shines in the sun. Each column bears an embossed Instagram logo—an outline of an instant camera, a "Share Black Stories" logo—two side-by-side zig-zag lines next to the words "SHARE BLACK STORIES" in all caps, and a series of informally shaped marks such as zig-zag lines and triangles. Behind each column the sidewalls are a matte gold color and bear low reliefs of both the Instagram and "Share Black Stories" logos. The inside of the booth has the appearance of an abstract desert landscape, with planes of pink and orange adorning the back and sidewalls. A yellow sun projects from the back wall, and three-dimensional fluffy white clouds hang from white slats at the top of the booth.

Below the clouds, five large pieces of marble in varying sizes sit on the wooden floor. The marble chunks are arranged in a row with the tallest piece in the middle and the smallest chunks at the end. Black and gray veins swirl through the white marble that are also subtly marked with the Instagram and "Share Black Stories" logos. Sitting on the grass, on the left and right sides of the booth, are two sets of golden display stands. Like the larger columns, the stands are embossed with a series of markings along with the Instagram and "Share Black Stories" logos. On top of each stand rests a gold crown with a unique design. For example, one crown is made of a thick metal band with large triangular points that jut out at an angle, while another is comprised of a thin band that has long diamond-encrusted points that project like rays of sunshine.

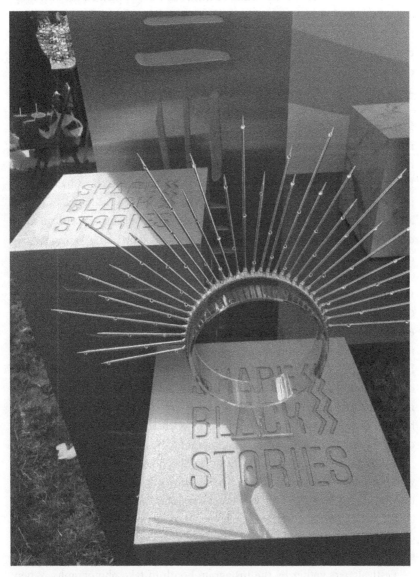

Figure 7.2 A crown for festivalgoers to wear in portraits at the Instagram photo booth, Afropunk Brooklyn, 2019.

The Instagram photo booth is intended to evoke Africa and futurism. As Joy Ofodu, an Instagram marketing coordinator who worked on the backdrop explains, "The #shareblackstories hashtag come[s] to life with afrofuturistic landscapes and color palettes drawn from artists on Instagram. African mud cloth symbols that each tell their own story. An African throne room. A reclaiming of frescoes. . . ."[35] In bringing up #ShareBlackStories, Ofodu references a recent and ongoing Black-focused campaign at Instagram.

The "Share Black Stories" Instagram campaign began just a few months before the festival in February 2019. To announce the campaign, the company released a press statement noting that, "To honor the Black community on Instagram and celebrate Black History Month in the U.S., we're kicking off #ShareBlackStories this February." Users could participate in the effort by not only uploading images tagged with #ShareBlackStories on the social media site, but also by using newly created camera effects and stickers featuring "African mud cloth patterns," along with "custom templates" created by Loveis Wise, an African American freelance illustrator.[36]

The company further promoted the campaign in a post on its own official Instagram account featuring a photo collage created by self-taught artist Tawny Chatmon. Chatmon, who is African American, describes her practice as "celebrating the beauty of black childhood."[37] The portrait in the Instagram post features a Black girl with voluminous natural hair sitting in a chair. A brown hand that is forming a tiny braid in her hair peeks out from the left side of the composition. As the post explains, "For artist Tawny Chatmon (@tawnychatmon), #ShareBlackStories, and Black History Month in general, is 'not about having other people validate us. It's about us celebrating ourselves—celebrating ourselves and creating that work that we want to be in this world.'"[38]

At Afropunk staffers working at the Instagram photo booth wear items adorned with the "Share Black Stories" logo. One employee with her hair styled in long braids gathered away from her face wears blue jeans, black-and-white Nikes, and a black t-shirt with the "Share Black Stories" logo stamped on the front. A staffer dressed in a jumpsuit made of an African textile wears a black tote bag across her shoulder with the "Share Black Stories" logo marked on the side in white.

Festivalgoers gather by the Instagram booth to take photographs. When they get to the front of the line, they hand their phones or other devices with digital cameras to a Black male Instagram staffer who takes their photograph. Before taking the photo, he asks concertgoers to select a crown to wear in the portrait. After the crown is chosen, concertgoers arrange themselves in the

stage set. Many pose on top of the marble pillars. For example, a lighter-skinned Black man with metallic hoops in his ears, a small tattoo near his right elbow, and a beaded black necklace from which a tooth-like object is suspended, sits on the second to last marble column on the left. While he doesn't wear a crown, a black bandanna is wrapped around his dark brown dreadlocks. His partner, a darker-skinned woman wearing the golden crown with over two dozen long, thin "rays," perches on the right side of the last marble pillar and leans against him with her arms wrapped against his arm and leg. Her pose leaves visible all of the light gray "Share Black Stories" logo on the marble pillar.

As the couple pose with warm but unsmiling expressions, they stare into the camera phone held by the Instagram worker. A clear plastic bag hangs from the staffer's right arm. The bag holds a few dozen fans composed of white paper and bamboo. When completely open, an image of the "Share Black Stories" logo is revealed on the fan. When the staffer finishes taking portraits of concertgoers, he returns their phones and hands them an Instagram fan.

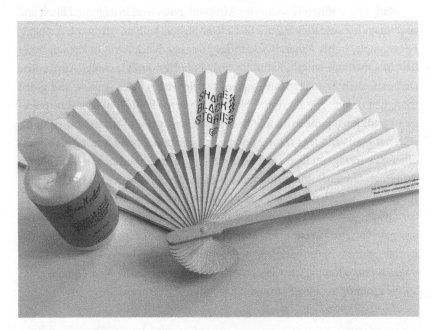

Figure 7.3 Festivalgoers who sit for portraits at corporate photo booths are often given free promotional products, including the "Share Black Stories" fan handed out at the Instagram booth and the "Coconut & Hibiscus Illuminating" body lotion handed out at the Shea Moisture booth.

When Afropunk festivalgoers sit for portraits at the Instagram booth, the social media company yields a return on their sponsorship. Festivalgoers who take portraits at the Instagram booth are exposed to the Instagram brand as well as Black messaging linked to the "Share Black Stories" campaign. Instagram continues to yield a return from the Afropunk festival sponsorship online. There, some of the festivalgoers who take portraits at the Instagram booth post their portraits on Instagram using the #ShareBlackStories hashtag. Consistent with the classic form of prosumption elaborated in the sociological literature, these uploads provide Instagram with its core product—online posts featuring images. They also provide the company with a product specifically designed with Black users in mind—images featuring Black life that can populate the #ShareBlackStories hashtag. But, the return that Instagram receives from its sponsorship of Afropunk is not limited to festivalgoers creating "product" for the company by populating the Instagram feed with posts for the #ShareBlackStories hashtag. Instagram also benefits from the sponsorship by festivalgoers promoting the company.

Many of the #ShareBlackStories Afropunk posts lend Instagram a Black and cool image because they feature Black festivalgoers with an Afropunk aesthetic. For example, in her #ShareBlackStories post, one Black Afropunker wears her hair in a medium-length, naturally curly bob. Her outfit includes Afrocentric elements, such as an African-inspired textile with a black, yellow, and green triangular design. She also wears black Doc Marten boots, a style of shoe popular in traditional punk fashion. She is posed across two of the marble columns with her boots and legs resting on one and her upper body leaning across another. The Instagram logo emblazoned on one of the columns is fully visible in the image. Similarly, in another post, a Black Afropunker with a tightly coiled short, natural hairstyle wears a classic punk metallic septum ring in between her nostrils along with a long jacket that features a yellow-and-black Afrocentric pattern. The "Share Black Stories" and Instagram logos stamped on the marble columns in the backdrop are partially visible in the post. Besides the Instagram photo booth, festivalgoers also venture over to the AT&T photo areas on the grounds to take photos with a distinctive backdrop.

#CodesOfCulture

In the Red Stage area, right next to the main entrance and the box office, is the Arts & Times section. The Art & Times photo area is a section of the concert

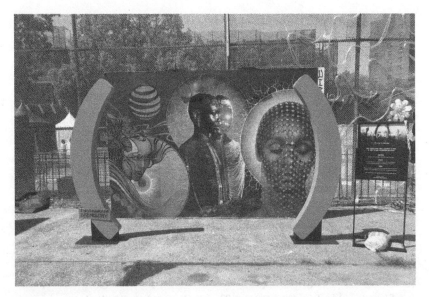

Figure 7.4 AT&T photo backdrop designed by New York Artist Miguel Ovalle, Afropunk Brooklyn, 2019.

grounds that includes a series of photo backdrops. Some backdrops are simple in design. For example, one backdrop painted bright yellow is composed of a small stage-like base that is about two feet off the ground and two tall walls that angle in toward each other. Another backdrop, more intricate in design, is arranged against the chain-link fence that faces Navy Street. Created by artist Miguel Ovalle, this backdrop consists of a large piece of cardboard-like material with a painted Afrofuturistic scene attached.

The background of the scene is a midnight blue sky. In one corner of the painting is an image of a woman with a brown face. A round, sun-like figure that is orange with bits of blue stands behind her. In the middle of the picture there is an image of a Black person in profile. Next to the profile is a person whose face is obscured by a sky filled with clouds and twinkling stars. Behind both of these figures there is a round blue planet. The far right of the composition depicts the face of another brown-skinned woman. Her face is covered by a silver and diamond veil. Two large, light blue sculptures stand on the concrete in front of the painting. Together, the sculptures look like the parentheses that envelop an area code.

Unlike the other backdrops in the Art & Times area, this backdrop, as described by Ovalle in an Instagram post featuring the work, is an "@att

commissioned wall."³⁹ Company branding is indicated by the blue color of the parentheses sculptures. It is also indicated by the unmistakable AT&T logo that is present in the top left-hand corner of the composition. There, the blue-striped AT&T planet logo floats in the midnight atmosphere.

AT&T backdrops located in other places on the festival grounds also feature two large blue sculptures that evoke the parentheses from an area code. Just behind the parentheses in one photo area, there is an installation composed of old school music speakers that are stacked on top of one another in the form of a pyramid. The subwoofers in the stereos are black and encased in wooden frames. Interspersed throughout the pyramid are flowers of different shapes, colors, and sizes. In the center of two subwoofers on the far left and right is the AT&T globe logo with blue-and-white stripes. In another AT&T photo area, the parentheses sculptures bracket a work by Gianni Lee—an African American artist who paints and creates art in other media—that is painted on three large rectangular boards that are placed together. This painting features a black water creature. The creature is being pulled out of a mass of blue water by a series of stick figures in black and pink. One of the stick figures has angel wings and a halo. All of their heads are heart-shaped, and they have two x's for eyes.

An AT&T employee who is staring at his phone mans this backdrop. He has rich dark skin and short natural hair that is dyed platinum blonde. He is dressed in almost all black—black pants, black tennis shoes with white and hot pink stripes, and a black t-shirt. The white fanny pack that he wears around his waist complements the white writing on his t-shirt, which reads "It's a (718) thing." "718," which is the area code for New York City, is bracketed by two parentheses. The AT&T staffer is standing slightly in front of a sign announcing the AT&T "Codes of Culture" campaign.

A copy of the "Codes of Culture" campaign sign also stands by the AT&T backdrop created by Ovalle in the Art & Times section. The sign is held up by a black metal frame. At the top of the sign there is an image of a crowd of people with their hands raised in the air. At the center of the crowd is a Black person with naturally curly hair. "IT'S A (718) THING" is written across the photo in white text. Another section of white text describes the sweepstakes where festivalgoers can win a trip to any of the upcoming Afropunk concerts by uploading a photo to the website CodesofCulture.com, generating an AT&T "meme" version of the photo, and posting the AT&T-branded image on social media using the hashtags #CodesOfCulture, #Afropunk2020, and

#Sweepstakes. An AT&T staffer manning this backdrop encourages festivalgoers to enter the contest.

As described by MaMa, the ad agency that created the campaign, "Codes of Culture" is targeted at the young ethnic market: "AT&T faced a huge issue to connect with multicultural millennials. We solved their problem through an ongoing campaign that did not advertise a single phone. Instead, we celebrated the cultural meaning behind area codes." Sponsoring events like Afropunk was one means to "celebrate" the culture in these communities. "AT&T partnered with the outlets that matter most to its audience like . . . Afropunk . . . to help spread the word in real life proving that AT&T not only walks the walk but truly lives by the code," a MaMa campaign video explains.[40]

Festivalgoers can visit CodesofCulture.com to create an area code meme and enter the sweepstakes. After users upload a photo and enter their area code, a meme is created that features the photo overlayed with the phrase "It's a (###) thing." Each user's area code is featured within the area code parentheses. After the meme is created, buttons appear to post it on social media and to copy branded hashtags like #CodesOfCulture and #ItsA718Thing.

If contest entrants read the fine print on the site, they will learn what they are agreeing to when they participate in the sweepstakes. In exchange for the opportunity to win the grand prize, which is valued at around $25,000, participants must not only create a branded AT&T area code meme using a photo from their personal archive, but they must also give AT&T and its subsidiaries the right to use the image in any of their promotions, without notice or payment, in perpetuity. Text in gray fine print above the upload button reads in part, "I promise that I created the content and I give AT&T and its business partners the irrevocable right and license to use the content, including my name and likeness, in perpetuity anywhere and in any way for advertising and promotional purposes."

As implied in the fine print, this AT&T sweepstakes is a mechanism through which Afropunk festivalgoers promote the company. The social media posts give the company an appearance of Black cool. This veneer of Blackness and edge is linked to the fact that most of the posts feature Black people, and in many of the posts, the Black subjects in the portraits don an Afropunk aesthetic.[41] For example, in his AT&T meme on Instagram, a Black festivalgoer with shoulder-length dreadlocks wears a maroon vest with white skeleton bones. He is pictured standing in the middle of the backdrop created by Lee with the two large blue area code sculpture parentheses to his left and right.

In another AT&T contest meme post, two Black women stand in front of the photo backdrop that features the pyramid of old school wooden speakers. One wears her long reddish-brown dreadlocks in two buns on the side of her head. Her halter top with a flared bottom is made from blue and hot-pink wax print fabric. Punk elements of her outfit include ripped black sheer nylons and patent leather combat boots. As required for contest posts, the "It's a (###) thing" graphic is pasted over the image. Peeking underneath the graphic is the classic blue-and-white AT&T logo that forms part of two speakers in the backdrop.

#HotSheaSummer

Not too far from the AT&T backdrop near the Red Stage is the Beauty Village. The Beauty Village is arranged like a street bazaar with a series of storefronts. Each of the stalls features cosmetics and grooming products sold by mainly Black-owned companies. At the top of each booth, there is a black sign that lists each company's name in a bright neon color. Shea Moisture is one of the first booths along the main thoroughfare in the village.

Shea Moisture, which is a B Corporation, or a company that pursues profit and purpose, aims to sustainably manufacture natural hair and other personal care products. The brand is especially popular among Black women with natural, or non-chemically relaxed, hair. Shea Moisture, part of Sundial Brands, was founded in 1991 in Harlem by Liberian immigrants Richelieu Dennis, Mary Dennis, and Nyema Tubman. The company remained Black-owned until 2017 when Sundial was sold to Unilever, a multinational consumer goods company for reportedly $1.6 billion. The purchase was part of Unilever's attempt to target "multicultural and millennial consumers" along with "sustainability conscious consumers" in the market for personal care products.[42]

At Afropunk, the Shea Moisture booth is one of the most popular attractions in the Beauty Village. Black-and-gray guide stanchions stand in the front of the booth to help organize the crowd. In the line, several Black women with natural hairstyles wait to take photographs. One woman wears her dark hair with a slight red tint in a voluminous puff on top of her head and the back clasped together with a gold barrette. Another has curly, long black hair that cascades to the center of her back. Next to her is a Black woman who wears two twists at the front of her head that are secured on the bottom with a series of wooden beads. Additional twists are in the front of her hair, and in the back are a series of medium-sized buns. Behind her is a woman who wears her short

dark black hair in a series of twists that, if kept in, will eventually evolve into dreadlocks. Behind her is a woman with dozens of braids throughout her long hair. Yellow thread is intertwined through some of the braids, and others are adorned with bright yellow flowers.

The photo booth where this group of women waits to take portraits has white walls covered with clear plastic sheets. Small white lights, linked together by long black strings, hang from the ceiling. A sheet of shiny, crinkled, pink chrome film forms the backdrop of the booth. Green AstroTurf-like material covers the floor. Two signs placed in silver metal holders stand to the right and left of the photo area. The background of both signs consists of washes of pink, orange, and violet that bleed into one another. The sign on the left explains how festivalgoers can receive a free sample of a Shea Moisture product. In all-white writing, it reads in part, "SNAP your photo, TAG @SheaMoisture &

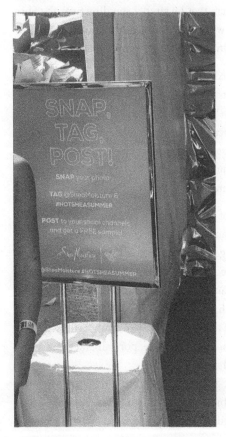

Figure 7.5 #HotSheaSummer sign at Shea Moisture photo booth, Afropunk Brooklyn, 2019.

#HOTSHEASUMMER, POST to your social channels and get a FREE sample!"
"@SheaMoisture #HOTSHEASUMMER" is written at the bottom of the sign,
and just above this text is the Shea Moisture logo along with a logo for "Com-
munity Commerce" spelled out in the shape of a heart.

"Community Commerce" is the term that Shea Moisture uses to describe
its social mission. As Cara Sabin, the CEO of Sundial Brands explains, "At Shea
Moisture we invest proceeds from each and every purchase directly into the
community."[43] A $1 million grant program for minority and women of color en-
trepreneurs and scholarship programs for girls at Babson College and for stu-
dents attending HBCUs are part of the company's community "investments."

The other sign at the booth also has the Shea Moisture and Community
Commerce logos, along with the Shea Moisture Instagram handle and the
#HotSheaSummer hashtag. However, whereas the sign on the left instructs fes-
tivalgoers on how to post their digital photos on their social media accounts,
the sign on the right alerts festivalgoers that by simply standing near the Shea
Moisture booth, their likenesses and words may be used for brand promotion.
In small white typeface, the sign reminds festivalgoers:

> By entering the event premises, you consent to interview(s), photography, au-
> dio recording, video recording, and its/their release, publication, exhibition, or
> reproduction to be used for news, webcasts, promotional purposes, telecasts,
> advertising, inclusion on websites, social media, or any other purpose by Shea
> Moisture and its affiliates and representatives. Images, photos and/or videos
> may be used to promote similar events in the future, highlight the event and
> exhibit the capabilities of Shea Moisture.

When festivalgoers get to front of the line and it is their turn to sit for a
portrait, they step inside the photo booth. As they strike various poses, an em-
ployee takes their picture using a large black camera. After the photo session
is complete, festivalgoers enter their contact information into a digital device.
The photo will be transformed into an animated GIF and then sent to them.
As festivalgoers leave the photo booth, they pass by Shea Moisture employees
handing out free 3.2-ounce samples of the company's "Coconut & Hibiscus Illu-
minating" body lotion. Before being handed a sample, portrait takers are asked
if they have posted their GIF to social media.

Festivalgoers who input their e-mail address into the Shea Moisture
kiosk receive a message with the subject "Shea Moisture x Afropunk—Your
gif!" The e-mail reads, "Here's your gif! Don't forget to tag us @SheaMoisture

#HOTSUMMERSHEA." Attached to the e-mail is a GIF created from festival-goers' poses in the Shea Moisture photo booth. Above the GIF there are buttons to download it, as well as to post it on Facebook, Twitter, and Instagram. In the GIF festivalgoers are set against a shiny, crinkled, pink Mylar backdrop. When the GIF is played, their image moves from left to right. In white writing across the bottom of the GIF, it reads: "Shea Moisture Established 1912"[44] and "Community Commerce." Across the top of the GIF is the hashtag #HotSheaSummer. At the end of the nine-second GIF, the image of the festivalgoer disappears and is replaced by the Shea Moisture and Community Commerce logos set against a pink background. #HotSheaSummer is written beneath the logos.

The sponsored GIFs that festivalgoers post on Instagram reinforce the company's association with Blackness and cool. The images convey Blackness and edginess because they often feature Black subjects who don a characteristically Afropunk style. In her #HotSheaSummer post, one Black Afropunker wears skin-tight black pleather pants and a silver bra top underneath a sheer black tank top. This classic punk style is combined with an Afrocentric hairstyle—long micro braids that hang down to the waist. Another Black festivalgoer posts an image of herself in punk gear such as a black bondage top. Her Afrocentric-braided hairstyle nods to punk too—the black braids gathered into a bun on top of her head are streaked with neon blue strands. In a similar fashion, a Black festivalgoer with a short natural hair style that is dyed platinum blonde wears classic punk bright-green neon lipstick and a black-and-white jacket with an Afrocentric design in her post. All these posts feature the Shea Moisture logo.

An incident from 2017 illustrates just how important it is for Shea Moisture to convey a Black image. Since its founding, Black women have been a core consumer segment for the company. To that end, many of their promotions, such as print ads and commercials, feature Black women with a range of different skin tones and hair textures. However, in 2017 the company ran a commercial that featured a light-skinned woman of African descent with loose curls, and two white women with straight hair. A firestorm erupted on social media. The use of white models in the ads, along with not featuring any darker-skinned models with coily hair, made some loyal consumers question the company's commitment to their historically core customer base—Black women. As one customer shared on social media, "apparently shea moisture is changing their formula to help white girl hair???"[45] Even the author of a blog post on Afropunk.com criticized the commercial for abandoning its core consumer base:

"Now that they have a massive, thriving business, Shea Moisture tried to leave us for a white girl."[46] Shea Moisture ultimately pulled the ad and apologized.

In their apology statement, the company reaffirmed its commitment to representing the full spectrum of "ethnic groups" and hair textures. In a Facebook post the company wrote,

> While this campaign included several different videos showing different ethnicities and hair types to demonstrate the breadth and depth of each individual's hair journey, we must absolutely ensure moving forward that our community is well-represented in each one so that the women who have led this movement [the natural hair movement] never feel that their hair journey is minimized in any way.[47]

This incident illustrates that the race of people who appear in promotions plays an important role in how consumers perceive a company. Not including a fuller range of Black women in this ad made some consumers question Shea Moisture's loyalty to Black women.[48] #HotSheaSummer Afropunk promotions featuring a wide range of Black women with natural hair help to convey the company's commitment to this market.

Being Seen

A few days after the festival, the official Afropunk Instagram account posted a "Codes of Culture" area code image reminding eventgoers that it was not too late to enter the AT&T sweepstakes: "#Latergram but there's still time to rep your code to win a trip to *any* AFROPUNK in the world thanks to our friends at AT&T #CodesOfCulture #AFROPUNK2020 #sweepstakes." Social media posts like the #CodesOfCulture posts allow corporate sponsors to bolster the return on their investment in the festival. While having a presence at the event allows corporations to market to those in attendance, Black festivalgoers' branded social media posts help companies to project an image of Blackness and edginess to a much wider audience.

On one hand, the exchanges between corporations and festivalgoers might seem uneven. Corporations get festivalgoers to serve as models and distributors for the promotional posts; in return festivalgoers receive a photo, and sometimes also product samples, or a chance to win a prize. However, in considering

the value exchanged between festivalgoers and corporations at Afropunk, it is useful to consider art historian Krista Thompson's analysis of club photography in Black communities. In this photographic genre, urban clubgoers pose for photos against temporary backdrops set up at nightlife venues. The backdrops, which often feature luxury cars, "sparkling skylines," and other idealistic imagery, allow Black clubgoers to place themselves in a world of their imagining. As Thompson concludes, "black urban populations use these contemporary picturing practices to present, indeed emblazon, their images of personhood, prestige, and pictorial immortality."[49] Corporate portraiture at music events like Afropunk is another contemporary picturing practice that gives visibility to Black consumers. Indeed, the importance of visibility to concertgoers is captured by one of the hashtags that accompanies reposts of festivalgoers images on the official Afropunk Instagram account: #AfropunkWeSeeYou.

Branding Diversity

IN MAY 2020 demonstrations erupted across the United States in response to the killings of George Floyd, Breonna Taylor, and other African Americans. Amid the protests was an outpouring of race-related philanthropy by businesses to support organizations like the National Museum of African American History and Culture (NMAAHC).[1] For example, on June 8, 2020, Bank of America announced that it was giving $25 million to the Smithsonian to launch a new initiative "Race, Community and Our Shared Future." The initiative involves programming at NMAAHC along with other Smithsonian museums and centers. Given that the gift will in part support activities at an African American museum, the donation is a signifying act communicating that Bank of America is committed to equity. The gift also conveys that Bank of America cares about diversity because public relations texts frame it in this fashion. For instance, a press release about the donation contextualizes it as part of the bank's larger $1 billion commitment "to advance issues of racial equality, health care and economic opportunity in minority communities."[2]

Honeywell, another Fortune 500 company, also used a donation to NMAAHC in the wake of the uprisings to express its commitment to equity. The gift, which was made before Floyd was killed, was publicized in a statement disavowing racism by the company's CEO. In the statement, the NMAAHC gift is referenced to prove that caring about diversity is not a newfound value of the company.[3] In a similar vein, an anti-racism statement put out by global sportswear company Nike after the uprisings notes the company's "long history of

providing support to the communities in which they operate." This statement includes a hyperlink to another statement, "How We Stand Up for Equality," which mentions that Nike was a founding donor of NMAAHC.[4]

These donations highlight a key argument of *Black Culture, Inc.*: that corporate philanthropy and sponsorships related to ethnoracial minorities (aka ethnic community support) are a key mechanism through which businesses cultivate an image as diverse and inclusive. In this way, ethnic community support is a form of what I term *diversity capital*, or a cultural practice that allows organizations to solve problems and leverage opportunities related to race and ethnicity and other social differences. This chapter summarizes the main arguments of the book and highlights the contributions for theory and research on cultural capital as well as the scholarship on corporate philanthropy and sponsorships. It also offers directions for future research on ethnic community support.

Race, Cultural Capital, and Community Support

While sociologists claim that corporate support of art and culture, like corporate philanthropy and sponsorships more generally, is used by companies to bolster their images, the existing research focuses on giving to "mainstream" initiatives.[5] Using the case of Black cultural patronage, this book elaborates how corporate support of ethnoracial minority focused initiatives is used in a distinct way—to give the appearance that companies care about diversity and equity. In making this argument, I develop the concept of *diversity capital*. Diversity capital advances research on race and cultural capital by extending theory around Black cultural capital and multicultural capital to organizations. Theory on Black cultural capital articulates how cultural practices related to Blackness are a resource used by individuals to signal their racial identity.[6] Research on multicultural capital asserts that elites signal openness through consuming culture across social boundaries including culture associated with ethnoracial minorities such as African Americans.[7] The elaboration of diversity capital in this book highlights how cultural practices linked to ethnoracial minorities, such as philanthropy and sponsorships related to these groups, are used by organizations to establish and maintain an image of being inclusive and equitable.

Focusing on Black cultural patronage, this book outlines the various processes through which ethnic community projects an image of corporations as diverse and inclusive. On one hand, acts of Black cultural patronage, such as donating to an African American museum or sponsoring a Black music

festival, function as diversity signs that express that a company cares about diversity. However, Black cultural philanthropy and sponsorships do not shape the racial images of companies simply because they are performative acts in and of themselves. Black cultural patronage also bolsters a company's image as diverse and inclusive because of public relations texts. In owned, earned, recipient, paid, and social media channels, Black cultural patronage is promoted and framed as indicative of businesses' valuing diversity and inclusion. In addition, at sponsored events brands are symbolically linked to Blackness via taking place in Black organizational spaces, signage that emphasizes Blackness, Black rituals, Black commentary by hosts, and/or other "Black" organizational, cultural, and emotional dynamics.

By elaborating how Black cultural patronage is used to brand corporations as diverse and inclusive, this book advances theory on race and cultural capital as well as theory on corporate philanthropy and sponsorships. In the remainder of the concluding chapter, I highlight the book's other contributions to our understanding of corporate community support and outline directions for future research. I focus on diversity washing, corporate image construction as a collective process, the sanitation of social realities, consumer responses, and the relative value of ethnic community support. Lastly, I consider how these insights are helpful for understanding corporate community support related to Asian American, Latinx, and Native American art and culture.

Diversity Washing

Black Culture, Inc. describes in-depth how Black community support projects an image of companies as diverse and inclusive. This begs the question, "Are these companies' projected racial images consistent with reality—are they authentic?" As we have seen in previous chapters, in some cases there is a degree of conflict between image and reality that results in Black community support functioning as a form of diversity washing that sanitizes racial inequality and misdeeds at companies.

Conflicts may arise because products that are promoted to African Americans as a part of Black community support are inherently harmful. We see this in Chapter 4 with the Kool brand of cigarettes. While the Kool Jazz Festival helped to project an image of the brand as caring about African Americans, the very product being marketed to the group—menthol cigarettes—was scientifically proven at the time to cause negative health effects.[8] Today, Altria, which

owns Philip Morris USA, promotes its support of NMAAHC as evidence of its longstanding commitment to African Americans, even though tobacco use is a major contributor to heart disease, cancer, and stroke, the leading causes of death for the group.[9]

To a degree, there is a similar conflict with McDonald's and Coca-Cola. McDonald's sponsorship of the Essence Festival and Inspiration Celebration Gospel Tour cultivates an image of the brand as valuing African Americans, yet signature products promoted to this market are unhealthy. For example, fast food, which is linked to cardiovascular disease, is served at no charge to festivalgoers at the Essence Festival by McDonald's.[10] Similarly, Coca-Cola projects an image of uplifting African Americans via their Essence Festival sponsorship, but it also passes out free samples of sugary soda (which is associated with an increase in medical problems such as diabetes) at the event.[11]

Corporate racial images and racial realities are misaligned with respect to the treatment of other stakeholders as well. For example, in the summer of 2020, just two months after McDonald's pledged to donate to the NAACP and Urban League in the wake of the 2020 BLM protests, a group of Black franchise owners sued the company for steering them toward urban locations that are less profitable.[12] It's also true that for some companies the bold statements about valuing diversity that accompany announcements about ethnic community support coexist with low representation of African Americans in management or on boards. For instance, Amazon issued a press release during the unrest proclaiming support for the growing social movement. "Black lives matter. We stand in solidarity with our Black employees, customers, and partners," the statement noted.[13] The press release also included a pledge to donate $10 million to a group of nonprofits that included NMAAHC. However, in 2020, the year the statement was made, just 3.8 percent of the company's senior leaders were African American.[14] In the same vein, the Chairman and CEO of investment bank Goldman Sachs announced a $10 million "Fund for Racial Equity" in June 2020, remarking that "To honor the legacies of George Floyd, Breonna Taylor, and Ahmaud Arbery, we must all commit to help address the damage of generations of racism."[15] In 2020, 3.2 percent of executives, senior officials, and managers at Goldman Sachs were African American.[16]

Instances where past or ongoing commitments to ethnic community support are mobilized by companies to justify not taking further steps to advance equity may also reveal inconsistencies between projected racial images and racial realities. For example, in 2021 the Walmart board opposed a shareholder

proposal to prepare a report addressing if and how the company's "racial jus-tice goals and commitments" aligned with the starting pay for sales associates.[17] The board's opposition statement argued that the proposal was "unnecessar-ily duplicative of the company's prior announcements and its ongoing work."[18] Included among the developments offered as evidence of Walmart's ongoing equity efforts were the company's newly established Center for Racial Equity, which had already made "approximately $14 million in grants" and was pledged "to award $100 million in grants over five years."[19]

In 2021, the boards of other corporations also highlighted ethnic commu-nity support in statements opposing shareholder proposals around racial eq-uity. For example, the board of Citigroup opposed a shareholder proposal to conduct a racial equity audit on the grounds that the company was "already addressing the intent" of the proposal.[20] Included among the board's rational-izations for how Citigroup was currently meeting the proposal's intent was a discussion of the company's race-related philanthropy such as a donation of $10 million in 2020 "to Black-led organizations fighting for racial justice."[21] Making a similar argument, the Goldman Sachs board deemed a shareholder proposal for a racial equity audit "unnecessary" given the company's "ongoing commit-ment" to diversity and inclusion including the creation of the eight-figure Fund for Racial Equity.[22] That same year the JPMorgan Chase & Co. board urged shareholders to vote against a proposal to conduct a racial equity audit by high-lighting how the bank was already taking "significant steps" to "advance racial equity and combat systemic racism" including involvement in philanthropic efforts in Black and Latinx communities.[23]

Cases where ethnic community support is used to shape a company's image as valuing diversity may function as diversity washing under the circumstances outlined above. However, as I note in the following, corporations do not act alone in producing their racial images.

Corporate Image Construction as a Collective Process

Black Culture, Inc. advances the scholarship on corporate community support by more fully elaborating the role of the media, consumers, and recipients in bolstering the images of businesses when they give. While the existing literature asserts that support provides an image boost for corporations,[24] scholarship does not account for the role of third parties, such as the media and consum-ers, in this process. The role of recipients in helping corporations to improve

their images is also not elaborated in depth. By accounting for the role of third parties, and more fully accounting for the role of recipients in corporate image-making via community support, this book offers a more detailed explanation of how philanthropy and sponsorships benefit corporations.

As we saw in Chapter 4, the production of a positive image for the cigarette brand Kool involved the company sponsoring an event by George Wein's production company—the Kool Jazz Festival. The Black media also played a part in the company's impression management via this sponsorship. By disseminating corporate messaging around the festival in editorial pages and ads, Black newspapers helped to shape Kool's image as a brand that was giving back to the Black community.

However, the media is not the only third party involved in the production of positive corporate images through community support. Consumers themselves also play a critical role. We see the role of consumers in the image production process at the Afropunk festival. There, companies such as AT&T and Instagram draw on the labor of festivalgoers to promote a Black and cool image for their brands. It is festivalgoers, many of whom are Black and styled in a distinctly Afropunk aesthetic, who take photographs in company-sponsored booths and post these photos on social media. These festivalgoers' Instagram posts lend the companies an image of Blackness and edginess.

We also see the role of consumers in shaping brand images in the chapters on the Essence Festival and the Inspiration Celebration Gospel Tour.[25] At these events, consumers help to create the atmosphere that is then associated with the brand. At the Essence Festival the music that is played in the convention center helps to elicit positive emotions and bonding among the festivalgoers. Black festivalgoers' feelings and behavior help to create a branded environment rife with Black pride and Black solidarity. In essence, Black festivalgoers are both producers and consumers of the branding that is taking place. Similarly, when concertgoers repeat in unison the McDonald's slogan "Black & Positively Golden" at the Inspiration Celebration Gospel concert, they help to sustain McDonald's image as a brand connected to the Black community. Walmart's racial branding is also co-produced by Black consumers. The company's "Reign On" marketing campaign is brought to life at the Essence Festival by eventgoers who walk through the convention center carrying the free branded "Reign On" tote bag over their shoulders and donning the golden giveaway crowns on their heads.

Black Culture, Inc. also offers new insight on how the actions of recipients support the positive imaging of companies when they give. By outlining how

staff at cultural organizations act as character witnesses who offer laudatory comments about businesses in PR texts about gifts—as we saw with the case of Denny's NCRM gift—we see how recipients are actively involved in the impression management of donors.

Given recent critiques around nonprofit funding, further elaborating the role of these various parties in the impression management of corporations is important. Protestors and other critics typically direct their ire around donations at two parties: the corporations that use gifts to project a positive image and the nonprofits that accept their support. For example, some corporations participating in the recent wave of racial justice philanthropy related to the Black Lives Matter protests have been lambasted as using their gifts to signal that they are "woke."[26] Similarly, oil companies that give to museums are accused of using their donations to appear virtuous even as they produce products that destroy the environment.[27] Nonprofits are criticized for participating in the image polishing of companies by allowing their good names to be linked to these "problematic" companies.

Black Culture, Inc. illustrates how responsibility for the image washing that companies engage in via community support cannot only be laid at the feet of donors and recipients.[28] It is also a result of the actions of third parties like the media and consumers. Moreover, recipients of funding do not only play a part in the image cleanup process because their positive reputations rub off on corporations when they donate; high-level staff at nonprofits also make positive statements in support of corporations in various media. In addition, recipients produce their own PR texts that portray corporations as good corporate citizens. Ultimately, image washing through community support should be understood as a phenomenon that depends on an interplay of actions among multiple parties.

Sanitizing Social Reality

While *Black Culture, Inc.* offers insight on how community support is used to define the images of corporations, it also offers perspective on a related topic—the role of corporate community support in defining social realities, such as racial inequality. The PR texts that are created to promote community support do not only frame corporations in a particular fashion. They also frame the social realities associated with whatever is being supported in certain ways. Or, they select and highlight certain aspects of those social realities, while ignoring

and deemphasizing others. Given that the fundamental goal of PR texts publicizing corporate community support is to cultivate a positive image for companies, we might expect that those aspects of social reality that are unpleasant and controversial will be left out of and/or deemphasized in these promotional materials. In the case of community support related to racial inequality, such as support for cultural institutions linked to civil rights, we might expect that PR texts promoting corporate support will avoid highlighting the more difficult and controversial aspects of racial imbalances in power and opportunities. For example, as we saw in the case of the Denny's commercial about the million-dollar donation to NCRM, the narrative about civil rights told in the ad was wholly triumphant and devoid of the uglier parts of that history, such as the reign of terror perpetuated by the Ku Klux Klan. Ultimately, the ad presents a sanitized version of the struggle for racial justice in the United States.

The capacity of PR texts to define the meaning of social realities, such as racial inequality, should be accounted for when considering the consequences of corporate funding. To return to the Denny's case, on one hand the seven-figure grant helped to support an institution that presents a complex and challenging narrative about civil rights. On the other hand, the company's support was also linked to defining civil rights history, in particular Martin Luther King, Jr.'s legacy, in a unidimensional fashion. This insight suggests that we should rethink how philanthropy and sponsorships are commonly understood to impact social inequality.

Often, the impact of philanthropy and sponsorships on social inequality is considered through a "cherry picking" lens.[29] Or, donors limit the capacity for widespread social change by supporting moderate rather than radical initiatives. However, the analysis in *Black Culture, Inc.* highlights how corporate philanthropy and sponsorships may also play a role in reproducing social inequality by presenting sanitized images of inequality in PR texts about corporate support. We can consider both points in relationship to the proposed United States National Slavery Museum. For an array of reasons, this museum never got off the ground. It has been suggested by those involved that the difficult topic of slavery may account for some of the reluctance of corporations to support such an institution.[30] Commenting on the fact that around 75 percent of corporate donors invited to support the effort declined, the museum's executive director concluded that, "[S]lavery is not a touchy-feely topic. . . . People are a little nervous about it."[31] An endeavor such as a national slavery museum could be at risk of minimal corporate support because the subject matter is

challenging. However, even if corporations would support such a museum, they may focus on the triumphant aspects of this history in the promotional texts that they produce to publicize their support.

Consumer Perceptions

While it is important to consider the role of ethnic community support in the construction of corporate images and broader societal realities, it is also critical to remember that consumers and other stakeholders do not always interpret corporate messaging in the ways that companies anticipate. For example, while corporations intend for their support of Black culture to communicate that they genuinely care about diversity and Black people, consumers may view it as at best a superficial attempt to pretend that they care about these issues, and at worse an effort to cover up harmful behavior related to African Americans. Before delving more into consumers rejecting the identity claims that corporations make, it is instructive to consider cultural theorist Stuart Hall's research on encoding and decoding.

Hall asserts that while advertising creatives and other producers may encode advertisements and other promotional texts with meaning, audiences don't necessarily interpret texts in the same way. Hall argues that there are three common modes of decoding texts: dominant-hegemonic, negotiated reading, and oppositional reading.[32] In the dominant-hegemonic position, audiences interpret a text in the way intended by the producer of the text. On the other end of the spectrum, oppositional readings take place when audiences interpret a message in a contrary fashion. The negotiated reading mode is a middle ground that occurs when audiences interpret the text in a way that only partially corresponds to what the producer has in mind.[33] To gain insight on decoding it is helpful to revisit Bank of America's support of NMAAHC, which we analyzed in Chapter 2.

To celebrate Black History month in 2019, Bank of America posted a tweet publicizing their support of NMAAHC. The post included a short video featuring the museum's then-director Lonnie G. Bunch, III, along with a series of images featuring notable Black historical events and figures. At the end of the video, a voiceover says, "We're proud to support our partner Lonnie Bunch, III, who brings history to life."[34] Following, the Bank of America and NMAAHC logos appear on the screen side by side.[35]

This promotion of Bank of America's patronage at NMAAHC symbolically links the company to diversity and the history of African Americans in

the United States. However, some social media users did not interpret Bank of America's support of NMAAHC as evidence that the company values diversity. Instead, they had an oppositional reading and accused the company of using their support as a sham to cover racial discrimination or as an empty symbol of diversity unaccompanied by concrete action to increase equity in banking. For example, one Twitter user wrote, "Nice of @BankofAmerica to announce this during #BlackHistoryMonth. What have you done to support Black people [to] get into businesses and homes? Real action is an all-year commitment. #underwhelmed."[36] Another user tweeted, "Now do a post about the #BlackHistory of @BankofAmerica discriminating against black and brown people. In the 2000s, not the 1950s."[37] This tweet included a link to a CBS article about the bank's $335-million agreement to settle a racial discrimination suit regarding fair lending practices and Black and Latinx customers.[38]

However, consumers don't always reject the racial image claims made by corporations. In some cases, consumers undertake negotiated or dominant-hegemonic readings of corporate messaging around Black cultural patronage. Here, I reference findings from a focus group and in-depth interviews with Black consumers related to Target's patronage at NMAAHC.[39] After exposure to Target messaging around the donation, consumers often responded with a negotiated reading where on one hand they questioned the extent of Target's commitment to Black people and culture (that is, they wondered about the degree of Target's commitment), but on the other hand they concluded that, to some extent, the company does care. This conflicted response is captured by the statements of one consumer who expressed skepticism about the sincerity of the donation, saying, "If corporations take a stance on something it's hard to know if it's genuine or if it's for sales," but then also concluded, "Well, it's [Target] not like my first place to go and shop . . . , but it's definitely good to know if I am shopping at Target [that] they give a damn about me and people like me." On the other hand, another consumer had a dominant-hegemonic response where she interpreted the messaging as intended by Target. At no point did she question the veracity of Target's claims about being a good company. She concluded:

> Now that I know about it [the donation by Target to NMAAHC], I am impressed. I didn't know that they were involved. I've really followed that museum since it was opened last year, and I've wanted to go for a long time. And now, knowing that Target is involved makes me look at them in a new light—with a little bit more respect.

A next step in understanding ethnic community support as a form of racial image management is learning more about why consumers accept or reject the identity claims made by corporations; or, we need more insight on the reception of this messaging.[40] Under what circumstances do consumers believe what corporations say about their racial identity in corporate messaging around community support? For example, if a company has a history of discriminating against a particular ethnoracial group and that experience is part of the group's collective memory, consumers from that group may be cynical about messaging that the company is a good racial actor.

The Relative Value of Ethnic Community Support

Another important line of future research is investigating how much companies are willing to invest in ethnic community support, relative to "mainstream" community support, to manage their images. In considering this issue, research on how corporations and other organizations value work related to diversity is instructive. Research on corporate executives shows that the jobs of managers who occupy "racialized jobs," or jobs with a connection to Black communities and civil rights—such as "vice president of diversity, equity, and inclusion"; "chief diversity officer"; and "head of inclusion & diversity"—are less secure than those who hold "mainstream jobs" or jobs focused on "general (i.e., predominately white) constituencies."[41] Scholarship in other areas, such as healthcare, also suggests that racial equity work, or labor focused on helping organizations become more accessible to Black and other ethnoracial communities, is less valued.[42] If corporations view their racial image as less important than other aspects of their image, such as their industry image, then they may put fewer dollars toward ethnic community support. In this regard, Boeing's support of Smithsonian museums is notable.

In 2008, Boeing announced a seven-figure donation to NMAAHC.[43] The NMAAHC donation was not the company's first gift to a Smithsonian museum. As discussed in Chapter 2, the corporation has been a long-time supporter of the National Air and Space Museum (NASM). Gifts to both NMAAHC and NASM construct the company's identity—donations to NMAAHC signal that the company values diversity whereas gifts to the NASM affirm the company's leading position in the aerospace industry. Although support of each cultural institution helps to convey a positive image for Boeing, less money was donated to the museum that helps to legitimate the company's racial image than

its aerospace image. While the $5 million donation to NMAAHC put the corporation among the museum's exclusive Cornerstone donors, the company has made a substantially larger investment in NASM. Between 2006 and 2019, Boeing gave multiple donations to NASM, including gifts of $2 million, $15 million, and $30 million. If companies typically view their racial image as less vital to their survival and growth than other aspects of their image, then this may contribute to the broader pattern of funding disparities between "ethnic" and "mainstream" nonprofits.[44]

Asian, Native American, and Latinx Corporate Community Support

Since the idea of ethnic community support as a form of diversity capital is developed in *Black Culture, Inc.* by focusing on the case of Black cultural patronage, in this section I briefly consider how other forms of ethnic community support also serve to brand companies as diverse and inclusive. I specifically consider corporate support of Asian, Native American, and Latinx culture as forms of diversity capital.

Wells Fargo: Lunar New Year Cultural Events

Each year, the multinational financial services company Wells Fargo sponsors various Asian cultural events. PR about some of these sponsorships is used to cultivate an image of the bank as committed to Asian Americans. For instance, in 1993 the company created a special branded float for the Lunar New Year parade in San Francisco. The Lunar New Year is a period celebrated worldwide across the Chinese diaspora. Years later, in 2017, the float was promoted on the bank's website as a reminder "that Wells Fargo has been part of the Asian-American community for generations."[45] Similarly, in 2013 the company sponsored a Lunar New Year art exhibit at Alhambra City Hall and a Lunar New Year festival at the Pacific Asia Museum in Pasadena, California. An executive at the bank framed the event as an articulation of the bank's valuing of "the Asian community."[46]

His statement is distinct from commentary related to corporate support of Black culture in that it makes claims related to caring about Asian Americans. However, just as the promotion of some Black cultural initiatives takes place in earned media, publicity around sponsorship of these Asian cultural activities is also placed in earned media. The executive's statement is printed in volume 2, number 5 of the *Alhambra Press*, a local newspaper that covers Alhambra a city

in Los Angeles County. It appears on page 3 in an unsigned article with the title, "Wells Fargo celebrates year of the snake with special customer appreciation promotions and community sponsorship."[47]

As we saw with PR statements created by Kool to promote the Kool Jazz Festival that were reprinted in the editorial pages of newspapers in the 1970s and 1980s, this article, which includes contact information to interview a "Wells Fargo spokesperson," was also reproduced in different papers. Other news venues in California printed versions of the same article in online editions."[48]

BNSF: National Native American Veterans Memorial

When BNSF Railway made a $500,000 gift to the National Native American Veterans Memorial in 2018, a monument that stands on the grounds of the National Museum of the American Indian (NMAI), the company produced a host of PR materials promoting the donation. The owned media texts frame the gift as concrete evidence of the company's commitment to Native Americans. For example, a press release about the donation includes a statement from a diversity and inclusion executive, the company's director of tribal relations, who reminds readers that the donation is part of the company's broader involvement with Native Americans. He notes how he and other staff "have done extensive outreach to tribal communities." A whole section in the press release also provides an overview of the company's involvement with Native Americans via the tribal relations group noting that "the BNSF Tribal Relations team is the first in the industry."[49]

The donation is also promoted in a community relations post on the BNSF website titled "BNSF Focused on Creating Strong and Lasting Ties with Tribal Nations." The gift is discussed in a highlighted section in the post that features a rendering of the memorial. This section includes a statement from the director of NMAI, who affirms the generosity of the company in its effort to preserve the memories of Native American veterans.[50]

As we saw with publicity around Black cultural patronage by corporations, the promotion of this half-million-dollar donation to NMAI tells only part of the story of diversity and inclusion at BNSF. What is left out of the promotional story is that since 2015 the company has been embroiled in a lawsuit with the Swinomish Indian Tribal Community for violating an easement agreement around BNSF trains carrying crude oil across the reservation.[51] As the chairman of the Swinomish Indian Tribal Community asserts, "It's unacceptable for BNSF to put our people and our way of life at risk without regard

to the agreement we established in good faith." Promotion of the NMAI gift offers an indirect counternarrative to the claim that BNSF puts Native Americans at risk.[52]

Buchanan's (Diageo): J Balvin and Latinx Culture

In 2019 Buchanan's, a scotch whisky brand owned by Diageo, a global producer of alcohol, promoted a partnership with J Balvin.[53] J Balvin is a world famous reggaetón singer from Colombia. Buchanan's, a sponsor of J Balvin's Vibras and Energía Tours, also hired the global superstar as creative director of Imparables Colección, a design contest that is part of their broader Es Nuestro Momento campaign. As part of the initiative, contestants submitted entries for a chance to have their original designs featured on a limited-edition Buchanan's pack. The company also commissioned four Latinx and Latin American artists to create artwork as part of the campaign. Balvin, who is described in a press release for the campaign as a "proud Colombian music artist" also created a limited-edition bottle "inspired by his culture."[54]

The box and label for Balvin's bottle includes a graffiti-style artistic rendering of his name. Press releases for the initiative define the campaign as expressing Buchanan's commitment to Latinx culture and people. One press release explains, "Buchanan's is a proud champion of Hispanic culture."[55] Another press statement explains that the company's collaboration with Balvin was intended to "empower" Latinx people. Balvin himself testifies to how Buchanan's uplifts Latinx people, saying that the brand "has supported my career and the Latin community for years."[56]

To communicate with Latinx people and to signal a connection to them, this campaign includes promotional materials in Spanish. The campaign site has a button to choose an English or Spanish version of the text.[57] The Spanish version of the site makes the same proclamations about the brand's commitment to Latinx culture and people: "Buchanan's celebra la cultura Hispana porque Es Nuestro Momento de reconocer a la nueva generación de líderes hispanos y sus contribuciones en los Estados Unidos."

Just as promotional texts about Black cultural patronage emphasize positive aspects of a corporation's diversity while downplaying or ignoring those aspects of a company's racial past and present that are not so flattering, so does this Buchanan's promotion. Buchanan's frames their support of Balvin and other Latinx and Latin American artists as an expression of care for Latinx people. What is left unsaid is that the targeting of ethnoracial minority consumers by

companies that produce "vice" products, such as alcohol and tobacco, may con-
tribute to poor health and social outcomes in those communities.[58]

The Cost of Ethnic Community Support

Through an in-depth examination of Black cultural patronage, *Black Culture,
Inc.* elaborates how corporations use philanthropy and sponsorships related to
ethnoracial minorities to brand themselves as diverse and inclusive. On one
hand, this is a win-win situation for corporations as well as the nonprofits and
other recipients of their largesse. In a changing environment where corpora-
tions' success and survival increasingly depend on communicating that they
care about diversity and are connected to ethnoracial minorities, ethnic philan-
thropy and sponsorships are a valuable cultural resource. Likewise, the money
that these companies give to recipients often serves the public good. Still, these
donations and other forms of support potentially come at a cost—drawing at-
tention away from how some companies have in the past, and continue to, per-
petuate racial inequality.

Notes

Chapter 1

1. Banks 2010b, 2017, 2018, 2019b; Carter 2003; Fleming and Roses 2007; Meghji 2019; Wallace 2017, 2019.

2. Berrey 2015; Dobbin and Kalev 2017; Edelman 2016; Skrentny 2014.

3. Skrentny 2014: 13.

4. Also see Nancy Leong's (2013, 2021) analysis of "identity capitalism," which describes how in-group members, including companies, accrue benefits by association with members of out-groups.

5. Dávila 2001.

6. For example, see Chambers (2009), Crockett (2008), and Hunter (2011a).

7. Johnson et al. (2019) provide wide-ranging perspectives on the ways that race structures marketplace activities.

8. A growing critique of philanthropy in general is that it is self-interested and reinforces inequality (Giridharadas 2018; McGoey 2015; Reich 2018).

9. My analysis includes philanthropic pledges made by Fortune 500 companies in response to the BLM uprisings in the summer of 2020.

10. For a broader discussion of how progress on racial diversity in corporate America has stalled, see Dobbin and Kalev (2021), Newkirk (2020), and Stainback and Tomaskovic-Devey (2012).

11. After a series of racial indiscretions in 2018, including alleged use of the N-word by founder and CEO John Schnatter, Papa John's ousted the leader and made a $500,000 donation to Bennett College, an HBCU, in 2019 (Papa John's 2019). That same year after widespread criticism for selling a sweater evocative of blackface, luxury fashion company Gucci announced a $5 million Changemakers Fund to help create opportunities in the African American community (Carrera 2019; Hanold Associates 2019). I discuss the Denny's case in Chapter 3.

12. Alexander 1996a, 1996b.

13. DiMaggio 1982a, 1982b; Lena 2019.

14. Field Museum n.d.; Ford Corporate n.d.

15. Individual and corporate philanthropy are also linked via the executives who

work at corporations. It is not unusual for executives who serve on cultural boards to help arrange gifts from their companies to the nonprofits that they support. In some cases, corporate managers are specifically recruited to join cultural boards to serve as a conduit between nonprofits and businesses (Banks 2019a: 82–89; Ostrower 2002).

16. Banks 2021:162–164; Vogel 2016.

17. Soule 2009; Tsutsui and Lim 2015.

18. Himmelstein 1997; Martorella 1996.

19. While philanthropy and sponsorships have some technical distinctions, in practice they both often fall under corporate efforts to contribute to the public good. Classically, philanthropy differs from sponsorships in that with the former there is no expectation that a company will benefit from the transaction. With that, philanthropy is typically more eligible for tax deductions than sponsorships. In addition, philanthropy has been traditionally executed by corporate foundations, while sponsorships have traditionally been overseen by corporate marketing teams. However, in more recent decades the distinction between philanthropy and sponsorships has blurred. As Ed Able, then director of the American Alliance of Museums, observed about this shift over 25 years ago, "More and more of the funding for cause-oriented activities is coming from the marketing budget and less from a true philanthropic budget. [Businesses] are looking to some degree of quid pro quo" (Yu 1992). Reflecting on this change, the head of a major corporate foundation explained that grants to nonprofits are increasingly made on the basis of expected returns for the company: "There's measuring of outcome before we agree to award a grant. So there's a new way of thinking that's much more investment-oriented than the old charitable contribution" (Yu 1992). The overlap between philanthropy and sponsorships is also reflected by findings from a survey of fundraising professionals, which found that close to 70 percent agreed that their organizations do not view these forms of support differently (IEG n.d.).

20. Cohn 1970: 70–73; Gasman and Drezner 2008.

21. Chen, Patten, and Roberts 2008; Himmelstein 1997; Porter and Kramer 2002; Stendardi 1992: 21–30; Walker 2013.

22. Barman 2017.

23. Alexander 1996a: 92.

24. Alexander 1996a, 1996b; DiMaggio and Useem 1982; Kirchberg 2003; Martorella 1990, 1996.

25. Alexander 1996b: 25.

26. Ibid.: 25, 57.

27. Bourdieu 1986.

28. These critiques are part of a broader revision of cultural capital theory, asserting that the forms of culture that function as a resource vary within different social milieus; see Hall 1992; Lamont 1992; Lamont and Lareau 1988.

29. Carter 2003; Claytor 2020; DiMaggio and Ostrower 1990; Hall 1992; Meghji 2019; Wallace 2017, 2019.

30. Carter 2003.

31. Ibid.

32. Banks 2010a, 2010b, 2017, 2018, 2019a, 2019b; Fleming and Roses 2007; Grams 2010; Meghji 2019; Wallace 2019. This approach to racial identity fits within a larger tradition of viewing racial identity as accomplished through sets of behavior or "performances." For example, see Sarah Susannah Willie's (2003) research on how Black college students perform race.

33. Bryson 1996.

34. Johnston and Baumann 2007, 2010; Khan 2011; Lena 2019; Lizardo and Skiles 2012, 2015; Peterson 1997.

35. Ray 2019; Wooten 2019.

36. Wooten 2006.

37. Díaz-Bustamante, Carcelén, and Puelles 2016: 2; Hatch and Schultz 2002; Massey 2015.

38. Grier and Brumbaugh 1999; Grier, Brumbaugh, and Thornton 2006. Marketing researchers sometimes measure the racial image attributes of products by asking consumers to indicate the types of ethnoracial groups with which they associate specific products. For example, research in the 1980s assessed the extent to which consumers perceived the "smoker image" of particular cigarette brands as African American ("The 1983 Image Study").

39. Berrey 2015; Edelman 2016; Krieger, Best, and Edelman 2015; Leong 2021; Skrentny 2014.

40. Banks 2021: 54–68; Dávila 2001; Maheshwari 2017.

41. Adobe 2019.

42. On one hand, growth in "ethnic" markets is a function of increasing immigration from regions such as Latin America and the Caribbean and Asia. Prior to 1965, immigration from countries outside of Europe was severely limited. But, with the passage of the Hart-Celler Immigration Act, which eliminated national quotas in 1965, immigration from Africa, Asia, the Caribbean, and Latin America swelled. These immigrants, as well as their children, have contributed to a so-called browning of the United States. Some estimates project that by 2045, non-white people will become the majority (Frey 2018). Though the US Black population as a whole hasn't changed as dramatically over the past six decades as the Asian and Latinx populations, there has been a large shift in the class demographics of this group. Whereas the majority of Black people in the United States were working class and poor prior to the 1960s, by the 1990s most African Americans could be considered middle class (Pattillo 2007). This was a result of new civil rights laws banning discrimination in schools and the workplace as well as a strong economy in the 1960s (Wilson 1978). This class transformation means that African Americans have more "buying power" or discretionary income to spend on goods and services (Burnett and Hoffman 2010).

43. Bobo 2001; Bobo et al. 2012.

44. Bobo et al. 2012: 53.

45. Bobo, Kluegel, and Smith 1997; Bonilla-Silva 2006.

46. Banks 2021: 71; Crockett 2008; Hunter 2011b; Schor 2004: 48. Research on the

Black culture industry also highlights how audiences for Black culture are racially broad (Cashmore 1997).

47. Schultz 2019.

48. Galaskiewicz 1985; Useem 1984.

49. Dobbin 2009.

50. Edelman 2016. See also Henderson, Hakstian, and Williams (2016) and Pittman (2020) for analyses of consumer discrimination.

51. While this book focuses on diversity capital as it relates to ethnoracial minorities, similar dynamics may also be at play with cultural practices tied to gender, sexual orientation, and disability status.

52. The use of "ethnic" culture to brand companies has parallels with the use of the arts to brand urban ethnoracial minority neighborhoods (Wherry 2011).

53. Massey 2015: 7.

54. Berrey 2015.

55. See Skrentny (2014) for a discussion of how companies aim to project their racial image to various racial audiences. Also, research on ethnic marketing elaborates on how companies direct messaging at racially segmented audiences such as the "African American market," the "multicultural market," and the "general market." This research also addresses how increasingly companies direct messaging at the "total market" or consumers across racial and ethnic groups (Banks 2021: 54–68).

56. Skrentny (2014) outlines how firms seek to communicate "openness," "lack of racism," and care to various racial audiences.

57. For example, research on affirmative action asserts that judges defer to "cosmetic compliance" with civil rights law when making decisions about discrimination cases (Edelman 2016).

58. For broader discussions of gift giving as a form of communication conveying that givers honor and respect recipients, see Belk (1977) and Mauss (1967).

59. This includes owned media (media channels that a company controls), recipient media (media channels that recipients of ethnic community support control), earned media (media channels controlled by a third party that cover a company for no direct remuneration), paid media (media channels that a third party controls and a company pays money for), and social media (media channels where participants share content).

60. Tolley 2015: 18.

61. On race and framing see Natasha K. Warikoo's (2016) research on the ways that students at elite colleges and universities think about the admissions process. Students who view admissions through a "diversity frame" emphasize the educational value of a diverse student body.

62. As research on culture and commerce elaborates, brand images are developed via advertisements where referents (such as a particular type of person or object) are placed next to company names, logos, and products. Through placing referents with particular meanings next to company names, logos, and products, the meanings of the referents are transferred to the brand (McCracken 1986). A similar dynamic takes place in physical space at support-related venues. When company names and logos are placed

within, on the grounds of, and inside of venues, meanings of venues themselves along with happenings in and around venues are transferred to brands.

63. For example, research on race and advertising elaborates on how ads that include "ethnic consistent cues" for a particular ethnoracial group, such as "depictions of [their] ancestral heritage," help to convey that products are intended for use by members of that group (Grier, Brumbaugh, and Thornton 2006: 38).

64. These interviews were conducted over the course of 2008 to 2016 as part of a project on philanthropy at African American museums.

65. To content analyze data, such as documents in the cultural patronage database, I used NVivo, which is a qualitative data analysis program.

66. McDonnell and King 2013.

67. Truth Initiative 2018; US Food & Drug Administration 2021.

68. Gardiner 2004.

69. DeNora 2000.

70. Fryar et al. 2018.

71. Wade 2012.

Chapter 2

1. NMAAHC 2021.

2. Carter 2003.

3. Trescott 1996.

4. "Accepting Smithson's Gift" n.d.

5. "Who Was James Smithson?" n.d.

6. "Accepting Smithson's Gift" n.d.

7. Masters 1992.

8. Trescott 1996.

9. Heyman 1998.

10. Masters 1992.

11. "O. Orkin Insect Zoo."

12. "The Iconic Flag Sweater."

13. Exxon Mobil Corporation 2003.

14. Target 2017.

15. Lott 2014.

16. Trescott 2001.

17. Museum of the American Indian 1985.

18. Museum of the American Indian n.d.

19. Development Campaign-Documents, 1990–1992 n.d.: 49.

20. "Corporations with Indian Names" n.d.

21. Ibid.

22. Blake 1989.

23. Berkman 1991.

24. Weinraub 1990.

25. Ibid.

26. "NMAI Launches Corporate Membership Program" 1997.
27. Ryan 2004.
28. Bank of America 2015.
29. Ralph Lauren 2018.
30. Fthenakis 2016.
31. Ibid.
32. Yiin 2016.
33. Taft and Burnette 2003: 7.
34. Ibid: 44.
35. Ibid: 41.
36. Ibid: 70–71.
37. AT&T 2016b.
38. Ibid.
39. King 2016.
40. AT&T 2016a; AT&T n.d.
41. Exelon 2016a.
42. Mediacloud.Exeloncorp 2016.
43. Pepco 2016.
44. Exelon 2016b.
45. "Part of Our Fabric" n.d.
46. Bank of America 2016.
47. "The Power to March Forward" 2019.
48. @BankofAmerica 2019.
49. 21CF Staff 2016.
50. FOX Searchlight 2016.
51. 20th Century Studios 2016.
52. 21CF Staff 2016.
53. NMAAHC Collection n.d..
54. Parker 2016.
55. Target 2016a.
56. Target 2016b.
57. Ibid.
58. Ibid.
59. Monee 2016.
60. FedEx 2002.
61. FedEx 2011.
62. FedEx 2016.
63. FedEx 2019.
64. FedEx 2016.
65. Salmans 1981.
66. "Altria Group Donates . . ." 2014.
67. "Altria's Diversity & Inclusion Heritage" 2020.

Chapter 3

1. Bunch 2019: 119.

2. Gayle 2020; Moynihan 2018; Pogrebin, Harris, and Bowley 2019.

3. Alexander 1996b, 2014.

4. Goffman 1963.

5. Devers et al. 2009; Highhouse, Brooks, and Gregarus 2009.

6. McDonnell and King 2013.

7. Ibid.: 391.

8. DiMaggio and Useem 1982: 191–192.

9. Alexander 2014: 368.

10. Denny's n.d.

11. Prior to the 1960s, it was not uncommon in certain parts of the United States, such as the South, for African Americans to be treated in an inferior manner in restaurants. Jim Crow practices—such as not allowing Black people in restaurants at all; making them enter through a separate entrance, like a back door; not allowing them to sit when having purchased food; or making them sit in undesirable areas—were common (Banks 2021: 127–133). Many restaurants that engaged in these practices advertised that they did so. For example, signs such as "we serve whites only" or "colored entrance in the rear" were displayed in the front of these establishments.

12. U.S. v. Flagstar Corporation and Denny's, Inc. 1994.

13. The group also included an East Indian woman. U.S. v. TW Services, Inc. 1993.

14. Ibid.

15. Ibid.

16. Adamson 2000: xi.

17. Ibid.: 9.

18. Labaton 1994; U.S. v. Flagstar Corporation and Denny's, Inc. 1994.

19. Adamson 2000: 49.

20. Ibid.: 55–56; Holmes 1995.

21. Adamson 2000: 56–60.

22. Ibid.: 57–59.

23. Ivey 2002.

24. Ibid.; Business Editors 2000.

25. Ivey 2002.

26. "Ex-WVU Player Sues Denny's" 1999.

27. Guilarte 1999.

28. Schaver 1999.

29. Mitchell 2001.

30. "Ex-WVU Player Sues Denny's" 1999.

31. McRae 2001.

32. Winston 2000.

33. Mitchell 2001.

34. As part of the renovation, the museum purchased the boarding house directly

across the street from the Lorraine Motel. The boarding house was where James Earl Ray, the man who assassinated King, stayed (Jackson 1998).

35. Denny's 2001.

36. Ibid.

37. Denny's 2002b.

38. Denny's 2002a.

39. Ibid.

40. Denny's 2002d.

41. National Civil Rights Museum 2002b.

42. National Civil Rights Museum 2002a.

43. National Civil Rights Museum 2002c.

44. Denny's 2002c.

45. Livernois 2003.

46. Tejedor 2005.

47. "South: Gypsies Vs. Denny's" 2005

48. Livernois 2003.

49. Tejedor 2005.

50. Ferruzza 2005.

51. "Three Companies Show Why They Are Best-in-Class for Diversity" 2006.

52. Atkins 2005.

53. Ibid.

54. Denny's 2005.

55. Ibid.

56. Denny's 2006.

57. Denny's 2008.

58. Denny's 2010.

59. "Women Called Racial Slurs Told to Leave Local Denny's" 2019.

60. Ibid.

61. Denny's 2021.

62. King 1963.

63. For a related analysis of social responsibility efforts and collective memory around civil rights history, see West (2021) who describes how corporate advertisements commemorating the establishment of a national holiday for Dr. Martin Luther King, Jr. often present a less radical version of his legacy.

Chapter 4

1. Maloney and McGinty 2018.

2. CDC 2020.

3. US Food & Drug Administration 2021.

4. Knowles and McGinley 2019.

5. US Food & Drug Administration 2021.

6. AMA 2021.

7. Gardiner 2004.

8. Evidence that tobacco firms used marketing to shape race-related meanings around cigarettes sits within a broader body of scholarship showing how the meanings of cigarettes were actively shaped by marketing efforts in the tobacco industry as a whole (Hsu and Groda 2015; National Cancer Institute 2008).

9. Stephen and Galak 2012: 624.

10. Jackson and Moloney 2016; Jacobs and Townsley 2011: 9; Lewis, Williams, and Franklin 2008; Reich 2010; Russell 2008.

11. Project for Excellence in Journalism 2010.

12. Farsetta and Price 2006.

13. Big Tobacco's influence on news reporting is not limited to the Black media. Shaping news coverage has been part of the tobacco industry's larger strategy to increase market share and shape public opinion about cigarettes (National Cancer Institute 2008).

14. Khaire 2017.

15. For example, a "Promotions Plans" letter describes how 536,000 packs of cigarettes would be available for sampling across the 14 cities on the 1981 KJF tour schedule (Novak 1981).

16. Ganz, Rose, and Cantrell 2018.

17. Borawski et al. 2010.

18. Ganz, Rose, and Cantrell 2018.

19. Nelson 1999.

20. "The Brown & Williamson Story" 1980.

21. "Kool" n.d: 8.

22. Ibid.: 10.

23. Action Marketing Ltd. 1978.

24. Wein and Chinen 2003: loc. 6464–6470.

25. B&W records suggest that in 1977 the company would pay "between $500,000 and $750,000" for concerts in 13 markets (McKeown 1976). At one point, the company paid Wein $1.3 million to stop promoting the festival in Newport. They were concerned that the name, the Kool Newport Jazz Festival, was providing free promotion for Newport, a rival cigarette brand (Wein and Chinen 2003).

26. Wein and Chinen 2003: loc. 6578.

27. Action Marketing Ltd. 1978; Essence 1979; I. Holmes 1979.

28. Novak 1981.

29. Kirk 1979.

30. Broecker 1977: 3.

31. Wein and Chinen 2003: loc. 6579.

32. Wein and Chinen 2003.

33. Ibid.: loc. 6337.

34. Moody 2008.

35. Nelson 1999.

36. Browne, Deckard, and Rodriguez 2016; Fields and Newman 2020; Jacobs 2000; Moody 2008.

37. Jacobs 2000: 539.

38. *Freedom's Journal* 1827.

39. Jacobs 2000.

40. Ibid.: 585.

41. Jacobs 2000.

42. Ibid.

43. Ibid.

44. Ibid.: 786.

45. Gardiner 2004: S60. Gardiner also reminds us that *Ebony* ran Kool ads featuring the New York Yankees Black baseball hero Elston Howard in the 1950s and 1960s (ibid.).

46. In "Quid Pro Quo: Tobacco Companies and the Black Press" (McCandless, Yerger, and Malone 2012), the authors demonstrate close ties between the tobacco industry and the major trade organization of the Black press, the National Newspaper Publishers Association (NNPA). However, while the article presents evidence from the Legacy Tobacco Documents Library and archives of the NNPA that tobacco companies "viewed their support of the Black press as buying its loyalty and securing its favor," there is not a corresponding analysis of editorial coverage to concretely demonstrate corporate influence (ibid.: 744). This chapter expands this approach by not only examining archival data relating to efforts by the tobacco industry to influence the Black press, but also doing a complementary analysis of actual news stories to investigate evidence of corporate influence.

47. Sales Department 1979.

48. "Kool Jazz Festival" 1979; Sales Department 1979.

49. "800000 Hampton Kool Jazz Festival" 1980; "800000 Oakland Kool Jazz Festival" 1980.

50. "Kool Jazz Festival–Atlanta" 1986.

51. Santangelo 1976.

52. "Kool Jazz Festival–Atlanta" 1986.

53. Ibid.

54. "800000 Hampton Kool Jazz Festival" 1980.

55. "Kool Jazz Festival–Atlanta" 1986.

56. Santangelo 1976.

57. Willson 1975.

58. Ibid.

59. "Kool Jazz Festival and Kool Country on Tour Marketing Plans" 1978: 8.

60. "Kool Jazz Festival–New York Publicity Program" 1981.

61. Ibid.

62. "800000 Hampton Kool Jazz Festival" 1980.

63. Ketchum Public Relations 1982.

64. Ibid.

65. "800000 Hampton Kool Jazz Festival" 1980.

66. Sales Department 1979.

67. Khaire 2017: 78.

68. *Atlanta Daily World* 1976.

69. Ibid.

70. *Indianapolis Recorder* 1976.

71. *Afro-American* 1976.

72. *New Journal and Guide* 1983.

73. *Indianapolis Recorder* 1976.

74. *Atlanta Daily World* 1978a.

75. *Indianapolis Recorder* 1977b.

76. *Atlanta Daily World* 1978a.

77. *Indianapolis Recorder* 1977b.

78. *Call and Post* 1985.

79. *Amsterdam News* 1981.

80. *Amsterdam News* 1983.

81. *Amsterdam News* 1981.

82. *Call and Post* 1980.

83. *Amsterdam News* 1981.

84. *Atlanta Daily World* 1978a.

85. Sales Department 1979.

86. *Atlanta Daily World* 1980.

87. *New Journal and Guide* 1979.

88. *Call and Post* 1983.

89. *Los Angeles Sentinel* 1982.

90. *Call and Post* 1985.

91. *Call and Post* 1983.

92. *Call and Post* 1980.

93. *Amsterdam News* 1981.

94. Ibid.

95. "Kool Jazz Festivals General Information" 1981.

96. *Los Angeles Sentinel* 1982.

97. *Call and Post* 1980.

98. *Amsterdam News* 1981; "Hampton Kool Jazz Festivals: Close-Up" 1980.

99. *New Journal and Guide* 1979.

100. Mills 1978.

101. National Cancer Institute 1996: 1.

102. National Cancer Institute 1996.

103. *Atlanta Daily World* 1978a.

104. CDC n.d.

105. Ibid.

106. While I haven't come across evidence demonstrating that Kool staff specifically pursued editorial coverage of the festival to avoid promotion of the brand without the warning of the Surgeon General, it is the case that the government ban on broadcast advertising in 1971 contributed to tobacco companies shifting their marketing to focus more on sponsorships like the Kool Jazz Festival ("Kool History" n.d.: 160; National

Cancer Institute 2008, 39–40, 82–83). Regardless of what caused B&W to seek out news stories on the festival, the effect of the coverage was that the brand was promoted without the stigmatizing government warning.

107. *Atlanta Daily World* 1979.

108. "Kool Country on Tour" 1980.

109. "Kool; Kool Parent; Kool Super Lights" n.d.

110. "The Most Refreshing Taste You Can Ge[t] in Any Cigarette" 1977.

111. Mills 1978.

112. Ibid.

113. *Los Angeles Sentinel* 1981.

114. *Sun Reporter* 1979.

115. "Kool Jazz Festival and Kool Country on Tour Marketing Plans" 1978: 6.

116. *New Journal and Guide* 1976; *Oakland Post* 1976; *Wichita Times* 1975.

117. *Oakland Post* 1976.

118. "George Wein Presents the 750000 Kool Jazz Festivals" 1975.

119. *Indianapolis Recorder* 1977a.

120. *Atlanta Daily World* 1977; *Oakland Post* 1975a.

121. "George Wein Presents the 750000 Kool Jazz Festivals" 1975.

122. *The Skanner* 1982.

123. "Kool Jazz Festival" 1982.

124. *Oakland Post* 1975a.

125. "George Wein Presents the 750000 Kool Jazz Festivals" 1975; *Oakland Post* 1975a.

126. Barman 2016.

127. "Kool Jazz Festival and Kool Country on Tour Marketing Plans" 1978: 6.

128. *Tri-State Defender* 1976.

129. "Community Relations Program Announced by 760000 Kool Jazz Festivals" 1976.

130. *Tri-State Defender* 1977.

131. "Community Relations Program Announced By 760000 Kool Jazz Festivals" 1976.

132. *Oakland Post* 1975b.

133. *Oakland Post* 1975a.

134. McCarthy 1975.

135. *Sun Reporter* 1978.

136. "Kool Jazz Festivals" 1978.

137. *Atlanta Daily World* 1978b.

138. Santangelo and Wein 1975.

139. *Atlanta Daily World* 1979; *Los Angeles Sentinel* 1979.

140. *Atlanta Daily World* 1979.

141. "Jazz Festivals—The Events of the Year" 1979.

142. "Kool Jazz Festivals 790000" 1979.

143. *Philadelphia Tribune* 1981.

144. "Program of Kool Jazz Festival New York Announces" 1981.

145. *Tri-State Defender* 1978.

146. "Kool Jazz Festival" 1978.

147. Ibid.

148. "Program of Kool Jazz Festival New York Announces" 1981.

149. Campbell 1979.

150. Byrd 1983.

151. Brown & Williamson 1983.

152. Matthews 1982.

153. Clark 1980.

154. Ibid.

155. McDonough 1983.

156. Ibid.

157. Ibid.

158. Austin 1976.

159. Ibid.

160. Wein 1976.

161. Wein's letter provides a detailed account of the profits made from the show. "Urge us to give more and do what you can to pressure us," he writes. But, he is "concerned" that the article might discourage others from giving "for fear of the same type of criticism." He ends the letter with an invitation to continue the discussion during his next trip to Oakland the following year (Wein 1976).

162. "New Brand Information" 2004.

Chapter 5

1. Hardimon 2016.

2. DeNora 2000.

3. Ibid.: 153.

4. Bruner 1990.

5. DeNora 2000: 139.

6. Ibid.: 143.

7. DeNora 2000.

8. Lena 2012: 98–109. Also see Gans (1999) for a broader discussion of how members of taste publics, including those distinguished racially and ethnically, share distinct taste cultures.

9. Silber, Silber & Associates, and Triplett 2015: 23.

10. Koontz and Nguyen 2020.

11. Lewis: 2014: 246.

12. Wein and Chinen 2003: loc. 7353.

13. Ibid.: loc. 7356.

14. Lewis 2014: 246.

15. Ibid.: 248.

16. Ibid.

17. Ibid.

18. AT&T 2019.

19. officialnewcupid 2019.

20. *New Cupid* 2018.

21. Walmart World 2018.

22. Shorty Awards n.d.

23. Ibid.

24. Victorian 2019.

25. Young 2019.

26. Alpha Kappa Alpha Sorority, Inc. 2017.

27. Moye 2019.

28. Ibid.

29. At various times, the screen behind the stage flashed the menu and invited festivalgoers to "Try some McDonald's favorites." Along with listing the various food items that were being served, this notification alerted customers to the times that they would be offered—breakfast items from 10 a.m. to 12:00 p.m. and lunch fare from 2:00 p.m. to 4:00 p.m.

30. "McDonald's Launches 'Black & Positively Golden' Campaign" 2019.

31. Ibid.

32. DeNora 2000.

33. Given that Black people are more likely than non-Black people to consume Black music, the largely R&B, rap/hip hop, and gospel music played at the festival would likely be a less effective marketing tool for white Americans as well as other ethnoracial minorities.

Chapter 6

1. Fryar et al. 2018.

2. Grier and Kumanyika 2008; Wade 2012.

3. Molotsky and Weaver 1986; Segall 2008.

4. The Christian music industry, like the music industry more broadly, is segregated along racial lines (Lena 2012: 98–109): Gospel music is the province of Black artists while contemporary Christian music, or CCM, is the domain of white artists. Thomas A. Dorsey, an African American musician, is considered the father of gospel music. Gospel grows out of various Black cultural traditions such as jazz and blues, "rhythmic acts of drumming [and] dancing, and . . . verbal expressions such as field hollers or moans of the enslaved African in America" (Banjo and Williams 2011:116). In contrast, CCM has its roots in the Jesus People Movement of the 1960s and draws on rock and other popular musical traditions (ibid.). Today, not only do the themes of each genre of sacred music vary—with gospel more often centering on themes such as conquering, testimony, and communal connection and CCM more often focusing on themes like faithfulness and eternity-bound consciousness (ibid.)—they are also played on different radio stations and ranked on different music charts.

5. Ibid.

6. GMA 2015. In addition, findings from the 2008 Survey of Public Participation in the Arts, a national survey on adult cultural consumption in the United States, show that 26.5 percent of African Americans, as opposed to 6.8 percent of white Americans and 6.3 percent of Hispanic people report that gospel is their favorite type of music (Iyengar, Bradshaw, and Nichols 2009: 60–61).

7. Masci 2018.

8. Crockett 2008.

9. While observations at the Tallahassee concert inform my analysis of branding via this concert sponsorship, this chapter focuses on one event—the DMV concert—for narrative coherence.

10. I define "diversity framing" as the use of words, phrases, images, and sounds to communicate that Black community support is a manifestation of a company's valuing of diversity.

11. I define "gospel framing" as the use of words, phrases, images, and sounds to emphasize that a company's support of gospel music is a manifestation of a company's connection to and veneration of Christianity.

12. Harris et al. 2019.

13. McDonald's n.d.b.

14. For a comprehensive history of McDonald's involvement in civil rights struggles in the United States, see Chatelain (2020).

15. Chatelain 2016, 2020.

16. Jou 2017.

17. NBMOA n.d.

18. Ibid.

19. Chambers 2009, 2017: 246; Harris 2009.

20. The philosophy underlying positive realism was first articulated by Emmett McBain, Burrell's one-time business partner (Chambers 2018).

21. Banks 2021: 68–71.

22. Kroc and Anderson 1977: 184.

23. Ronald McDonald House Charities n.d.

24. *Essence* 1986.

25. Zito 1983.

26. *Essence* 2004.

27. Chrysler Group 2006.

28. "Product Placement in the Pews?" 2006.

29. *Ebony* 2005.

30. McDonald's USA 2019.

31. McDonald's 2013.

32. McDonald's 2009.

33. "McDonald's Plans Biggest Marketing Overhaul in 16 Years" 2019.

34. McDonald's n.d.a.

35. McDonald's USA 2019.

36. "McDonald's Black & Positively Golden Announces 13th Annual Inspiration Celebration Gospel Tour" 2019.

37. Wohl 2019.

38. Art Sky Agency 2019.

39. Wohl 2019.

40. Ibid.

41. The exchange of money from concertgoers to the RMHC in this moment is enabled by the Black Christian offering ritual that is arguably second nature to most people in the sanctuary. It is culture, specifically Black culture, that facilitates this exchange (Wherry 2012). Inducing consumers from another ethnoracial group to donate to the RMHC would likely require a different set of rituals.

42. lonniehuntermusic 2019.

Chapter 7

1. Willoughby 2018.

2. Bey 2019.

3. The race and ethnicity of the people who appear in ads help to convey the racial meanings of brands and products (Grier and Brumbaugh 1999; Grier, Brumbaugh, and Thornton 2006: 37). There is a long history of using Black people in ads to promote the perception that brands are inclusive. For example, in the 1940s when the Black population was shifting from a rural southern population to an increasingly urban and northern population, there was a growing focus on African Americans as a distinct consumer market. To engage these consumers, companies began to develop specific promotions for the "negro market." A central feature of these appeals was the presence of Black models, presented in a positive fashion. Marketing professionals insisted that to appeal to Black consumers, advertisements needed to not only include African Americans but to also include idealized representations of the group. These ads, featuring products like alcohol and cigarettes, were placed in Black media such as *Ebony* and *Jet* magazines (Chambers 2009; Haidarali 2005). Using certain types of Black people in ads, such as rap and basketball stars, has also projected an image that brands are cool (Banks 2021: 71; Crockett 2008; Schor 2004: 48). Black festivalgoers' branded Afropunk posts are in essence a form of what consumer behavior scholar David Crockett terms "marketing blackness," or a "promotional strateg[y] reliant on persons and other symbolic and material representations socially and historically constructed as black . . ." (2008: 245).

4. Banks 2021: 71; Crockett 2008; Schor 2004: 48.

5. Ritzer 2015a: 1. 2015b; Ritzer and Jurgenson 2010.

6. Ritzer 2015a: 3.

7. For example, instead of individuals only reading social media posts on various sites, they also create them (Ritzer 2015a: 5).

8. Zajc 2015: 30.

9. Tuten 2019: 270.

10. Belch and Belch 2021.

11. Ibid.

12. Ibid.

13. Ismail 2018.

14. Haenfler 2014: 16.

15. Hebdige 1979: 16.

16. Ibid.: 107.

17. Leblanc 1999: 160.

18. Ibid.

19. Ibid.

20. Hebdige 1979: 94.

21. Ibid.: 95.

22. Hebdige 1979.

23. *Time* 1977.

24. Bergeron 2015.

25. *Time* 1978.

26. Siroto 1993.

27. Limnander 2000.

28. Fair 2003.

29. Spooner 2003.

30. Ibid.

31. Drake 2010.

32. Hebdige 1979; Leblanc 1999.

33. *The Rad Voice* 2018. Also see Ellis 2018 and Hosking 2018.

34. Color Of Change n.d.

35. Ofodu 2019.

36. Llewellyn and Ofodu 2019.

37. Chatmon n.d.

38. Instagram 2019.

39. dizmology 2019.

40. MaMa n.d.a., n.d.b.

41. While this Afropunk campaign was promoted at branded AT&T photo booths at the Brooklyn festival, anyone could enter the sweepstakes by creating an area code image on the contest website and posting it on social media.

42. Berg 2018; Unilever 2017, 2019.

43. Sabin n.d.; Shea Moisture n.d.a.

44. Although the Shea Moisture company was founded in the 1990s, Sofi Tucker, a grandmother of one of the company's founders, started selling shea nuts in Sierra Leone in 1912 (Shea Moisture n.d.b.).

45. Williams 2017.

46. White 2017.

47. Shea Moisture 2017.

48. The consumer backlash can be viewed within the frame of intergroup boundaries related to racism as well as intragroup boundaries linked to colorism (Glenn 2009;

Golash-Boza 2018; Hunter, Allen, and Telles 2001). To some critics, colorism—a system of ideas relying on the belief that lighter skin along with physical characteristics such as straighter hair is superior to features like darker skin and curlier tresses—was being promoted by the ad. There is a long history of cosmetics companies reproducing colorist ideology by marketing products such as skin lighteners and hair straighteners to African American women (Hunter 2011a; Rooks 1996).

49. Thompson 2015: 49.

Chapter 8

1. To understand corporate philanthropy during these uprisings, I created a database of statements made by all Fortune 500 companies that responded to the protests by pledging to make donations to address inequality.

2. Bank of America 2020; Smithsonian 2020.

3. Adamczyk 2020.

4. Nike n.d.a, n.d.b. Corporate engagement with the racial protests in 2020 fits within the broader trend of companies including "progressive messaging" in branding (Khamis 2020). Also, see Bonaparte (2020) who describes how in response to the 2020 BLM uprisings, companies such as Aunt Jemima and Uncle Ben's committed to update their branding for those products with symbols evocative of racial stereotypes around service.

5. Alexander 1996a, 1996b; Kirchberg 2003; Martorella 1996.

6. Banks 2010b, 2019a, 2019b; Carter 2003; Grams 2010; Meghji 2019; Wallace 2019.

7. Johnston and Baumann 2007, 2010; Khan 2011; Lena 2019; Lizardo and Skiles 2012, 2015; 2012; Peterson 1997.

8. National Cancer Institute 1996.

9. CDC 2020.

10. Bahadoran, Mirmiran, and Azizi 2015.

11. Vartanian, Schwartz, and Brownell 2007.

12. "Black Former Franchisees Sue McDonald's for $1 Billion, Claiming Bias" 2020.

13. Amazon 2020.

14. Amazon n.d.

15. Goldman Sachs 2020b.

16. Goldman Sachs 2020a: 117.

17. Walmart 2021, 90.

18. Ibid.: 92.

19. Ibid.: 91.

20. Citigroup Inc. 2021: 132.

21. Ibid: 133.

22. The Goldman Sachs Group, Inc. 2021: 89–90.

23. JPMorgan Chase & Co. 2021: 6, 101.

24. Alexander 1996a, 1996b; Kirchberg 2003; Useem 1984.

25. The role of consumers in the creation of brand value, such as their involvement in the production of the symbolic meanings of brands, is an increasing focus of marketing theory and research (Pongsakornrungsilp and Schroeder 2011).

26. Clowes 2020; Nguyen 2020.

27. Gayle 2020.

28. On diversity washing, also sometimes termed "wokewashing," see Clowes (2020). In addition, in her analysis of mission-driven marketing, Myriam Sidibe uses the term "purpose-washing" to define the same process of "purpose-driven activities serv[ing] mainly for publicity purposes" (Sidibe 2020: 18).

29. Bartley 2007.

30. "Slavery Museum's Appeal" 2006.

31. Klein 2008. By 2011 the non-profit organizing the museum project had filed for bankruptcy (Amsden 2015).

32. Hall 1980.

33. Also see Grier and Brumbaugh (1999), McCracken (1986), and Zhou and Belk (2004) for perspective on how consumers sometimes interpret corporate messaging in ways that diverge from intended meanings.

34. @Bank of America 2019.

35. Ibid.

36. @Jimmy_Besos 2019.

37. @WayneTrackerAG 2019.

38. "Bank of America Settles Discrimination Suit for $335M" 2011.

39. These findings are from a research project that I led on responses to purpose-driven corporate messaging by young adult consumers.

40. See Taylor, Johnston, and Whitehead (2014) for a broader discussion of the need for more research on interpretations of corporate messaging related to CSR. They note that while there is growing research on how corporations produce messaging related to CSR, "less studied is how individuals think and feel when they see their politics appropriated by corporations" (ibid.: 2).

41. Collins 1997: 14, 75.

42. Wingfield 2019: 34.

43. Boeing 2008.

44. Barge et al. 2020; DeVos Institute of Arts Management 2015; Dorsey et al. 2020.

45. Wells Fargo 2017.

46. *Alhambra Press* 2013.

47. Ibid.

48. *Arcadia Weekly* 2013; *Monrovia Weekly* 2013; *Pasadena Independent* 2013.

49. BNSF 2018b.

50. BNSF 2018a.

51. Swinomish Indian Tribal Community v. BNSF Railway Company 2020.

52. Cavaliere 2015.

53. This sponsorship falls within the broader efforts of advertisers to engage the "Hispanic market." See Dávila (2001) for an analysis of the role of this industry in both selling to and defining the contours of Latinx identity.

54. Diageo 2018a.

55. Ibid.

56. Diageo 2019.

57. Diageo 2018b.

58. Banks 2021: 98–101; Chaudhuri 2017.

References

"Accepting Smithson's Gift." n.d. Smithsonian Institution Archives. Washington, DC. https://perma.cc/F47W-VHHD

Action Marketing Ltd. 1978. "Kool Black Market Alternatives." Brown & Williamson Tobacco Company. https://www.industrydocuments.ucsf.edu/docs/lxxk0154

Adamczyk, Darius. 2020, June 17. "A Statement from Our Chairman and CEO on Our Opposition to Racism and Our Promotion of Equality and Opportunity." *Honeywell Press & Media*. https://perma.cc/S8YT-BJ6L

Adamson, Jim. 2000. *The Denny's Story: How a Company in Crisis Resurrected Its Good Name*. New York: Wiley.

Adobe. 2019. "Diversity in Advertising." https://perma.cc/5BPE-HJ2U

Afro-American. 1976, July 13–17. Advertisement for Kool Jazz Festival.

Alexander, Victoria D. 1996a. "From Philanthropy to Funding: The Effects of Corporate and Public Support on American Art Museums." *Poetics* 24: 87–129.

———. 1996b. *Museums and Money: The Impact of Funding on Exhibitions, Scholarship, and Management*. Bloomington: Indiana University Press.

———. 2014. "Art and the Twenty-First Century Gift: Corporate Philanthropy and Government Funding in the Cultural Sector." *Anthropological Forum* 24 (4): 364–380.

Alhambra Press. 2013, February 4. "Wells Fargo Celebrates Year of the Snake with Special Customer Appreciation Promotions and Community Sponsorships." Vol. 2, no. 5.

Alpha Kappa Alpha Sorority, Inc. 2017. "Another FIRST!" Lambda Pi Omega Chapter. https://perma.cc/98XX-45X9

"Altria Group Donates $1 Million to the Smithsonian's National Museum of African American History and Culture." 2014, July 31. https://perma.cc/RM68-6P4U

"Altria's Diversity & Inclusion Heritage." 2020. https://perma.cc/SHY2-5QW8

AMA. 2021, April 2. "FDA Agrees to Ban Menthol to Protect African Americans." https://perma.cc/3L2B-6TD2

Amazon. 2020, June 3. "Amazon Donates $10 Million to Organizations Supporting Justice and Equity." https://perma.cc/9ZPH-RRHD

———. n.d. "Our Workforce Data." Amazon.com. https://perma.cc/US45-487M

Amsden, David. 2015, February 26. "Building the First Slavery Museum in America."
 New York Times. https://perma.cc/28PX-GZUA

Amsterdam News. 1981, February 21. Advertisement for Kool Jazz Festival.

———. 1983, June 18. Advertisement for Kool Jazz Festival.

Arcadia Weekly. 201, January 31. "Wells Fargo Celebrates Year of the Snake with Special
 Customer Appreciation Promotions and Community Sponsorships." https://perma.
 cc/PXK6-VFEK

Art Sky Agency. 2019, April 27. "Recording Artist and Entrepreneur Moses Stone Part-
 ners with McDonald's with Powerful New Campaign 'Black & Positively Golden'
 with His Hit Song 'We Golden.'" https://perma.cc/GFK2-U8MC

@BankofAmerica. 2019, February 1. "We're Proud to Support Our Partners at the Na-
 tional Museum of African American History and Culture." Twitter post. 2:00 p.m.
 https://perma.cc/X3HD-LN7V

@Jimmy_Besos. 2019, February 6. "Jimmy Besos on Twitter . . ." Twitter post. 9:20 p.m.
 https://perma.cc/9GLL-NS6U

Atkins, Debbie. 2005, August 4. "Grand Slam." *The Pitch.* https://perma.cc/XKQ9-VCEP

Atlanta Daily World. 1976, June 24. Advertisement for Kool Jazz Festival. Entertainment
 and Travel sec.

———. 1977, March 24. "Sixth Atlanta Kool Jazz Festival Slated in June."

———. 1978a, April 27. Advertisement for Kool Jazz Festival.

———. 1978b, May 7. "Top Soul and Jazz to Appear on Atlanta Kool Jazz May 19."

———. 1979, June 15. "Kool Jazz Festival Slated for Atlanta June 29."

———. 1980, June 26. Advertisement for Kool Jazz Festival.

AT&T. 2016a. "Diversity & Inclusion 2015 Annual Report. 2018." ATT.com. https://web.
 archive.org/web/20160705115049/https://about.att.com/content/dam/sitesdocs/
 DiversityInclusion_2016_AR.pdf

———. 2016b, September 14. "AT&T Contributes $1 Million to the National Museum
 for African American History and Culture in Washington, D.C." https://perma.cc/
 N2GT-G4R2

———. 2019. "AT&T Dream in Black Is Excited to Return to New Orleans." Essence
 Media Center. 2019. https://web.archive.org/web/20191215165159/https:/efnewscen-
 ter.com/att/

———. n.d. "AT&T Diversity & Inclusion." https://web.archive.org/web/20190131231834/
 https://about.att.com/pages/diversity

@WayneTrackerAG. 2019, February 15. "@BankofAmerica @NMAAHC" Twitter
 post. https://perma.cc/3MF2-MJ5D

Austin, Edith. 1976, June 19. "Bay Bits." *Sun Reporter.* Ethnic NewsWatch.

Bahadoran, Zahra, Parvin Mirmiran, and Fereidoun Azizi. 2015. "Fast Food Pattern and
 Cardiometabolic Disorders: A Review of Current Studies." *Health Promotion Perspec-
 tives* 5 (4): 231–240.

Bànjo, Omotayo O., and Kesha Morant Williams. 2011. "A House Divided? Christian
 Music in Black and White." *Journal of Media and Religion* 10 (3): 115–137.

Bank of America. 2015, February 9. "Bank of America Native American Professional

Network." https://web.archive.org/web/20150317172435mp_/http://about.bankofamerica.com/en-us/global-impact/native-american-professional-network.html

———. 2016, October 5. "Connecting to the Richness of Our Past—The National Museum of African American History and Culture." Bankofamerica.com. https://web.archive.org/web/20170622073828/https://about.bankofamerica.com/en-us/nmaahc-richness-of-past.html

———. 2020, June 8. "Smithsonian Announces 'Race, Community and Our Shared Future' Initiative." *Bank of America Newsroom.* https://perma.cc/95KQ-K3HA

"Bank of America Settles Discrimination Suit for $335M." 2011, December 21. *CBS News.* https://perma.cc/CU2S-RERZ

Banks, Patricia A. 2010a. "Black Cultural Advancement: Racial Identity and Participation in the Arts Among the Black Middle Class." *Ethnic and Racial Studies* 33 (2): 272–289.

———. 2010b. *Represent: Art and Identity Among the Black Upper-Middle Class.* New York: Routledge.

———. 2017. "Ethnicity, Class, and Trusteeship at African American and Mainstream Museums." *Cultural Sociology* 11 (1): 97–112.

———. 2018. "Money, Museums, and Memory: Cultural Patronage by Black Voluntary Associations." *Ethnic and Racial Studies* 42 (15): 2529–2547.

———. 2019a. *Diversity and Philanthropy at African American Museums: Black Renaissance.* New York; Abingdon, Oxon: Routledge.

———. 2019b. "High Culture, Black Culture: Strategic Assimilation and Cultural Steering in Museum Philanthropy." *Journal of Consumer Culture.* https://doi.org/10.1177/1469540519846200

———. 2021. *Race, Ethnicity, and Consumption: A Sociological View.* New York; Abingdon, Oxon: Routledge.

Barge, Ben, Brandi Collins-Calhoun, Elbert Garcia, Jeanné Lewis, Janay Richmond, Ryan Schlegel, Spencer Ozer, and Stephanie Peng. 2020, August. "Black Funding Denied: Community Foundation Support for Black Communities." Washington, DC: National Committee for Responsive Philanthropy. https://perma.cc/JX7F-TM7Y

Barman, Emily. 2016. *Caring Capitalism: The Meaning and Measure of Social Value.* New York: Cambridge University Press.

———. 2017. "The Social Bases of Philanthropy." *Annual Review of Sociology* 43 (271): 1–90.

Bartley, Tim. 2007. "How Foundations Shape Social Movements: The Construction of an Organizational Field and the Rise of Forest." *Social Problems* 54 (3): 229–255.

Belch, George E., and Michael A. Belch. 2021. *Advertising and Promotion: An Integrated Marketing Communications Perspective,* 12th ed. New York: McGraw-Hill Education.

Belk, Russell W. 1977. "Gift Giving Behavior. Part A." *Faculty Working Papers: No. 450.* Urbana-Champaign: University of Illinois, College of Commerce and Business Administration.

Berg, Madeline. 2018, September 21. "These Mother-and-Son Entrepreneurs Went from

Selling Soap on Harlem Streets to an $850 Million Fortune." *Forbes*. https://perma.cc/TL4Q-QQ3L

Bergeron, Ryan. 2015, August 17. "Punk Shocks the World." CNN. https://perma.cc/7EML-TRVY

Berkman, Meredith. 1991, March 8. "How 'Dances With Wolves' Got Real." *Entertainment Weekly*. https://web.archive.org/web/20170502130840/https://ew.com/article/1991/03/08/how-dances-wolves-got-real/

Berrey, Ellen. 2015. *The Enigma of Diversity: The Language of Race and the Limits of Racial Justice*. Chicago: University of Chicago Press.

Bey, Tyler. 2019, October 22. "Why Target and Other Corporate Businesses Don't Belong at Afropunk." *VOXATL*. https://perma.cc/WBJ2-X9Q4

"Black Former Franchisees Sue McDonald's for $1 Billion, Claiming Bias." 2020, September 1. *CBS News*. https://perma.cc/NR28-5WK5

Blake, Michael. 1989. "Dances With Wolves (Script)." Internet Movie Script Database (IMSDb). https://perma.cc/6XEX-MYGP

BNSF. 2018a, November 20. "BNSF Focuses on Creating Strong and Lasting Ties with Tribal Nations." *Rail Talk*. https://web.archive.org/web/20200426112512/https:/www.bnsf.com/news-media/railtalk/community/tribal-relations.html

———. 2018b, December 1. "BNSF Railway Foundation Supports National Native American Veterans Memorial." *BNSF Railway*. https://perma.cc/6GB7-QW4X

Bobo, Lawrence D. 2001. "Racial Attitudes and Relations at the Close of the Twentieth Century." In *America Becoming: Racial Trends and Their Consequences, Volume 1*, edited by Neil J. Smelser, William Julius Wilson, and Faith Mitchell (pp. 264–301). Washington, DC: National Academy Press.

Bobo, Lawrence D., Camille Z. Charles, Maria Krysan, and Alicia D. Simmons. 2012. "The Real Record on Racial Attitudes." In *Social Trends in American Life: Findings from the General Social Survey Since 1972*, edited by Peter V. Marsden (pp. 38–83). Princeton, NJ: Princeton University Press.

Bobo, Lawrence, James R. Kluegel, and Ryan A. Smith. 1997. "Laissez-Faire Racism: The Crystallization of a 'Kinder, Gentler,' Anti-Black Ideology." In *Racial Attitudes in the 1990s: Continuity and Change*, edited by Steven A. Tuch and Jack K. Martin (pp. 15–42). Westport, CT: Praeger.

Boeing. 2008, April 24. "Boeing Donates $5 Million to the Smithsonian National Museum of African American History and Culture." Boeing.Mediaroom.com. https://perma.cc/Z8RN-BXPA

Bonaparte, Yvette Lynne. 2020. "Meeting the Moment: Black Lives Matter, Racial Inequality, Corporate Messaging, and Rebranding." *Advertising & Society Quarterly* 21 (3). https:doi.org/10.1353/asr.2021.0000

Bonilla-Silva, Eduardo. 2006. *Racism Without Racists: Color-Blind Racism and the Persistence of Racial Inequality in the United States*, 2nd ed. Lanham, MD: Rowman & Littlefield.

Borawski, E. A., A. Brooks, N. Colabianchi, E. S. Trapl, K. A. Przepyszny, N. Shaw, and L. Danosky. 2010. "Adult Use of Cigars, Little Cigars, and Cigarillos in Cuyahoga

County, Ohio: A Cross-Sectional Study." *Nicotine & Tobacco Research* 12 (6): 669–673. https://doi.org/10.1093/ntr/ntq057

Bourdieu, Pierre. 1986. "The Forms of Capital." In *Handbook of Theory and Research for the Sociology of Education*, edited by John G. Richardson (pp. 241–258). New York: Greenwood Press.

Broecker, B. L. 1977, November 29. "Kool Jazz Festivals." Brown & Williamson Records. https://www.industrydocuments.ucsf.edu/docs/lswb0100

Brown & Williamson. 1983. "KOOL Jazz Festival." Philip Morris Records; Master Settlement Agreement. https://www.industrydocuments.ucsf.edu/docs/ypvn0030

"The Brown & Williamson Story." 1980. Brown & Williamson Records; Master Settlement Agreement. https://www.industrydocuments.ucsf.edu/docs/hfyn0099

Browne, Irene, Natalie Delia Deckard, and Cassaundra Rodriguez. 2016. "Different Game, Different Frame? Black Counterdiscourses and Depictions of Immigration in Atlanta's African-American and Mainstream Press." *Sociological Quarterly* 57 (3): 520–543.

Bruner II, Gordon C. 1990. "Music, Mood, and Marketing." *Journal of Marketing* 54 (4): 94–104. https://doi.org/10.2307/1251762

Bryson, Bethany. 1996. "'Anything but Heavy Metal': Symbolic Exclusion and Musical Dislikes." *American Sociological Review* 61: 884–899.

Bunch III, Lonnie G. 2019. *A Fool's Errand: Creating the National Museum of African American History and Culture in the Age of Bush, Obama, and Trump*. Washington, DC: Smithsonian Books. Kindle Edition.

Burnett, Jr., Leonard E., and Andrea Hoffman. 2010. *Black Is the New Green: Marketing to Affluent African Americans*. New York: Palgrave Macmillan.

Business Editors. 2000, February 22. "Denny's Jim Adamson Writes Book on the Restaurant Chain's Transformation to Leader in Racial Diversity." *PR Newswire*. Factiva.

Byrd, William. 1983, August 23. "Jazz Legends Played It Kool at the Fox." *Atlanta Daily World*.

Call and Post. 1980, July 26. Advertisement for Kool Jazz Festival.

———. 1983, June 9. Advertisement for Kool Jazz Festival.

———. 1985, July 11. Advertisement for Kool Jazz Festival.

Campbell, Kirt. 1979, July 13. "Jazz Masters Vy for Best Kool." *New Journal and Guide*.

Carrera, Martino. 2019, February 7. "Gucci Issues Apology in Wake of Blackface Accusations." *WWD*. https://perma.cc/2KJ8-HKBY

Carter, Prudence L. 2003. "'Black' Cultural Capital, Status Positioning, and Schooling Conflicts for Low-Income African American Youth." *Social Problems* 50 (1): 136–155.

Cashmore, Ellis. 1997. *The Black Culture Industry*. London; New York: Routledge.

Cavaliere, Victoria. 2015, April 7. "Native American Tribe Sues BNSF over Washington Oil Train Traffic." *Reuters*. https://web.archive.org/web/20200426120004/https://www.reuters.com/article/us-usa-washington-oiltrain/native-american-tribe-sues-bnsf-over-washington-oil-train-traffic-idUSKBN0MY28A20150407

CDC. 2020, November 16. "African Americans and Tobacco Use." Centers for Disease Control and Prevention. https://perma.cc/4U68-95G6

———. n.d. "Smoking & Tobacco Use: Legislation." https://perma.cc/3A96-BBXA

Chambers, Jason. 2009. *Madison Avenue and the Color Line: African Americans in the Advertising Industry*. Philadelphia: University of Pennsylvania Press.

Chambers, Jason P. 2017. "Positive Realism: Tom Burrell and the Development of Chicago as a Center for Black-Owned Advertising Agencies." In *Building the Black Metropolis: African American Entrepreneurship in Chicago*, edited by Robert E. Weems, Jr. and Jason Chambers. Urbana: University of Illinois Press.

———. 2018. "Work That Mattered: Emmett McBain and the Creation of 'Positive Realism' in Advertising." *Advertising & Society Quarterly* 19 (4). https://doi:10.1353/asr.2018.0032

Chatelain, Marcia. 2016, August. "The Miracle of the Golden Arches: Race and Fast Food in Los Angeles." *Pacific Historical Review* 85 (3): 325–353.

———. 2020. *Franchise: The Golden Arches in Black America*. New York: Norton.

Chatmon, Tawny. n.d. "Artist Statement." https://perma.cc/4WND-M3VG

Chaudhuri, Saabira. 2017, May 5. "Liquor Makers Step Up Efforts to Win over Hispanic Drinkers." *Wall Street Journal*. https://perma.cc/395X-S7C5

Chen, Jennifer C., Dennis M. Patten, and Robin W. Roberts. 2008. "Corporate Charitable Contributions: A Corporate Social Performance or Legitimacy Strategy?" *Journal of Business Ethics* 82 (1): 131–144.

Chrysler Group. 2006, October 2. "Chrysler Sponsors R&B Superstar's Gospel Tour to Launch All-New Chrysler Aspen and Raise Funds for Medical Education." *PR Newswire*. U.S. Newsstream.

Citigroup Inc. 2021. "Citigroup Inc. 2021 Notice of Annual Meeting and Proxy Statement." https://perma.cc/R2C9-SG8Q

Clark, Rozell. 1980, July 3. "Atlanta Jazz Festival Was a Little 'Kool' This Year." *Atlanta Daily World*.

Claytor, Cassi Pittman. 2020. *Black Privilege: Modern Middle-Class Blacks with Credentials and Cash to Spend*. Stanford University Press.

Clowes, Ed. 2020, June 6. "Brand Action: Force of Change or Simply 'Wokewashing'?" *The Telegraph*. https://perma.cc/6ZS5-T3TK

Cohn, Jules. 1970. "Is Business Meeting the Challenge of Urban Affairs?" *Harvard Business Review* (March–April): 68–82.

Collins, Sharon M. 1997. *Black Corporate Executives: The Making and Breaking of a Black Middle Class*. Philadelphia: Temple University Press.

Color Of Change. n.d. "About." https://web.archive.org/web/20200102154206/https://colorofchange.org/about/

"Community Relations Program Announced by 760000 Kool Jazz Festivals." 1976. Brown & Williamson Records. https://www.industrydocuments.ucsf.edu/docs/jrwp0099

"Corporations with Indian Names." n.d. Smithsonian Institution Archives, Accession 96–143. Washington, DC: National Museum of the American Indian, Office of the Director, Records.

Crockett, David. 2008. "Marketing Blackness: How Advertisers Use Race to Sell Products." *Journal of Consumer Culture* 8 (2): 245–268.

Dávila, Arlene. 2001. *Latinos, Inc.: The Marketing and Making of a People*. Berkeley: University of California Press.

Denny's. 2001. "Annual Report." Spartanburg, SC: Advantica Restaurant Group, Inc. https://perma.cc/7BLB-9343

———. 2002a, January 10. "Denny's Launches Multi-Year Campaign Promoting Human and Civil Rights." *PR Newswire*. Factiva.

———. 2002b, January 17. "B-Roll Feed: Denny's Re-ignites Martin Luther King Jr.'s Dream by Raising $1 Million to Benefit the National Civil Rights Museum." *PR Newswire*. Factiva.

———. 2002c. Advertisement for Denny's. *Ebony* (February).

———. 2002d, June 9. "About Denny's—Community Outreach." https://web.archive.org/web/20020609042833/http://www.dennysrestaurants.com/aboutus/CommunityOutreach.asp

———. 2005, March 7. "Community Outreach." https://web.archive.org/web/20050307000039/http:/www.dennys.com/en/cms/Community+Outreach/33.html#B1

———. 2006, August 13. "Diversity Facts." https://web.archive.org/web/20060813100626/http:/www.dennys.com/en/cms/Diversity/36.html

———. 2008, August 13. "Diversity Facts." https://web.archive.org/web/20080724083700/http://www.dennys.com/en/cms/Diversity/36.html

———. 2010. "Diversity Report." Spartanburg, SC: Denny's Corporation. https://perma.cc/8JE2-88U9

———. 2021. "Diversity Fact Sheet." https://perma.cc/S3LU-ZU2P

———. n.d. "About." Denny's. https://perma.cc/3BGG-T88N

DeNora, Tia. 2000. *Music in Everyday Life*. Cambridge; New York: Cambridge University Press.

Devers, Cynthia E., Todd Dewett, Yuri Mishina, and Carrie A. Belsito. 2009. "A General Theory of Organizational Stigma." *Organization Science* 20 (1): 154–171. https://doi.org/10.1287/orsc.1080.0367

Development Campaign-Documents, 1990–1992. n.d. Smithsonian Institution Archives, Accession 96–143. Washington, DC: National Museum of the American Indian, Office of the Director, Records.

DeVos Institute of Arts Management. 2015. "Diversity in the Arts: The Past, Present, and Future of African American and Latino Museums, Dance Companies, and Theater Companies." Washington, DC: DeVos Institute of Arts Management.

Diageo. 2018a, September 24. "Buchanan's Blended Scotch Whisky Names Global Latin Superstar J Balvin Creative Director of the Imparables Colección Celebrating Culture, Creativity and Inspiring Greatness Within." https://perma.cc/23UB-Z4TG

———. 2018b, September 24. "Buchanan's Blended Scotch Whisky Nombra al Súper Estrella Global Latino J Balvin como Director Creativo de la Imparables Colección Celebrando la Cultura, Creatividad e Inspirando la Grandeza que se lleva Dentro." https://perma.cc/RL8P-KW55

———. 2019, February 20. "Buchanan's Blended Scotch Whisky Releases Limited Edition Design by Global Latin Artist J Balvin." https://perma.cc/Z533-ZVEY

Díaz-Bustamante, Mónica, Sonia Carcelén, and María Puelles. 2016. "Image of Luxury Brands: A Question of Style and Personality." *SAGE Open* 6 (2):1–15.

DiMaggio, Paul. 1982a. "Cultural Entrepreneurship in Nineteenth-Century Boston, Part II: The Classification and Framing of American Art." *Media, Culture, and Society* 4: 303–322.

———. 1982b. "Cultural Entrepreneurship in Nineteenth-Century Boston: The Creation of an Organizational Base for High Culture." *Media, Culture, and Society* 4: 33–50.

DiMaggio, Paul, and Francie Ostrower. 1990. "Participation in the Arts by Black and White Americans." *Social Forces* 68 (3): 753–778.

DiMaggio, Paul, and Michael Useem. 1982. "The Arts in Class Reproduction." In *Theory and Society*, edited by Michael W. Apple (pp. 181–201). London: Routledge.

dizmology. 2019, August 26. "Wall I Painted" Instagram post. https://perma.cc/WF7L-SKQ8

Dobbin, Frank. 2009. *Inventing Equal Opportunity*. Princeton, NJ: Princeton University Press.

Dobbin, Frank, and Alexandra Kalev. 2017. "Are Diversity Programs Merely Ceremonial? Evidence-Free Institutionalization." In *The Sage Handbook of Organizational Institutionalism*, edited by Royston Greenwood, Christine Oliver, Thomas B. Lawrence, and Renate E. Meyer (pp. 808–828). London: Sage.

———. 2021. "The Civil Rights Revolution at Work: What Went Wrong" *Annual Review of Sociology* 47: 18.1–18.23.

Dorsey, Cheryl, Peter Kim, Cora Daniels, Lyell Sakaue, and Britt Savage. 2020, May 4. "Overcoming the Racial Bias in Philanthropic Funding." *Stanford Social Innovation Review.* https://perma.cc/WF36-4DGZ

Drake, Monica. 2010, June 24. "Punk Fans Find a Home in Brooklyn." *New York Times.* https://www.nytimes.com/2010/06/25/arts/music/25afropunk.html; https://perma.cc/Y4W6-NWKK

Ebony. 2005. "Advertisement for McDonald's" (February). https://perma.cc/JX8J-4RS6

Edelman, Lauren B. 2016. *Working Law: Courts, Corporations, and Symbolic Civil Rights.* Chicago: University of Chicago Press.

"800000 Hampton Kool Jazz Festival: 13th Year in the City, Hampton Coliseum." 1980. Brown & Williamson Records. https://www.industrydocuments.ucsf.edu/docs/nhlp0128

"800000 Oakland Kool Jazz Festival." 1980. Brown & Williamson Records. https://www.industrydocuments.ucsf.edu/docs/nglp0128

Ellis, Stacy-Ann. 2018, October 20. "Afropunk Leadership and Affiliates Publicize Accounts of Festival's Abuse." *Vibe.* https://perma.cc/DAX6-JLZL

Essence. 1979. "Kool Proudly Presents 'The Buffalo Soldiers' Collector Print by Ernie Barnes." Philip Morris Records. https://www.industrydocuments.ucsf.edu/docs/jlkb0025

———. 1986. Advertisement for Kentucky Fried Chicken (August): 17:4. Women's Magazine Archive.

———. 2004. Advertisement for Kraft Foods (June): 35:2. Women's Magazine Archive.

Exelon. 2016a. "Diversity & Inclusion in Action: Leading the Way." Exeloncorp.com. https://web.archive.org/web/20190530052351/https://www.exeloncorp.com/careers/Documents/Div_Inclusion_Report.pdf

———. 2016b, September 24. "Exelon Foundation Donates $1 Million to the National Museum of African American History and Culture." https://perma.cc/3CHA-W24K

"Ex-WVU Player Sues Denny's: Suit Alleges Racial Discrimination." 1999, June 11. *Charleston Daily Mail.* U.S. Newsstream.

Exxon Mobil Corporation. 2003, November 18. "ExxonMobil a Sponsor of New Transportation Exhibition at the Smithsonian's National Museum of American History." Exxonmobil.com. https://web.archive.org/web/20190528203836/https://ir.exxonmobil.com/news-releases/news-release-details/exxonmobil-sponsor-new-transportation-exhibition-smithsonians/

Fair, S. S. 2003, October 19. "Pretty in Punk." *New York Times Magazine*: 63–70.

Farsetta, Diane, and Daniel Price. 2006. "Fake TV News: Widespread and Undisclosed." *Center for Media and Democracy*: 1–76.

FedEx. 2002, September 26. "FedEx Contribution Helps the National Civil Rights Museum Explore a Legacy." *Business Wire.*

———. 2011, August 5. "FedEx Salutes Legacy of Dr. King with $1 Million Donation to Memorial." https://web.archive.org/web/20190531062949/https://about.van.fedex.com/newsroom/fedex-salutes-legacy-of-dr-king-with-1-million-donation-to-memorial/

———. 2016. "Diversity and Inclusion." https://web.archive.org/web/20170530040605/https://fedexcares.com/about-fedex-cares/diversity

———. 2019. "Serving and Celebrating a Diverse World." https://perma.cc/Y8G3-DZMY

Ferruzza, Charles. 2005, June 30. "Separate Checks." *The Pitch.*

Field Museum. n.d. "Field Museum History." Field Museum. https://perma.cc/BR2Q-F22E

Fields, Corey D., and Shelby Newman. 2020. "Covering the Dawsons: Racial Variation in Newspaper Framing of Urban Crime." *Sociological Forum* 35 (S1): 1040–1057.

Fleming, Crystal M., and Lorraine E. Roses. 2007. "Black Cultural Capitalists: African-American Elites and the Organization of the Arts in Early Twentieth Century Boston." *Poetics* 35: 368–387.

Ford Corporate. n.d. "Edsel Bryant Ford Biography." https://web.archive.org/web/20210609193212/https://corporate.ford.com/articles/history/edsel-ford-biography.html

FOX Searchlight. 2016, June 21. *The Birth of a Nation: Official HD Trailer.* https://perma.cc/67R4-NL8Q

Freedom's Journal. 1827, March 16. "To Our Patrons." Vol. 1, No. 1. Wisconsin Historical Society.

Frey, William H. 2018, March 14. "The US Will Become 'Minority White' in 2045, Census Projects." Brookings. https://perma.cc/8FSQ-RMXK

Fryar, Cheryl D., Jeffery P. Hughes, Kirsten A. Herrick, and Namanjeet Ahluwalia. 2018. "Fast Food Consumption Among Adults in the United States, 2013–2016." *NCHS Data Brief*, no. 322 (October): 1–8.

Fthenakis, Lisa. 2016. "The First Quest for a National African American Museum." *The Bigger Picture* (blog). https://web.archive.org/web/20160923133543/https://siarchives.si.edu/blog/first-quest-national-african-american-museum

Galaskiewicz, Joseph. 1985. *Social Organization of an Urban Grants Economy: A Study of Business Philanthropy and Nonprofit Organizations.* Orlando: Academic Press.

Gans, Herbert J. 1999. *Popular Culture and High Culture: An Analysis and Evaluation of Taste.* New York: Basic Books.

Ganz, Ollie, Shyanika W. Rose, and Jennifer Cantrell. 2018. "Swisher Sweets 'Artist Project': Using Musical Events to Promote Cigars." *Tobacco Control* 27 (1). http://dx.doi.org/10.1136/tobaccocontrol-2017-054047

Gardiner, Phillip S. 2004. "The African Americanization of Menthol Cigarette Use in the United States." *Nicotine & Tobacco Research* 6: S55–S65.

Gasman, Marybeth, and Noah D. Drezner. 2008. "White Corporate Philanthropy and Its Support of Private Black Colleges in the 1960s and 1970s." *International Journal of Educational Advancement* 8 (2): 79–92.

Gayle, Damien. 2020, February 7. "Climate Activists Bring Trojan Horse to British Museum in BP Protest." *The Guardian.* https://perma.cc/Q6WY-LNZR

"George Wein Presents the 750000 Kool Jazz Festivals." 1975. Brown & Williamson Records. https://www.industrydocuments.ucsf.edu/docs/zlfb0136

Giridharadas, Anand. 2018. *Winners Take All: The Elite Charade of Changing the World.* New York: Knopf.

Glenn, Evelyn Nakano, ed. 2009. *Shades of Difference: Why Skin Color Matters.* Stanford, CA: Stanford University Press.

GMA. 2015, July 13. "GMA & CMTA Research Shows Popularity of Christian Music." https://perma.cc/HQZ7-HVT8

Goffman, Erving. 1963. *Stigma: Notes on the Management of Spoiled Identity.* New York: Simon & Schuster.

Golash-Boza, Tanya. 2018. "Colorism and Skin-Color Stratification." In *Race and Racism: A Critical Approach* (pp. 157–183). New York; Oxford, UK: Oxford University Press.

Goldman Sachs. 2020a. "Goldman Sachs 2020 Sustainability Report." CSR Report. https://perma.cc/5SEB-SY2Z

———. 2020b, June 3. "Goldman Sachs Establishes Fund for Racial Equity." https://perma.cc/XQF9-ZCR6

The Goldman Sachs Group, Inc. 2021. "Annual Meeting of Shareholders Proxy Statement." New York. https://perma.cc/YE86-GKJF

Grams, Diane. 2010. "Distinction of the Black Middle Class." In *Producing Local Color: Art Networks in Ethnic Chicago* (pp. 81–87). Chicago: University of Chicago Press.

Grier, Sonya A., and Anne M. Brumbaugh. 1999. "Noticing Cultural Differences: Ad Meanings Created by Target and Non-Target Markets." *Journal of Advertising* 28 (1): 79–93.

Grier, Sonya A., Anne M. Brumbaugh, and Corliss G. Thornton. 2006. "Crossover Dreams: Consumer Responses to Ethnic-Oriented Products." *Journal of Marketing* 70 (2): 35–51.

Grier, Sonya A., and Shiriki K. Kumanyika. 2008. "The Context for Choice: Health Implications of Targeted Food and Beverage Marketing to African Americans." *American Journal of Public Health* 98 (9): 1616–1629.

Guilarte, Mileydi. 1999, August 20. "Denny's Verdict: $300 Per Plaintiff, 9 Sought More in Racial Bias Case." *Sun Sentinel*. U.S. Newsstream.

Haenfler, Ross. 2014. *Subcultures: The Basics*. London; New York: Routledge.

Haidarali, Laila. 2005. "Polishing Brown Diamonds: African American Women, Popular Magazines, and the Advent of Modeling in Early Postwar America." *Journal of Women's History* 17 (1): 10–37.

Hall, John R. 1992. "The Capital(s) of Culture: A Nonholistic Approach to Status Situations, Class, Gender, and Ethnicity." In *Cultivating Differences: Symbolic Boundaries and the Making of Inequality*, edited by Michèle Lamont and Marcel Fournier (pp. 257–285). Chicago: University of Chicago Press.

Hall, Stuart. 1980. "Encoding/Decoding." In *Culture, Media, Language*, edited by Stuart Hall, Dorothy Hobson, Andrew Lowe, and Paul Willis (pp. 128–138). London: Hutchinson.

"Hampton Kool Jazz Festivals: Close-Up." 1980. Brown & Williamson Records. https://www.industrydocuments.ucsf.edu/docs/zrfp0099

Hanold Associates. 2019, March 18. "Announcing Gucci Changemakers." Hanold Associates.com. https://perma.cc/FC5Z-YU4L

Hardimon, Zharmer. 2016. "Inside the Party with a Purpose: Time Inc.'s Essence Festival Is a Marketer Draw." *Advertising Age*. https://web.archive.org/web/20160719135929/http://adage.com/article/media/time-s-essence-festival-a-marketers-draw/304986/

Harris, Jennifer L., Willie Frazier III, Shiriki Kumanyika, and Amelie G. Ramirez. 2019. "Increasing Disparities in Unhealthy Food Advertising Targeted to Black and Hispanic Youth." *Rudd Report*. Hartford: UConn Rudd Center for Food Policy and Obesity. https://perma.cc/YVA7-VAYE

Harris, Patricia Sowell. 2009. *None of Us Is as Good as All of Us: How McDonald's Prospers by Embracing Inclusion and Diversity*. Hoboken, NJ: Wiley.

Hatch, Mary Jo, and Majken Schultz. 2002. "The Dynamics of Organizational Identity." *Human Relations* 55(8): 989–1018.

Hebdige, Dick. 1979. *Subcultures: The Meaning of Style*. London: Routledge.

Henderson, Geraldine Rosa, Anne-Marie Hakstian, and Jerome D. Williams. 2016. *Consumer Equality: Race and the American Marketplace*. Santa Barbara, CA: Praeger.

Heyman, I. Michael. 1998, January 1. "Museums and Marketing." *Smithsonian Magazine*. https://perma.cc/2PX2-KS8V

Highhouse, Scott, Margaret E. Brooks, and Gary Gregarus. 2009. "An Organizational Impression Management Perspective on the Formation of Corporate Reputations." *Journal of Management* 35 (6): 1481–1493.

Himmelstein, Jerome L. 1997. *Looking Good and Doing Good: Corporate Philanthropy and Corporate Power*. Bloomington and Indianapolis: Indiana University Press.

Holmes, I. R. 1979, September 6. "Kool: Ernie Barnes Promotion." Brown & Williamson Records. https://www.industrydocuments.ucsf.edu/docs/mxnx0102

Holmes, Paul. 1995, January 1. "Customers of Color Make Some Companies Nervous (1995)." *Provoke Media*. https://perma.cc/47D7-3NL3

Hosking, Taylor. 2018, September 13. "Former Afropunk Employees Reveal the Messy Underbelly of the Organization." *Vice*. https://perma.cc/HV5R-EWSA

Hsu, Greta, and Stine Groda. 2015. "Taken-for-Grantedness as a Strategic Opportunity: The Case of Light Cigarettes, 1964 to 1993." *American Sociological Review* 80 (1): 28–62.

Hunter, Margaret. 2011a. "Buying Racial Capital: Skin Bleaching and Cosmetic Surgery in a Globalized World." *Journal of Pan African Studies* 4 (4): 142–164.

———. 2011b. "Shake It, Baby, Shake It: Consumption and the New Gender Relation in Hip-Hop." *Sociological Perspectives* 54 (1): 15–36. https://doi.org/10.1525/sop.2011.54.1.15

Hunter, Margaret, Walter Allen, and Edward Telles. 2001. "The Significance of Skin Color Among African Americans and Mexican Americans." *African American Research Perspectives* (Winter): 173–184.

"The Iconic Flag Sweater." 2021. Ralphlauren.com. https://perma.cc/J346-XHB2

IEG. n.d. "IEG's Nonprofit Sponsorship Survey." Sponsorship. https://perma.cc/T66Q-C8NK

Indianapolis Recorder. 1976, July 17. Advertisement for Kool Jazz Festival.

———. 1977a, March 19. "Ohio Valley KOOL Jazz Festival Dates Announced as July 22–23,"

———. 1977b, July 2. Advertisement for Kool Jazz Festival.

Instagram. 2019, February 4. "To Honor the Black Community . . ." Instagram post. https://perma.cc/NK22-P9XT?type=image

Ismail, Kaya. 2018, December 10. "Social Media Influencers: Mega, Macro, Micro or Nano." *CMSWire.com*. https://perma.cc/UA9V-6A6M

Ivey, Page. 2002, April 8. "Denny's Sheds Its Racist Image." *Columbian*. U.S. Newsstream.

Iyengar, Sunil, Tom Bradshaw, and Bonnie Nichols. 2009. "2008 Survey of Public Participation in the Arts." Washington, DC: National Endowment for the Arts. https://perma.cc/QY6X-M6PA

Jackson, Daniel, and Kevin Moloney. 2016. "Inside Churnalism." *Journalism Studies* 17 (6): 763–780.

Jackson, David Earl. 1998, November 4. "Civil Rights Blues: National Civil Rights Museum." *Tri-State Defender*. Ethnic NewsWatch.

Jacobs, Ronald N. 2000. *Race, Media, and the Crisis of Civil Society: From Watts to Rodney King*. Albany: State University of New York. Kindle.

Jacobs, Ronald N., and Eleanor R. Townsley. 2011. *The Space of Opinion: Media Intellectuals and the Public Sphere*. New York: Oxford University Press.

"Jazz Festivals—The Events of the Year." 1979. Brown & Williamson Records. https://www.industrydocuments.ucsf.edu/docs/gfmp0099

Johnson, Guillaume D., Kevin D. Thomas, Anthony Kwame Harrison, and Sonya A. Grier, eds. 2019. *Race in the Marketplace: Crossing Critical Boundaries*. London: Palgrave.

Johnston, Josée, and Shyon Baumann. 2007. "Democracy Versus Distinction: A Study of Omnivorousness in Gourmet Food Writing." *American Journal of Sociology* 113 (1): 165–204.

———. 2010. *Foodies: Democracy and Distinction in the Gourmet Foodscape*. New York: Routledge.

Jou, Chin. 2017. *Supersizing Urban America: How Inner Cities Got Fast Food with Government Help*. Chicago: University of Chicago Press.

JPMorgan Chase & Co. 2021. "Annual Meeting of Shareholders Proxy Statement." New York. https://perma.cc/5EZK-7WTZ

Ketchum Public Relations. 1982. Kool Jazz Festival Publicity Manual. Brown & Williamson Records. https://www.industrydocuments.ucsf.edu/docs/pglg0145

Khamis, Susie. 2020. *Branding Diversity: New Advertising and Cultural Strategies*. London; New York: Routledge.

Khaire, Mukti. 2017. *Culture and Commerce: The Value of Entrepreneurship in Creative Industries*. Stanford, CA: Stanford University Press.

Khan, Shamus Rahman. 2011. *Privilege: The Making of an Adolescent Elite at St. Paul's School*. Princeton, NJ: Princeton University Press.

King, Gerald. 2016, September 23. "A 'Baby Bell-Head' Reflects on the AT&T Contribution to the National Museum for African American History and Culture." *Your Inside Connections* (blog). https://perma.cc/V7UK-ZSWL

King, Martin Luther, Jr. 1963, August 28. "I Have a Dream." Speech. Washington, DC. https://perma.cc/6743-VKT7

Kirchberg, Volker. 2003. "Corporate Arts Sponsorship." In *Recent Developments in Cultural Economics*, edited by Ruth Towse (pp. 143–151). Cheltenham, UK: Edward Elgar.

Kirk, R. M. 1979, May 22. "Minority Marketing a Continuing Challenge." Brown & Williamson Records; Master Settlement Agreement. https://www.industrydocuments.ucsf.edu/docs/yjjd0134

Klein, Julia M. 2008, March 12. "A Slavery Museum Negotiates the Treacherous Route to Funding." *New York Times*. https://perma.cc/Y4RC-ZVAZ

Knowles, Hannah, and Laurie McGinley. 2019, November 1. "As Trump Tackles Vapes, African Americans Feel Stung by Inaction on Menthol Cigarettes." *Washington Post*. https://web.archive.org/web/20191215144954/https://www.washingtonpost.com/national/health-science/as-trump-tackles-vapes-african-americans-feel-stung-by-inaction-on-menthol-cigarettes/2019/10/31/d06e93d2-e6ec-11e9-a331-2df12d56a80b_story.html

"Kool." n.d. Brown & Williamson Records. https://www.industrydocuments.ucsf.edu/docs/sxmw0142

"Kool Country on Tour." 1980. Brown & Williamson Records. https://www.industrydocuments.ucsf.edu/docs/hflp0128

"Kool History." n.d. Brown & Williamson Records. https://www.industrydocuments.ucsf.edu/docs/qhff0135

"Kool Jazz Festival." 1978. Brown & Williamson Records. https://www.industrydocuments.ucsf.edu/docs/xtyp0138

———. 1979. Brown & Williamson Records. https://www.industrydocuments.ucsf.edu/docs/lknm0178

———. 1982. Brown & Williamson Records. https://www.industrydocuments.ucsf.edu/docs/ptkv0100

"Kool Jazz Festival–Atlanta." 1986. Brown & Williamson Records. https://www.industry-documents.ucsf.edu/docs/kgbv0100

"Kool Jazz Festival and Kool Country on Tour Marketing Plans." 1978. Brown & Williamson Records. https://www.industrydocuments.ucsf.edu/docs/zkgv0140

"Kool Jazz Festival–New York Publicity Program." 1981. Brown & Williamson Records. https://www.industrydocuments.ucsf.edu/docs/ypfp0128

"Kool Jazz Festivals." 1978. Brown & Williamson Records. https://www.industrydocuments.ucsf.edu/docs/gzpg0134

"Kool Jazz Festivals General Information." 1981. Brown & Williamson Records. https://www.industrydocuments.ucsf.edu/docs/pqfb0100

"Kool Jazz Festivals 790000." 1979. Brown & Williamson Records. https://www.industrydocuments.ucsf.edu/docs/qncv0100

"Kool; Kool Parent; Kool Super Lights." n.d. Brown & Williamson Records. https://www.industrydocuments.ucsf.edu/docs/tyyv0133

Koontz, Amanda, and Jenny Nguyen. 2020. "Hybridized Black Authenticity: Aspirational Lifestyle Ideals and Expectations of the Self-Disciplined Black Woman in *Essence*." *Sociological Quarterly* 61 (3): 448–473. https://doi.org/10.1080/00380253.2019.1711256

Krieger, Linda Hamilton, Rachel Kahn Best, and Lauren Edelman. 2015. "When 'Best Practices' Win, Employees Lose: Symbolic Compliance and Judicial Inference in Federal Equal Employment Opportunity Cases." *Law & Social Inquiry* 40 (4): 843–879.

Kroc, Ray, and Robert Anderson. 1977. *Grinding It Out: The Making of McDonald's*. New York: St. Martin's Griffin.

Labaton, Stephen. 1994, May 25. "Denny's Restaurants to Pay $54 Million in Race Bias Suits." *New York Times*. https://perma.cc/XFX7-NFP7

Lamont, Michèle. 1992. *Money, Morals, and Manners: The Culture of the French and American Upper-Middle Class*. Chicago: University of Chicago Press.

Lamont, Michèle, and Annette Lareau. 1988. "Cultural Capital: Allusions, Gaps and Glissandos in Recent Theoretical Developments." *Sociological Theory* 6 (2): 153–68.

Leblanc, Lauraine. 1999. *Pretty in Punk: Girls' Gender Resistance in a Boys' Subculture*. New Brunswick, NJ: Rutgers University Press.

Lena, Jennifer C. 2012. *Banding Together: How Communities Create Genres in Popular Music*. Princeton, NJ: Princeton University Press.

———. 2019. *Entitled: Discriminating Tastes and the Expansion of the Arts*. Princeton, NJ: Princeton University Press.

Leong, Nancy. 2013. "Racial Capitalism." *Harvard Law Review* 126 (8): 2151–2226.

———. 2021. *Identity Capitalists: The Powerful Insiders Who Exploit Diversity to Maintain Inequality*. Stanford, CA: Stanford University Press.

Lewis, Edward. 2014. *The Man from Essence: Creating a Magazine for Black Women*. New York: Atria Books.

Lewis, Justin, Andrew Williams, and Bob Franklin. 2008. "Four Rumours and an Explanation: A Political Economic Account of Journalists Changing Newsgathering and Reporting Practices." *Journalism Practice* 2 (1): 27–45.

Limnander, Armand. 2000, March 1. "Vogue View: Tracing a Trend: Hey, Punk!" *Vogue*.

Livernois, Joe. 2003, February 5. "Salinas, Calif., NAACP Aids Preparation of Discrimination Suit Against Denny's." *Knight Ridder Tribune Business News*. U.S. Newsstream.

Lizardo, Omar, and Sara Skiles. 2012. "Reconceptualizing and Theorizing 'Omnivorousness': Genetic and Relational Mechanism." *Sociological Theory* 30: 260–280.

———. 2015. "After Omnivorousness: Is Bourdieu Still Relevant?" In *Routledge International Handbook of the Sociology of Art and Culture*, edited by Laurie Hanquinet and Mike Savage (pp. 90–103). Abingdon, Oxon, UK; New York: Routledge.

Llewellyn, André, and Joy Ofodu. 2019, February 12. "Instagram Celebrates Black History Month with #ShareBlackStories." *Instagram Blog* (blog). https://perma.cc/HP77-2L44

lonniehuntermusic. 2019, July 27. "THE DMV IS LIT!!!!!" Instagram post. https://web.archive.org/web/20200915115951/https://www.instagram.com/p/BocQNfWn7CU/?igshid=zseinkjq1y53

Los Angeles Sentinel. 1979, May 10. "5th Annual Kool Jazz Festival." ProQuest.

———. 1981, April 3. "Kool Jazz at San Diego, June 5–6."

———. 1982, October 14. Advertisement for Kool Jazz Festival.

Lott, Steve. 2014, April 3. "Boeing Donation to National Air and Space Museum to Support Renovation, Education." Boeing.com. https://web.archive.org/web/20140513023846/https://boeing.mediaroom.com/Boeing-Donation-to-National-Air-and-Space-Museum-to-Support-Renovation-Education

Maheshwari, Sapna. 2017, October 12. "Different Ads, Different Ethnicities, Same Car." *New York Times*. https://perma.cc/3HE5-AVWS

Maloney, Jennifer, and Tom McGinty. 2018, November 15. "FDA Seeks Ban on Menthol Cigarettes." *Wall Street Journal*. https://perma.cc/FVV4-MZUM

MaMa. n.d.a. "About." https://perma.cc/7YJG-M9ZN

———. n.d.b. "AT&T: It's a (###) Thing." https://perma.cc/SQU7-UJTS

Martorella, Rosanne. 1990. *Corporate Art*. New Brunswick, NJ: Rutgers University Press.

———. 1996. *Art and Business: An International Perspective on Sponsorship*. Westport, CT; London: Praeger.

Masci, David. 2018, February 7. "5 Facts About the Religious Lives of African Americans." *Pew Research Center*. https://perma.cc/NU6C-W69D

Massey, Joseph Eric. 2015. "A Theory of Organizational Image Management." *Proceedings of 47th IIER International Conference*: 7–12.

Masters, Kim. 1992, February 29. "Bug-Eyed over Museum's Booster; Smithsonian Insect Zoo to Be Named for Orkin." *Washington Post*. https://perma.cc/7H89-XKLH

Matthews, Bob. 1982, June 12. "Kool Jazz Festival One in a Lifetime Event." *Afro-American*.

Mauss, Marcel. 1967. *The Gift: Forms and Functions of Exchange in Archaic Societies*. New York: Norton.

McCandless, Phyra M., Valerie B. Yerger, and Ruth E. Malone. 2012. "Quid Pro Quo: Tobacco Companies and the Black Press." *American Journal of Public Health* 102 (4): 739–750.

McCarthy, C. I. 1975, April 15. "George Wein Presents the 1975 Kool Jazz Festivals." Brown & Williamson Records. https://www.industrydocuments.ucsf.edu/docs/kqmv0139

McCracken, Grant. 1986. "Culture and Consumption: A Theoretical Account of the Structure and Movement of the Cultural Meaning of Consumer Goods." *Journal of Consumer Research* 13 (1): 71–84.

McDonald's. 2009, May 6. "McDonald's Inspiration Celebration Gospel Tour Coming to Philly!" *PRNewswire*. ProQuest.

———. 2013, April 25. "McDonald's and Gospel Music Superstars Announce Concert Tour to Give Back to Communities Nationwide." *PRNewswire*. ProQuest.

———. n.d.a. "My History, My Heritage, My Legacy." 365Black.com. https://perma.cc/8KEC-5X76

———. n.d.b. "Our History." https://perma.cc/P4J5-H8JH

"McDonald's Launches 'Black & Positively Golden' Campaign." 2019, April 1. *QSR Magazine*. https://perma.cc/H3DZ-E433

"McDonald's Plans Biggest Marketing Overhaul in 16 Years." 2019, April 1. *Insideradio.com*. https://perma.cc/37DX-PQLB

"McDonald's Black & Positively Golden Announces 13th Annual Inspiration Celebration Gospel Tour." 2019, April 10. *PR Newswire*. Global Newsstream.

McDonald's USA. 2019, April 10. "McDonald's Black & Positively Golden Announces 13th Annual Inspiration Celebration Gospel Tour and Talent Lineup." *PRNewswire*. https://perma.cc/R9MV-2ZRH

McDonnell, Mary-Hunter, and Brayden King. 2013. "Keeping up Appearances: Reputational Threat and Impression Management After Social Movement Boycotts." *Administrative Science Quarterly* 58 (3): 387–419.

McDonough, Buddy. 1983, June 25. "How Cool Is Kool?" *New Pittsburgh Courier*.

McGoey, Linsey. 2015. *No Such Thing as a Free Gift: The Gates Foundation and the Price of Philanthropy*. Brooklyn; London: Verso.

McKeown, F. E. 1976, August 16. "Kool Jazz Festivals." Brown & Williamson Records. https://www.industrydocuments.ucsf.edu/docs/mlfl0140

McRae, F. Finley. 2001, September 5. "Black Family Suing Denny's for Racial Bias." *Los Angeles Sentinel*. U.S. Newsstream.

Mediacloud.Exeloncorp. 2016. "Exelon Foundation Museum Donation Video." Mediacloud.Exeloncorp.com

Meghji, Ali. 2019. *Black Middle-Class Britannia: Identities, Repertoires, Cultural Consumption*. Manchester, UK: Manchester University Press.

Mills, R. A. 1978, July 20. "Kool Jazz Festival." Brown & Williamson Records. https://www.industrydocuments.ucsf.edu/docs/gjnx0102

Mitchell, John L. 2001. August 24. "Los Angeles Family Sues Denny's, Alleges Bias." *Los Angeles Times*. U.S. Newsstream.

Molotsky, Irvin, and Warren Weaver, Jr. 1986, July 19. "Gospel and Fried Chicken." *New York Times*.

Monee. 2016, February 16. "African-American Artistry, Join the Celebration!" *Pulse* (blog). https://web.archive.org/web/20160818143328/https://pulse.target.com/2016/02/african-american-artistry-join-the-celebration/

Monrovia Weekly. 2013, January 31. "Wells Fargo Celebrates Year of the Snake with Special Customer Appreciation Promotions and Community Sponsorships." https://perma.cc/2WTC-KKR5

Moody, Mia Nodeen. 2008. *Black and Mainstream Press' Framing of Racial Profiling: A Historical Perspective*. Lanham, MD: University Press of America.

"The Most Refreshing Taste You Can Ge[t] in Any Cigarette. No Wonder It's America's #1 Menthol." 1977. Lorillard Records. https://www.industrydocuments.ucsf.edu/docs/xxpw0110

Moye, Jay. 2019, July 2. "Coca-Cola Toasts to the 25th Anniversary of ESSENCE Festival—News & Articles." https://perma.cc/FC7Q-Z6JJ

Moynihan, Colin. 2018, March 10. "Opioid Protest at Met Museum Targets Donors Connected to OxyContin." *New York Times*. https://perma.cc/Z5K7-HPAC

Museum of the American Indian/Heye Foundation Records. 1985. "Proposal for General Operating Support" (464). Washington, DC: National Museum of the American Indian Archive Center, Smithsonian Institution.

———. n.d. "Corporate Appeal." (464). Washington, DC: National Museum of the American Indian Archive Center, Smithsonian Institution.

National Cancer Institute. 1996. "The FTC Cigarette Test Method for Determining Tar, Nicotine, and Carbon Monoxide Yields of U.S. Cigarettes." Report of the NCI Expert Committee. National Institutes of Health, National Cancer Institute. https://perma.cc/9FPQ-H6YE

———. 2008. "The Role of the Media in Promoting and Reducing Tobacco Use." *Smoking and Tobacco Control Monograph No. 19*. NIH Pub. No. 07–6242.

National Civil Rights Museum. 2002a, June 2. "The Campaign." https://web.archive.org/web/20020602115121/http://civilrightsmuseum.org/news/denny.asp

———. 2002b, August 28. "Homepage." https://web.archive.org/web/20020828064506/https:/www.civilrightsmuseum.org/

———. 2002c, December 1. "Join Us as We Re-ignite the Dream." https://web.archive.org/web/20021201190707/http://www.civilrightsmuseum.org/news/reignite.asp

NBMOA (National Black McDonald's Operators Association). n.d. "Our History." https://perma.cc/3DV9-XRCK

Nelson Jr., Stanley. 1999. *The Black Press: Soldiers Without Swords*. Documentary. Third World Newsreel. https://perma.cc/H5PV-TDXS

"New Brand Information." 2004. RJ Reynolds Records. https://www.industrydocuments.ucsf.edu/docs/pjxh0222

New Cupid. 2018, September 12. "HIT THE SHARE BUTTON." Facebook post. https://perma.cc/8HJR-8X97

New Journal and Guide. 1976, April 10. "Hampton Jazz Festival Set for June 25–27." ProQuest.

———. 1979, June 1. Advertisement for Kool Jazz Festival.

———. 1983, June 1. Advertisement for Kool Jazz Festival.

Newkirk, Pamela. 2020. *Diversity, Inc.: The Fight for Racial Equality in the Workplace.* New York: Bold Type Books.

"The 1983 Image Study." 1983. Product Design MSA Collection. https://www.industry-documents.ucsf.edu/docs/xtbk0037

"NMAI Launches Corporate Membership Program." 1997. *Native Peoples Magazine* 10 (Spring): 64–65.

Novak, M. J. 1981, April 3. "810000 Kool Jazz Festival Promotion Plans Letter." Brown & Williamson Records. https://www.industrydocuments.ucsf.edu/docs/hydk0144

Nguyen, Terry. 2020, June 3. "Consumers Don't Care About Corporate Solidarity. They Want Donations." *Vox.* https://web.archive.org/web/20200915111749/https://www.vox.com/the-goods/2020/6/3/21279292/blackouttuesday-brands-solidarity-donations

Nike. n.d.a. "How We Stand Up for Equality." *Nike Purpose* (blog). https://perma.cc/98JN-68BU

———. n.d.b. "NIKE, Inc. Statement on Commitment to the Black Community." *Nike Purpose* (blog). https://perma.cc/SYC6-7HH7

NMAAHC. 2021. "About the Museum." National Museum of African American History and Culture. https://perma.cc/38LW-7HSN

NMAAHC Collection. n.d. "Bible Belonging to Nat Turner." NMAAHC.si.edu. https://web.archive.org/web/20170218071851/https://nmaahc.si.edu/object/nmaahc_2011.28

Oakland Post. 1975a, May 4. "Ohio Players & Bobby Hutcherson Added to Kool Jazz." Ethnic NewsWatch.

———. 1975b, June 4. "Kooling It . . . with Kool Jazz." Ethnic NewsWatch.

———. 1976, May 16. "5th Annual Bay Area / Clip & Save: Kool Jazz Festival." Ethnic NewsWatch.

officialnewcupid. 2019, July 4. "Cupid (frm Cupid Shuffle) on Instagram" Instagram post. https://perma.cc/78CF-NRYE

Ofodu, Joy. 2019, August 24. "Bringing #ShareBlackStories to Afropunk 2019." *From Joy to the World* (blog). https://perma.cc/VLL6-7ER6

"O. Orkin Insect Zoo." 2021. https://perma.cc/MC69-W6S2

Ostrower, Francie. 2002. *Trustees of Culture: Power, Wealth, and Status on Elite Arts Board.* Chicago: University of Chicago Press.

Papa John's. 2019, January 24. "How Papa John's Is Standing with Bennett College." https://perma.cc/NHT3-ZQLB

Parker, Nate. 2016, October 23. "With #NatTurner Bible." Facebook post. https://perma.cc/EV2W-VMBK

"Part of Our Fabric: Exelon's Philanthropy, Workplace Programs Reflect Dedication

to Inclusion." n.d. Exeloncorp.com. https://web.archive.org/web/20190530062833/
https://www.exeloncorp.com/newsroom/part-of-our-fabric-exelons-workforce
-programs-reflect-dedication-to-inclusion

Pasadena Independent. 2013, January 31. "Wells Fargo Celebrates Year of the Snake with Special Customer Appreciation Promotions and Community Sponsorships." https://perma.cc/25VH-45J3

Pattillo, Mary. 2007. *Black on the Block: The Politics of Race and Class in the City.* Chicago: University of Chicago Press.

Pepco. 2016, December. "Exelon Foundation Donates $1 Million to the National Museum of African American History and Culture." *Community Focus: Pepco an Exelon Company.* Washington, D.C. https://perma.cc/QR4F-ZHLT

Peterson, Richard A. 1997. "The Rise and Fall of Highbrow Snobbery as a Status Marker." *Poetics* 25: 75–92.

Philadelphia Tribune. 1981, June 26. "Kool Festival Attracts Jazz Greats from All Over." ProQuest.

Pittman, Cassi. 2020. "'Shopping While Black': Black Consumers' Management of Racial Stigma and Racial Profiling in Retail Settings." *Journal of Consumer Culture.* 20 (1): 3–22.

Pogrebin, Robin, Elizabeth A. Harris, and Graham Bowley. 2019, October 2. "New Scrutiny of Museum Boards Takes Aim at World of Wealth and Status." *New York Times.* https://perma.cc/FSF3-UZBJ

Pongsakornrungsilp, Siwarit, and Jonathan E. Schroeder. 2011. "Understanding Value Co-Creation in a Co-Consuming Brand Community." *Marketing Theory* 11 (3): 303–324.

Porter, Michael E., and Mark R. Kramer. 2002, December. "The Competitive Advantage of Corporate Philanthropy." *Harvard Business Review* 80 (12): 56–69.

"The Power to March Forward." 2019. Bankofamerica.com. https://web.archive.org/web/20190228232526/https://promo.bankofamerica.com/powerto/social-progress

"Product Placement in the Pews? Microtargeting Meets Megachurches." 2006, November 15. Knowledge@Wharton. https://web.archive.org/web/20191226173107/https://knowledge.wharton.upenn.edu/article/product-placement-in-the-pews-microtargeting-meets-megachurches/

"Program of Kool Jazz Festival New York Announces." 1981. Brown & Williamson Records. https://www.industrydocuments.ucsf.edu/docs/rymp0134

Project for Excellence in Journalism. 2010. "How News Happens: A Study of the News Ecosystem of One American City." Washington, DC: Pew Research Center.

The Rad Voice. 2018, October 17. "AFROPUNK Harmed Way More People Than Previously Reported: Staff, Community Speak Out." https://perma.cc/U63R-MRZD

Ralph Lauren. 2018. "Ralph Lauren: Corporate Responsibility Report Fiscal 2017." New York: Ralph Lauren. https://perma.cc/QG3G-D9G5

Ray, Victor. 2019. "A Theory of Racialized Organizations." *American Sociological Review* 84 (1): 26–53.

Reich, Rob. 2018. *Just Giving: Why Philanthropy Is Failing Democracy and How It Can Do Better.* Princeton; Oxford, UK: Princeton University Press.

Reich, Zvi. 2010. "Measuring the Impact of PR on Published News in Increasingly Fragmented News Environments: A Multifaceted Approach." *Journalism Studies* 11 (6): 799–816.

Ritzer, George. 2015a. "The 'New' World of Prosumption: Evolution, 'Return of the Same,' or Revolution?" *Sociological Forum* 30 (1): 1–17.

———. 2015b. "Prosumer Capitalism." *Sociological Quarterly* 56 (3): 413–445.

Ritzer, George, and Nathan Jurgenson. 2010. "Production, Consumption, Prosumption: The Nature of Capitalism in the Age of the Digital 'Prosumer.'" *Journal of Consumer Culture* 10 (1): 13–36.

Ronald McDonald House Charities (RMHC). n.d. "Our Relationship with McDonald's." https://perma.cc/C3DZ-ZZHT

Rooks, Noliwe M. 1996. *Hair Raising: Beauty, Culture, and African American Women.* New Brunswick, NJ; London: Rutgers University Press.

Russell, Cristine. 2008. "Science Reporting by Press Release. An Old Problem Grows Worse in the Digital Age." *Columbia Journalism Review.* https://perma.cc/YAT8-XXTS

Ryan, Laura. 2004, September 21. "Accenture Supports Smithsonian's National Museum of the American Indian." Accenture.com. September 21, 2004. https://perma.cc/TB2J-MQG2

Sabin, Cara. n.d. "Letter from CEO." https://perma.cc/WZY8-PE7W

Sales Department. 1979. "Kool Jazz Festival." Brown & Williamson Records. https://www.industrydocuments.ucsf.edu/docs/tmhb0100

Salmans, Sandra. 1981, November 11. "Philip Morris and the Arts." *New York Times.* https://perma.cc/RU3L-BWKK; https://www.nytimes.com/1981/11/11/business/philip-morris-and-the-arts.html

Santangelo, D. J. 1976, January 21. Brown & Williamson Records. https://www.industrydocuments.ucsf.edu/docs/jrdv0100

Santangelo, D. J., and G. Wein. 1978, April 5. "Kool Jazz Festivals." Brown & Williamson Records. https://www.industrydocuments.ucsf.edu/docs/hxyp0099

Schaver, Mark. 1999, December 22. "2 File Suit Against Denny's in West Buechel; Men Allege Racial Discrimination, Undue Police Force." *Courier—Journal.* ProQuest.

Schor, Juliet B. 2004. *Born to Buy: The Commercialized Child and the New Consumer Culture.* New York: Scribner.

Schultz, E. J. 2019, June 20. "Sprite Shelves 'Obey Your Thirst' After 25 Years as It Updates Its Hip-Hop Marketing." *Ad Age.* https://perma.cc/J89R-R4RX

Segall, Laura. 2008. "The 9th Annual Super Bowl Gospel Celebration." *Ebony* (May): 136–137

Shea Moisture. 2017, April 27. "Wow, Okay—So Guys" https://perma.cc/BM6G-ST8E

———. n.d.a. "Community Commerce." https://perma.cc/4UTJ-MSSE

———. n.d.b. "Our Story." https://perma.cc/JS8R-TXTJ

Shorty Awards. n.d. "#ReignOn Essence Festival 2018—The Shorty Awards." https://perma.cc/4GRK-HE65

Sidibe, Myriam. 2020. *Brands on a Mission: Achieving Social Impact and Business Growth Through Purpose.* Abingdon, UK: Routledge.

Silber, Bohne, Silber & Associates, and Tim Triplett. 2015. *A Decade of Arts Engagement: Findings from the Survey of Public Participation in the Arts, 2002–2012.* Washington, DC: National Endowment for the Arts.

Siroto, Janet. 1993, September 1. "Vogue's View: Punk Rocks Again." *Vogue.*

The Skanner. 1982, July 28. "Kool Jazz." Ethnic NewsWatch.

Skrentny, John D. 2014. *After Civil Rights: Racial Realism in the New American Workplace.* Princeton, NJ: Princeton University Press.

"Slavery Museum's Appeal." 2006. September 23. Fredericksburg.com. https://web.archive.org/web/20130918180357/https://fredericksburg.com/news/fls/2006/092006/09232006/224101/

Smithsonian. 2020, June 8. "Smithsonian Announces 'Race, Community and Our Shared Future' Initiative." https://perma.cc/SR2N-LNDP

Soule, Sarah A. 2009. *Contention and Corporate Social Responsibility.* Cambridge, UK: Cambridge University Press.

"South: Gypsies Vs. Denny's." 2005, June 27. *NJBIZ.* U.S. Newsstream.

Spooner, James. 2003. *Afro-Punk.* Documentary. https://perma.cc/9CSM-75ZV

Stainback, Kevin, and Donald Tomaskovic-Devey. 2012. *Racial and Gender Segregation in Private Sector Employment Since the Civil Rights Act.* New York: Russell Sage Foundation.

Stendardi, Edward J. 1992. "Corporate Philanthropy: The Redefinition of Enlightened Self-Interest." *Social Science Journal* 29: 21–30.

Stephen, Andrew T., and Jeff Galak. 2012. "The Effects of Traditional and Social Earned Media on Sales: A Study of a Microlending Marketplace." *Journal of Marketing Research* 49 (5): 624–639.

Sun Reporter. 1978, July 13. "7th Kool Jazz Festival." Ethnic NewsWatch.

———. 1979, May 10. "Annual Kool Festival." Ethnic NewsWatch.

Swinomish Indian Tribal Community v. BNSF Railway Company. 2020. D.C. No. 2:15-cv-00543-RSL. United States Court of Appeals for the Ninth Circuit.

Taft, J. Richard, and Alice Green Burnette. 2003. "Final Report: Planning and Organization for a Private Sector Fundraising Campaign in Behalf of the National Museum of African American History and Culture." Smithsonian Institution Archives, Accession 07–172. Washington, DC: National Museum of African American History and Culture, Planning Records.

Target. 2016a. "Go Inside the National Museum of African American History & Culture Video Transcript." *A Bullseye View* (blog). https://web.archive.org/web/20190531053631/https://corporate.target.com/Videos-Transcripts/26166/NMAAHC-museum-tour-video

———. 2016b, September 19. "Opening Doors: A Chat with National Museum of African American History and Culture Director Lonnie Bunch." *A Bullseye View*

(blog). https://web.archive.org/web/20171011195259/https://corporate.target.com/article/2016/09/chat-with-lonnie-bunch

———. 2017, September 18. "Nurturing the Next Generation of Design: Target's Helping Budding Designers Think Big." *Target Corporate* (blog). https://perma.cc/7SZU-4LAQ

Taylor, Judith, Josée Johnston, and Krista Whitehead. 2014. "A Corporation in Feminist Clothing? Young Women Discuss the Dove 'Real Beauty' Campaign." *Critical Sociology* 42 (1): 123–144.

Tejedor, Chrystian. 2005, April 28. "7 Men Sue Florida City Denny's After Being Called 'Bin Ladens.'" *Knight Ridder Tribune Business News*. U.S. Newsstream.

Thompson, Krista A. 2015. *Shine: The Visual Economy of Light in African Diasporic Aesthetic Practice*. Durham, NC: Duke University Press.

"Three Companies Show Why They Are Best-in-Class for Diversity." 2006, March 16. *Knowledge@Wharton*. https://perma.cc/6PAV-D3VY

Time. 1977, July 11. "Music: Anthems of the Blank Generation." https://perma.cc/NKM3-RJPG

———. 1978, January 16. "The Sex Pistols Are Here: The Pioneers of Punk Rock Do Not Quite Burn Atlanta." https://perma.cc/K8GX-5M5Q

Tolley, Erin. 2015. *Framed: Media and the Coverage of Race in Canadian Politics*. Vancouver; Toronto: UBC Press.

Trescott, Jacqueline. 1996, December 18. "Corporate Patrons Are Museums' Last Hope, Smithsonian Chief Says." *Washington Post*. https://perma.cc/J5UA-TRST

———. 2001, March 30. "Air & Space Venue Renamed for Corporate Benefactor." *Washington Post*. U.S. Newsstream.

Tri-State Defender. 1976, March 20. "Gaye, Smokey at Festival." Ethnic NewsWatch.

———. 1977, May 14. "Kool Jazz Festival: To Make Grants." Ethnic NewsWatch.

———. 1978, July 5. "Kool Jazz Festival July 15." Ethnic NewsWatch.

Truth Initiative. 2018, August 31. "Menthol: Facts, Stats and Regulations." https://web.archive.org/web/20200110213127/https://truthinitiative.org/research-resources/traditional-tobacco-products/menthol-facts-stats-and-regulations

Tsutsui, Kiyoteru, and Alwyn Lim, eds. 2015. *Corporate Social Responsibility in a Globalizing World*. Cambridge, UK: Cambridge University Press.

Tuten, Tracy L. 2019. *Principles of Marketing for a Digital Age*. Thousand Oaks, CA: Sage.

20th Century Studios. 2016. *Hidden Figures: Official Trailer*. Youtube.com. https://www.youtube.com/watch?v=5wfrDhgUMGI

21CF Staff. 2016, September 29. "21st Century Fox Supports the Smithsonian National Museum of African American History & Culture." *21CF Blog* (blog). https://web.archive.org/web/20180801014319/https://www.21cf.com/blog/2016/09/29/21cf-smithsonian-national-museum-african-american-history-culture/

Unilever. 2017. "Annual Report." Rotterdam, Netherlands: Unilever. https://perma.cc/VC7T-KWFS

———. 2019. "Annual Report." Rotterdam, Netherlands: Unilever. https://perma.cc/W4BS-ZP89

US Food & Drug Administration. 2021. "FDA Commits to Evidence-Based Actions Aimed at Saving Lives and Preventing Future Generations of Smokers." https://perma.cc/N4JD-B5AP

U.S. v. Flagstar Corporation and Denny's, Inc. 1994. Northern District of CA (U.S.).

U.S. v. TW Services, Inc. 1993. Northern District of CA (U.S.).

Useem, Michael. 1984. *The Inner Circle: Large Corporations and the Rise of Business Political Activity in the U.S. and U.K.* New York: Oxford University Press.

Vartanian, Lenny R., Marlene B. Schwartz, and Kelly D. Brownell. 2007. "Effects of Soft Drink Consumption on Nutrition and Health: A Systematic Review and Meta-Analysis." *American Journal of Public Health* 97 (4): 667–675.

Victorian, Brande. 2019, July 9. "Ford Gives Black Women Artists a Platform at Essence Fest." *Madame Noire.* https://madamenoire.com/1080896/ford-gives-black-women-artists-a-platform-at-essence-fest/

Vogel, David. 2016. "Lobbying the Corporation: Citizen Challenges to Business Authority." In *Kindred Strangers: The Uneasy Relationship Between Politics and Business in America,* by David Vogel (pp. 166–194). Princeton, NJ: Princeton University Press.

Wade, Jeannette M. 2012. "African Americans, Fast Food, and the Birdcage of Oppression." In *Advances in Sociology Research, Volume 10,* edited by Jared A. Jaworski (pp. 129–150). Happauge, NY: Nova Science Publishers.

Walker, Edward T. 2013. "Signaling Responsibility, Deflecting Controversy: Strategic and Institutional Influences on the Charitable Giving of Corporate Foundations in the Health Sector." *Voices of Globalization: Research in Political Sociology* 21: 181–214.

Wallace, Derron. 2017. "Reading 'Race' in Bourdieu? Examining Black Cultural Capital Among Black Caribbean Youth in South London." *Sociology* 51 (5): 907–923.

———. 2019. "The Racial Politics of Cultural Capital: Perspectives from Black Middle-Class Pupils and Parents in a London Comprehensive." *Cultural Sociology* 13 (2): 159–177.

Walmart. 2021. "Notice of 2021 Annual Shareholders' Meeting." https://perma.cc/C4US-3QU6

Walmart World. 2018, December 14. "Down, Down, Do Your Dance." *Facebook* (blog). https://perma.cc/5S6L-M9RC

Warikoo, Natasha K. 2016. *Diversity Bargain: And Other Dilemmas of Race, Admissions, and Meritocracy at Elite Universities.* Chicago: University of Chicago Press.

Wein, George. 1976, October 8. Letter. Brown & Williamson Records. https://www.industrydocuments.ucsf.edu/docs/lmpx0102

Wein, George, and Nate Chinen. 2003. *Myself Among Others: A Life in Music.* Cambridge, MA: Da Capo Press. Kindle.

Weinraub, Judith. 1990, October 20. "Costner's Sioux Ceremony." *Washington Post.* https://perma.cc/59XN-77P6

Wells Fargo. 2017, February 3. "Slideshow: 100+ Years of Celebrating Lunar New Year." Wells Fargo Stories. https://perma.cc/N2B7-EVW4

West, E. James. 2021. "His Light Still Shines: Corporate Advertisers and the Mar-

tin Luther King, Jr. Holiday." *Advertising & Society Quarterly* 22 (1). doi:10.1353/asr.2021.0019

Wherry, Frederick F. 2011. *The Philadelphia Barrio: The Arts, Branding, and Neighborhood Transformation.* Chicago: University of Chicago Press.

———. 2012. *The Culture of Markets.* Cambridge, UK: Polity Press.

White, Erin. 2017, April 25. "Did Shea Moisture Hire the Same Ad Team as Pepsi or Sumthin'?" *AFROPUNK.* https://perma.cc/Y9EE-XTE4/

"Who Was James Smithson?" Smithsonian Institution Archives. Washington, DC. https://perma.cc/3CK4-73L5

Wichita Times. 1975, May 8. "Ohio Players Added to Kansas City Kool Jazz Festival."

Williams, Janice. 2017, April 25. "Black Is Beautiful: Shea Moisture Ad Reveals How African-American Women Are Often Maligned by Beauty Industry." *Newsweek.* https://perma.cc/5CN5-LWJ4

Willie, Sarah Susannah. 2003. *Acting Black: College, Identity, and the Performance of Race.* New York: Routledge.

Willson, M. O. 1975, April 8. Kool Jazz Festival Materials. Brown & Williamson Records; Oklahoma Privilege Downgrades Collection. https://www.industrydocuments.ucsf.edu/docs/gqyp0138

Willoughby, Vanessa. 2018, September 6. "Who Owns Afropunk?" *Bitch Media.* https://perma.cc/GE9H-ZGYD

Wilson, William Julius. 1978. *The Declining Significance of Race: Blacks and Changing American Institutions.* Chicago: University of Chicago Press.

Wingfield, Adia Harvey. 2019. *Flatlining: Race, Work, and Health Care in the New Economy.* Berkeley: University of California Press.

Winston, Chris. 2000, February 24. "Book Chronicles Denny's Com[e]back from Brink." *Spartanburg Herald-Journal.*

Wohl, Jessica. 2019, March 29. "McDonald's African-American Marketing Gets Biggest Overhaul in 16 Years." *Ad Age.* https://perma.cc/GVD4-FYNG

"Women Called Racial Slurs Told to Leave Local Denny's." 2019, July 21. *Lansing State Journal.* U.S. Newsstream.

Wooten, Melissa E. 2006. "Race and Strategic Organization." *Strategic Organization* 42 (2): 191–199.

———, ed. 2019. *Race, Organizations, and the Organizing Process. Vol. 60. Research in the Sociology of Organizations,* United Kingdom: Emerald Publishing Limited.

Yiin, Wesley. 2016, September 21. "Timeline: It Took over 100 Years for the African American Museum to Become a Reality." *Washington Post.* https://perma.cc/87F2-NA84

Young, Danielle. 2019, July 1. "Essence and Coca-Cola Announce 'If Not For My Girls' Celebrating the Strength, Bond & Friendship of Black Women." *Essence.* https://perma.cc/M4Q6-MK3R

Yu, Deborah. 1992, April 26. "Firms Trim Museum Donations." *Los Angeles Daily News.* Factiva.

Zajc, Melita. 2015. "Social Media, Prosumption, and Dispositives: New Mechanisms of the Construction of Subjectivity." *Journal of Consumer Culture* 15 (1): 28–47.

Zhou, Nan, and Russell W. Belk. 2004. "Chinese Consumer Readings of Global and Local Advertising Appeals." *Journal of Advertising* 33 (3): 63–76.

Zito, Tom. 1983, July 12. "A Wing and a Prayer." *Washington Post.* https://perma.cc/9D3C-T7A2

Index

CULTURE AND ECONOMIC LIFE

EDITORS: Frederick Wherry and Jennifer C. Lena

Diverse sets of actors create meaning in markets: consumers and socially engaged actors from below; producers, suppliers, and distributors from above; and the gatekeepers and intermediaries that span these levels. Scholars have studied the interactions of people, objects, and technology; charted networks of innovation and diffusion among producers and consumers; and explored the categories that constrain and enable economic action. This series captures the many angles in which these phenomena have been investigated and serves as a high-profile forum for discussing the evolution, creation, and consequences of commerce and culture.

The Moral Power of Money: Morality and Economy in the Life of the Poor
Ariel Wilkis
2018

The Work of Art: Value in Creative Careers
Alison Gerber
2017

Behind the Laughs: Community and Inequality in Comedy
Michael P. Jeffries
2017

Freedom from Work: Embracing Financial Self-
Help in the United States and Argentina
Daniel Fridman
2016